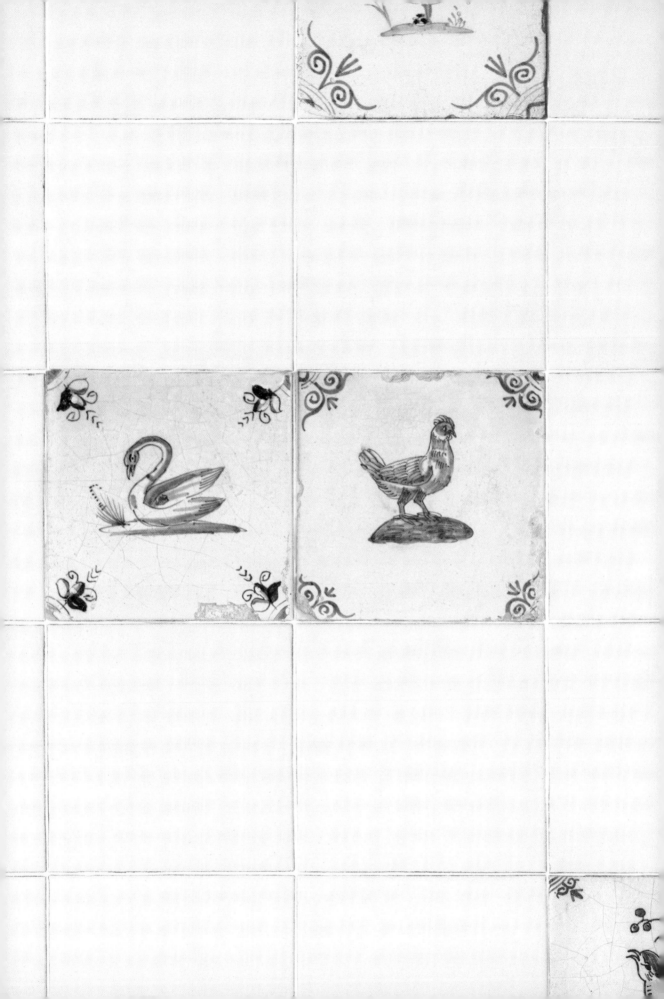

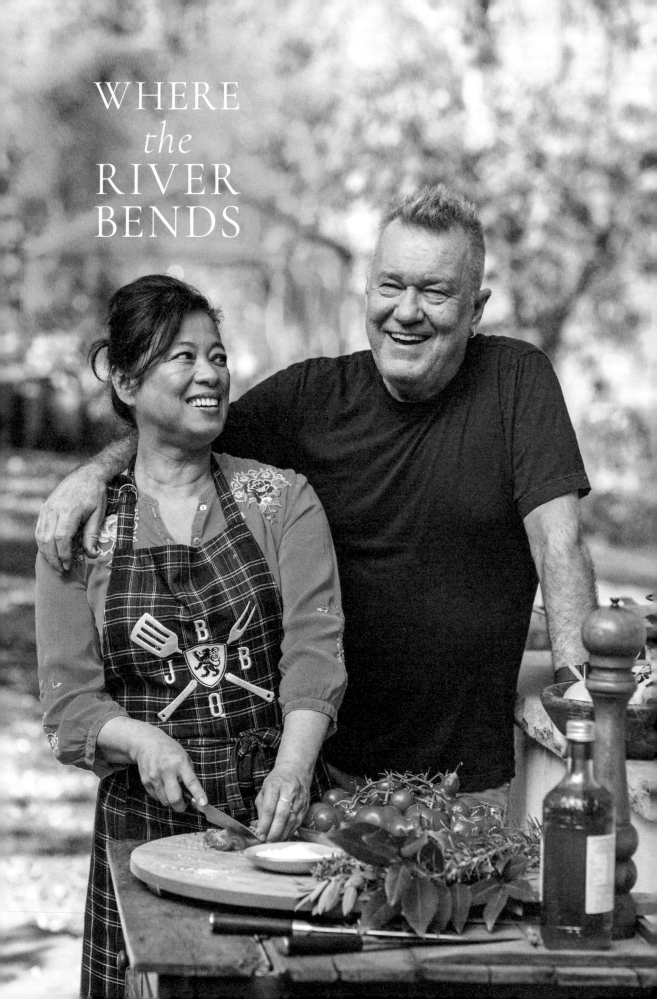

WHERE
the
RIVER
BENDS

WHERE *the* RIVER BENDS

Recipes and stories from the table of

JANE & JIMMY BARNES

Photography by Alan Benson

HarperCollins*Publishers*

*This book is dedicated to all our loved ones:
our children, our family and our extended family,
who have sat at our table and shared their love, hopes
and dreams with us, through the worst and best of times.
It is especially dedicated to Kusumphorn and John Mahoney —
Mum and Dad. Thank you for introducing us to the world
and all the wonderful food it has to offer. These are precious gifts,
which we now pass on to our children and grandchildren.*

Our home by the river 9

Cooking with love 14

CHAPTER
ONE

For Breakfast
21

CHAPTER
TWO

Light Lunches
47

CHAPTER
THREE

Pasta Classics
77

CHAPTER
FOUR

Thai Favourites
103

CHAPTER
FIVE

Everyday Dinners
135

CHAPTER
SIX

Sundays & Roasts
161

CHAPTER
SEVEN

Potatoes, Spuds & Tatties
189

CHAPTER
EIGHT

Vegetable Sides
211

CHAPTER
NINE

On the Grill
239

CHAPTER
TEN

Sweet Things
265

CHAPTER
ELEVEN

Pantry Basics
293

Index 310

Acknowledgements 317

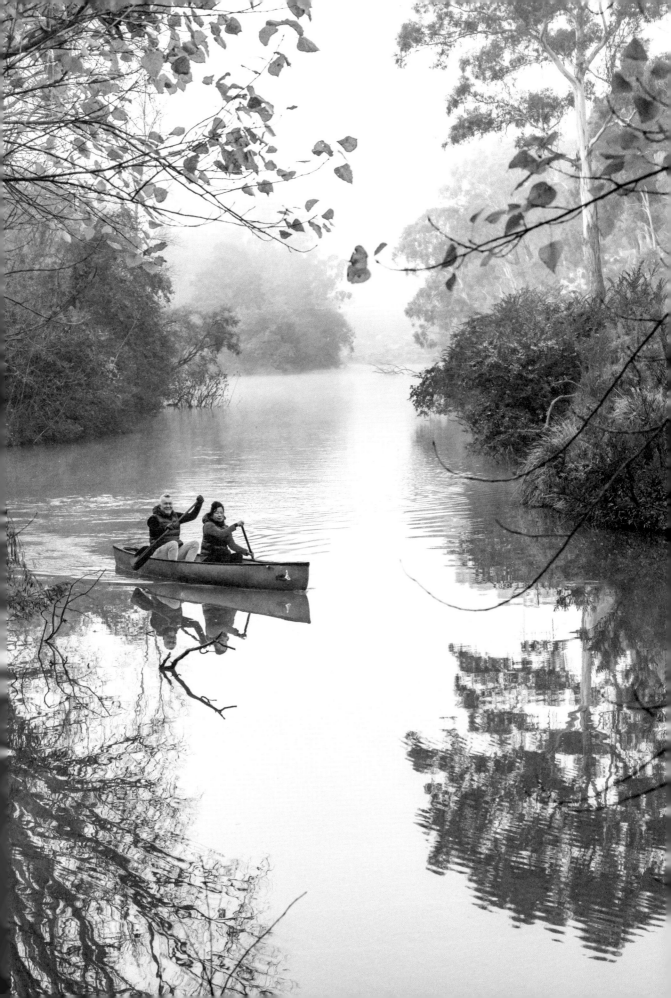

Our home by the river

MY EARLY LIFE AND JANE'S early life, as different as they were from each other, were both spent wandering from one place to another. Jane was born in Thailand and then, as the stepdaughter of a diplomat, lived and was educated in some of the most beautiful cities in the world, including Rome, Moscow, Kuala Lumpur and Tokyo. I, on the other hand, roamed as a hostage to poverty, spending my childhood running with my family from debts that always seemed to be snapping at our heels. We ran from Glasgow in Scotland all the way to Elizabeth in South Australia then on to Port Adelaide.

Jane and I were like two rivers following very different courses, and you'd have thought that our rivers were never meant to meet. Jane's early travels were gentle and slow, like a deep, wide river rolling through soft green hills, always constant, only changing direction when she needed to. She would pause and take stock every so often, prepare for a turn ahead and then move on in a measured and careful manner, looking forward to new adventures and the beauty that lay round the next bend. My erratic creek, on the other hand, surged from its source, fleeing the harsh, oppressive landscape of its origins, then twisted and turned, rushed and crashed, desperately gouging a path that was usually shallow and nearly always treacherous. There were no smooth waters, just endless raging rapids, tossed and tormented and out of control – but always searching for a place to rest, a place to breathe.

Astonishingly, and fortunately for me, our two rivers did eventually cross paths. Jane's broad, deep waters embraced my raging torrent and held me until I slowed and we ran on together, as one. Life would never be the same again.

Calm didn't come immediately, though. Both of us were so used to changing landscapes and constant motion that it was a while until we were able to slow down long enough to attach ourselves to any one place. But eventually we did, and we found somewhere we finally feel we both belong.

> Seventeen years later, we still sit by the river and pinch ourselves, wondering how we found such a beautiful place to spend the rest of our lives.

Appropriately, our home is on the banks of a river, the Wingecarribee River, in the Southern Highlands of New South Wales, on the traditional lands of the Gandangara people. It's not a big, imposing river or one that runs wild; it's quiet and seductive and beautiful. It meanders between the sleepy gum trees that surround our peaceful little town, and if you sit quietly you can watch kangaroos grazing on its banks, platypus paddling in the shallows and countless birds soaring in the breeze above the water.

Jane found this house for us, and fell in love with it immediately. She couldn't wait to take me to see it. In a heartbeat I felt the same. Seventeen years later, we still sit by the river and pinch ourselves, wondering how we found such a beautiful place to spend the rest of our lives.

Occasionally I talk Jane into taking a sunset cruise in our canoe. It's an easy trip, but I'm still the clumsy, fast-moving Scotsman I always was, so she is rightly wary of being in a small

boat – or any other confined space – with me. Yet she will still ride the river when I ask her to, because she understands how special it is to me, to us both. And every time, as we silently paddle our way back to our home, I look at my Jane silhouetted in the setting sun and think to myself, 'How did I get so lucky?'

This place by the river isn't just home for Jane and me, but for our entire extended family. As often as possible, we love to gather here and spend time together. And we especially like to cook and eat. The kitchen is the heart of family life for us. No matter how busy our lives become, and no matter how many or few of us there are, we make food every night and then sit down at our big dining room table to eat, talk and laugh.

Now, when I say we cook together, I mean we *all* contribute. When the kids were younger, they each decided on a favourite thing to make. Mahalia is a fabulous cook, who specialises in cakes and other sweets. Elly-May likes to cook vegetables, Eliza-Jane loves making pasta, and Jackie and I find ourselves drawn to fires – we'll grill or smoke anything that is left in front of us. And even though the kids have grown up now and left home, they, and their own families, love to gather in our kitchen and cook together whenever they can. Our kitchen is where we all feel at home.

The kitchen is the heart of family life for us. No matter how busy our lives become, we make food every night and then sit down at our big dining room table to eat, talk and laugh.

These days, I like to think of myself as a pretty good cook, but I know deep down that I am really still just the kitchen hand, always ready to chop, peel, grate, stir, fry, steam, grill or clean up whenever Jane asks me to. For in our kitchen, Jane is the boss. She is calm and always in control. She has an amazing knowledge of all kinds of cuisines, thanks to a lifetime of travelling (which she'll tell you about in her 'Cook's Tales'), and wonderful instincts when it comes to food. She can taste a dish and instantly tell you all the ingredients you would need to make it happen.

I try to do the same, but not quite as successfully. Although I do have a photographic memory, it's just not developed, so by the time I get home I have forgotten half of the ingredients and I have to improvise. This can work out really well or end up going horribly wrong. Most of the time it works out well, as I have good instincts. I will throw in a handful of this and a splash of that, never measuring precisely what I'm using, until the dish is balanced.

But with this approach, when it turns out great, it's often a one-off – the next time it might be totally different. So I don't advise doing this at home, especially if you want to be consistent with your cooking. Thank God for cookbooks, I say, and I am extremely happy that Jane is putting all her best recipes down on paper. Now I'll be able to make our favourite dishes for her without completely missing the mark.

So, while I'm here to you tell a few stories and (hopefully) entertain you, make no mistake, these are Jane's recipes. Recipes she has learned from relatives and dear friends and gathered over a lifetime. Recipes she has used to nourish our family in times of celebration as well as times of heartache. Recipes that have held us together through thick and thin. Recipes from our home, where the river bends. The place we hold dearest in our hearts.

– Jimmy

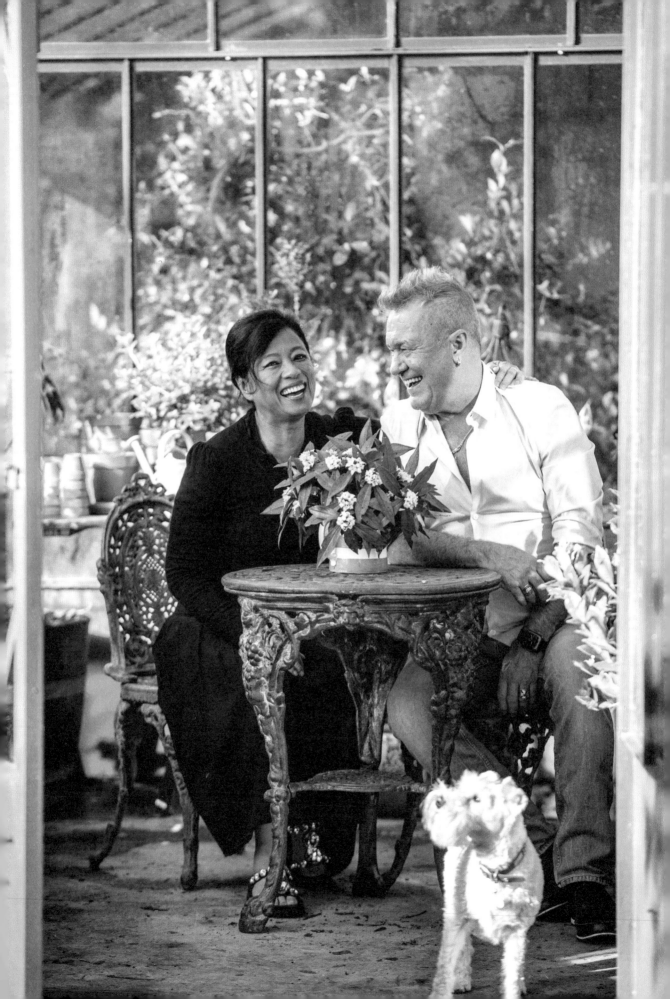

Cooking with love

FAMILY AND FRIENDS ARE VITALLY important to us, and our home, music and great food are what bring us all together. We are not chefs by any stretch of the imagination, but we do love to cook. We treasure delicious food and opportunities to nourish those special to us with love and intention. Cooking for others is a gift from the soul and a certain recipe for happiness, which in turn brings out the best in us all.

I was born into a culture that places the utmost importance on food. My mother is one of twenty-six children. Her father had moved to Thailand from China before the Communist Revolution and lived out his days in the Land of Smiles, having married seven wives. In Thailand, good food is often a raison d'être, even an obsession. We have been known to discuss dinner plans while enjoying lunch, and are more than willing to drive in suffocating traffic to the other end of town in search of a particular noodle dish, or in the hope of discovering a stall or restaurant that might become a new favourite.

Cooking for others is a gift from the soul and a certain recipe for happiness.

Ours was a privileged household, and the first food memories I have are etched with the flavours of the best of Thai and Chinese cuisine. Sunday family feasts were unforgettable. There were plenty of cousins to play and fight with, until we were all herded to a giant round table with a lazy Susan in the centre, which delivered delectable dumplings and other dishes in steaming bamboo baskets – usually five to seven dishes, accompanied by jasmine rice and clear soup to wash down any lingering spiciness between courses.

The sounds and smells of my grandmother Khun Yai's outdoor kitchen are still comforting to me, whether it's the memory of curry pastes being pounded, rice cooking or a master stock bubbling away. From as soon as I could run, I would regularly dash back at meal times through the mango grove, barefoot, to our cook's crackling charcoal-fuelled clay stoves, hoping I would be allowed to help in some way.

My parents divorced when I was four years old and my mother married John Mahoney, a young Australian diplomat who was then living in Thailand on his first overseas posting. When we moved with Daddy John to Australia, it was on certain conditions. In particular, Mum would not, could not, travel anywhere without her beloved fish sauce, or nam pla. So, when I, then only six years old, and my little sisters, Kaye and Jep, flew to Australia unaccompanied, she insisted we carry a large ceramic jar of this pungent condiment with us. All I remember of that trip was worrying that the jar might break; if it did, I was sure no one – not even the unsuspecting pilots – would have been able to stand the smell and we would all have plummeted into the ocean.

Thankfully that didn't happen, and we were welcomed to Canberra with open arms by the Mahoney family. Granny Violet and Grandpa Leslie George were so loving, and fussed over us like we were little China dolls. I saw frost for the first time in Canberra, then, as the winter set in, there was snow. For three young ones, whose only experience was of steamy Bangkok, we might as well have been on the moon – a beautiful, fascinating moon where you could see your breath as it came out of your mouth to warm your hands.

It was in Granny Violet's kitchen that I first tasted shortbread biscuits; baked beans on toast; grilled cheese, bacon and tomato sauce toast strips; cucumber sandwiches; scones and jam; perfect sponge cakes filled with whipped cream and strawberries; and mashed potatoes. Pretty much anything you could find in the Country Women's Association cookbook, my granny would make.

I learned a lot about 'Australian cuisine' during my years in Canberra, but I learned even more about food as a result of Daddy John's job. Every few years, our family would relocate to a different part of the world. We lived in Rome, Moscow, Malaysia, New Guinea, Japan, Kiribati and Malta, with breaks in Canberra in between. Each time, I was immersed in the local food culture; not only that, because I usually attended an international school, I also made friends with families from all corners of the globe and was exposed to their cuisines too.

Every few years, our family would relocate to a different part of the world.

Along with maths and music, good food is a universal language, and has always been a way to connect with the human heart. It was no surprise then that my father's work involved entertaining important guests at home, and much delicate political negotiation took place at my parents' carefully planned and expertly hosted dinner parties. Our family dining table was often the setting for vital 'peace talks', with great food almost always overcoming any impasse.

For most of us, indeed, cooking and enjoying wonderful food is the way we strengthen our connections. Eating together is treasured bonding time; it's an opportunity to share stories and experiences, teach and learn from each other, and pass on family recipes and food traditions. It can be a way to show our love. My favourite thing to do is get up early and put something on to cook, whether it be a pot of rice, chicken stock or a tray of biscuits. Often, this results in a kind of alchemy, the aromas from the kitchen sending waves of comfort through the house and making it feel even more like home.

For Jimmy and me, home is where the heart is, and our family and friends feel that too. We live at the end of a rainbow, down where the river bends.

– Jane

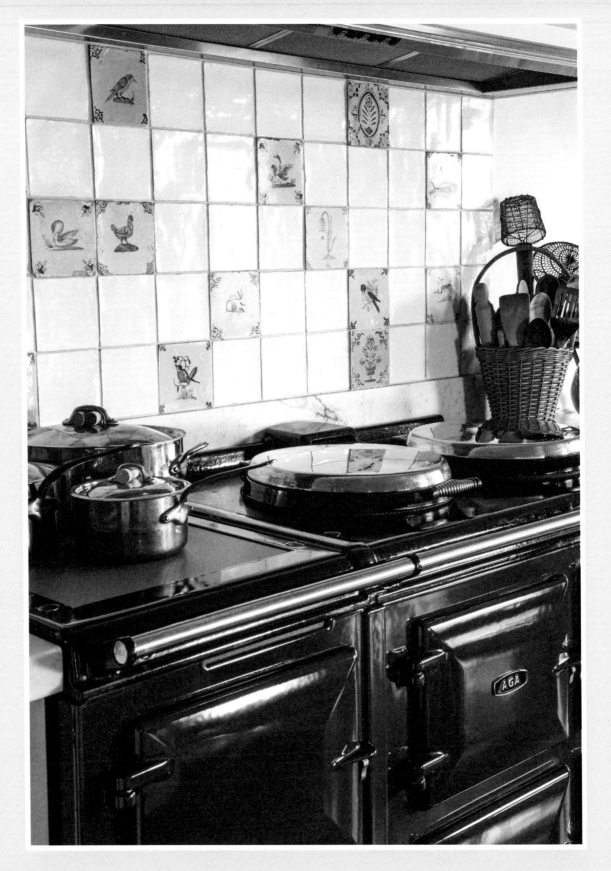

The heart of our home

The splashback in our kitchen incorporates thirty sixteenth-century Delft tiles, from Holland, which I collected over many years. Some are blue and white, some are yellow, brown and green. There are birds, bees, flowers, berries, fish, waterbirds, chickens, a musician, two dogs and a rabbit. Together they tell the story of our family's life here where the river bends.

The two dogs are Snoopy and Oliver, our beloved and greatly missed schnauzer brothers, who moved into the house with us when they first joined the family. The many birds represent the hundred-plus species of feathered friends that pass through our garden, ranging from kookaburras and rosellas to magpies, king parrots and bowerbirds. We even have resident birds of prey, including a family of whistling kites that live in our neighbour's tall gum. A family of ducks nest in our hedges and swim on the river, along with the geese that own the rock island at the bottom of the garden.

The bees on the tiles are our own honey bees. We planted beds of flowers around their hives, mainly blue flowers, which they love. We watch the rabbit hopping around on the other bank of the river, ever wary of the old fox that lives nearby, and occasionally spy the fish in the shallows.

The musician on our tiles walks along, playing his violin, so that music follows him wherever he goes. Our own musician lives here too, and he does much the same, albeit with his bagpipes. He was born a swan, James Dixon Swan, and on our wall the swan tile is right next to the chicken tile. The Thai word 'kookai', meaning chicken or hen, is my nickname. There, in our beautiful tile mural at the heart of our home, is our story of love, for all the world to see.

Cup and spoon measurements vary a little from one country to another, but usually not enough to affect the end result. Our measurements are Australian measures, so a cup is roughly 250 ml, a tablespoon is 20 ml, and a teaspoon is 5 ml.

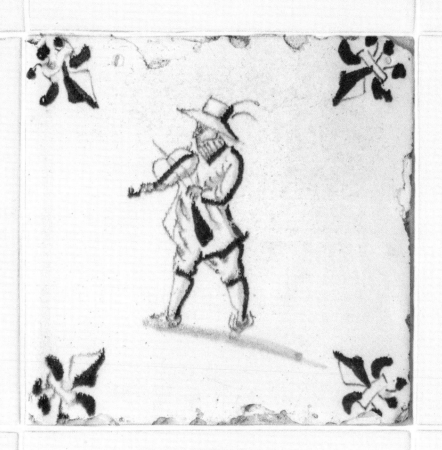

CHAPTER
ONE

For
Breakfast

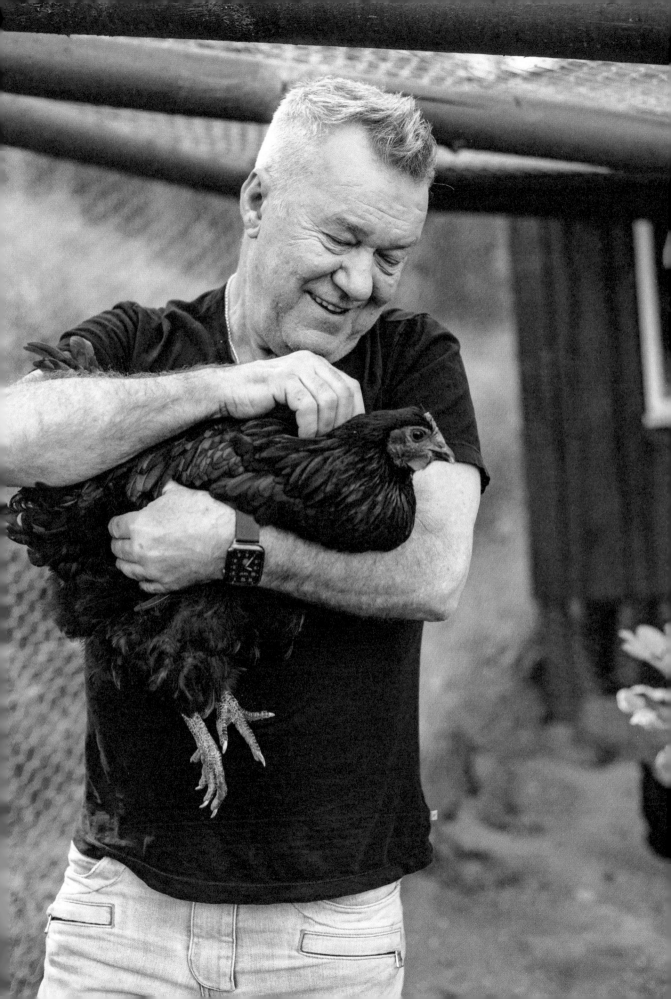

BREAKFAST, THEY SAY, IS THE most important meal of the day. It gives you the energy to tackle whatever life throws at you. Being a multicultural family, we like all sorts of things to eat in the morning, from yoghurt and fruit to curries and fish and everything in between. But the Scottish side of me, naturally, loves porridge. Jane makes porridge with milk and brown sugar and even cream. Totally decadent.

My love for porridge started in humble beginnings. As a young lad, I remember waking up and seeing my own breath flowing from my mouth on cold winter mornings. Almost freezing and snapping off before it floated away into the air like a cloud to meet the day. Our house was almost always bitterly cold. We would stumble out of bed onto a floor so icy your feet nearly froze to the linoleum. Then we would drag ourselves down the hallway and into the kitchen, which seemed to be the only warm room in the house.

If we were lucky, Mum would have made porridge. Not flash and luxurious like Jane makes it, but simple and plain. Just oats, water and salt. Very Scottish (Scots don't like to show off). Just enough to keep you alive and kicking – anyone who comes near you. If we were really lucky, there might be some sugar to toss on top to break up the blandness of the meal. But at the very least, the porridge was warm most days and surprisingly nutritious. (My granny used to eat hers with salt and butter, which at the time seemed weird, but now I can see the sense in it.) We didn't know back then that porridge was a superfood, but it gave us the strength to get out of the house and down the street to school and out of Mum's way.

Later, after growing up in Australia and visiting Scotland as a tourist, I learned of another way to have breakfast. In the flash hotels and country castles of the Highlands, I experienced a breakfast that could only be described as a celebration of the morning breaking through the cold dark night. Bacon, sausage, black pudding, baked beans, eggs and anything else you could squeeze onto a large dinner plate would be served to a guest as a 'traditional Scottish breakfast'. It was great, but not quite how I remembered Scotland.

At home, I usually like to start the day simply, with toast. Preferably served in bed with hot coffee (I am so spoilt). Now, I know what you're thinking. Who needs a recipe for toast? But you'd be surprised how many people out there can't make good toast. It is an art form that is slowly disappearing – dare I say, going up in smoke? No, I'd better not.

These days, you grab white sliced bread and stick it into a pop-up toaster. When the bell rings and it pops up, you grab it and put it on a plate and throw it onto the table. Job done. You can be back in bed before you've really woken up. You hardly have to open your eyes. But I'm here to tell you that there are better ways to make and serve toast. In fact, there are many ways to serve it.

We didn't know back then that porridge was a superfood, but it gave us the strength to get out of the house and down the street to school and out of Mum's way.

Toast is a very personal thing, so do it your way. Don't be afraid to experiment. Try it with vegemite or the jam of your choice. Or marmalade if you're that way inclined. Pile on some baked beans. Or put all these things on toast together if you really feel like it. I'm sure I've caught one of my grandchildren doing

just that. Though I must say, I have a feeling it was never really for eating at that point but for throwing at the dog.

Like everything, toast tastes better when cooked with love and attention. It can be made in a toaster or over a burner or even on a fork over an open fire, if you happen to have one going. Or you can cook it on an Aga stove. This last method is my personal favourite, as the Aga gives you a crisp, crunchy outside and a soft, delicate inside. It's magic.

> Like everything, toast tastes better when cooked with love and attention.

As kids, we would cook stale bread on a fork over an open fire. We couldn't afford to waste anything. I know what you're thinking: 'Oh, camping, nice.' But we weren't out camping, we were at home, inside. You see, we didn't have a toaster. Mum and Dad would be out and my sisters and brothers and myself would be scorching not only the toast but our hands as well, as we quickly tried to make toast before the house burned down. We spent so many freezing cold nights with all the doors and windows wide open, waving pieces of cardboard in the air, trying desperately to clear the smoke out before the fire department turned up. Only to find we had nothing in the house to spread on the toast. We'd be so disappointed with the lack of butter or jam that we would all just go to bed, leaving the burnt toast to cool and set rock hard on the kitchen bench.

In the morning I would be up early before the others and of course I would be hungry. I was always hungry. My siblings likened me to a seagull because I hovered around the table most nights, eating anything that was left on the plates. So I developed a taste for stale toast – cold, brittle, burnt toast at that. And to this day, that's the way I like it. Cold and burnt.

No toast goes to waste in our house, and it appears I am still part seagull. Though nowadays I love to spread thick French butter on the toast. The butter must also be cold, so that you can more or less slice it and just lay it on the toast. Mmm. Now that's a delicacy. (Jane, on the other hand, likes toast that is lightly browned but with a dark line along the crust, buttered while hot, and with vegemite scraped across it, tearing up the toast ever so slightly. A little subtle for my taste.)

I would write more on this subject, but I just noticed a lonely piece of burnt bread lying on the kitchen counter.

Whatever is your pleasure for breakfast, I am sure Jane will have something here to get your day off to a great start. After that, you'd better start moving because you are going to have to walk it off before Jane serves lunch.

Good luck.

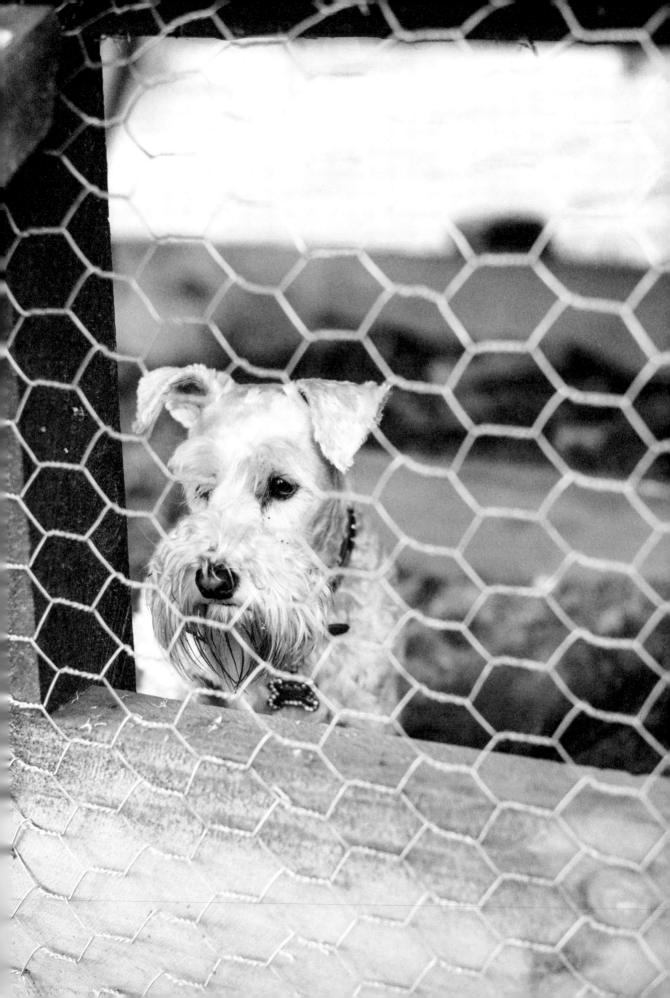

Grain-free muesli

Mahalia makes this especially for Jimmy, as a grain-free diet has helped him with managing his arthritis and other joint pain.

3 cups puffed buckwheat
1 cup dried coconut flakes
1 cup chopped nuts
⅓ cup mixed seeds
¼ cup honey
¼ cup maple syrup
**1 teaspoon ground
 cinnamon**
1 cup chopped dried fruit
**fresh fruit, milk and/or
 yoghurt, to serve**

Preheat the oven to 150°C (130°C fan-forced).

Scatter the buckwheat, coconut, nuts and seeds over a large rimmed baking tray.

In a small pot, combine the honey, maple syrup and a sprinkle of cinnamon. Cook over low heat, then drizzle over the mixture and toss to combine and coat evenly. Spread out to an even layer.

Place into the oven and cook for 25–30 minutes, stirring often so the mixture cooks evenly, until golden brown. Remove from the oven and set aside to cool completely.

Stir through the dried fruit and transfer to an airtight container. Muesli should remain fresh for 2 weeks.

Serve about ⅓ cup muesli with fresh fruit, milk and/or yoghurt.

[COOK'S NOTES]

For the nuts, we use almonds, macadamias, hazelnuts, pistachios, walnuts and pecans – you could have any combination of these that you like. For the seeds, try a mix of pumpkin seeds (pepitas), sunflower seeds, flaxseeds and chia. For the dried fruit, you can use goji berries, dried apricots, cranberries, currants, strawberries, blueberries, cherries and medjool dates.

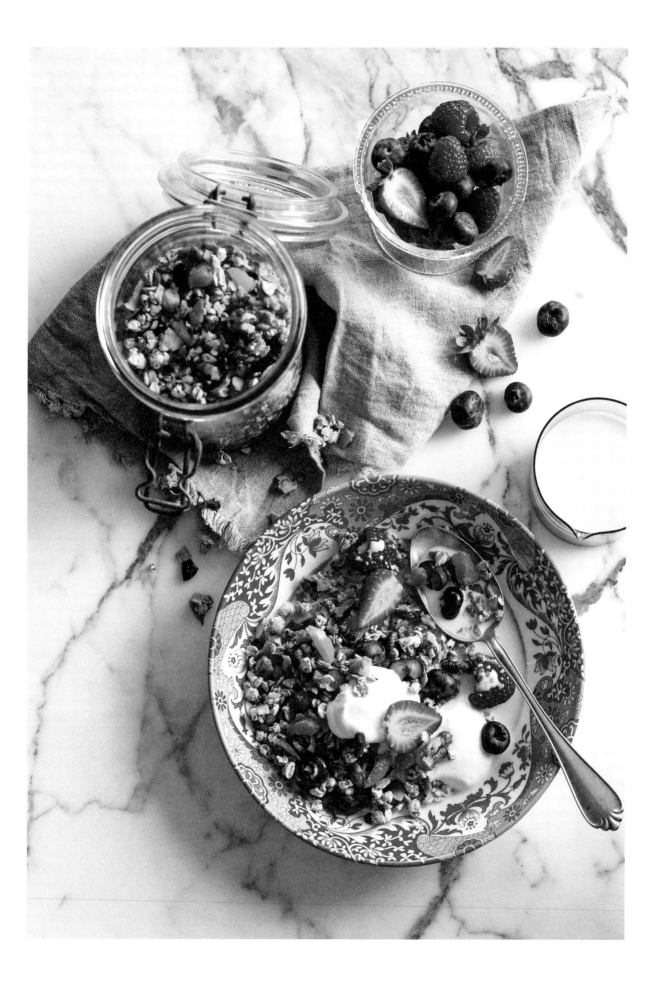

Eggs Rico (campfire eggs)

[*SERVES 4–6 — OR 12!*]

I think this recipe got its name from a friend of a friend's friend! This is a campfire breakfast, for when you have many mouths to feed and one giant pan. We always make this when we go camping, and often at home as a quick and easy brekky.

butter, for cooking
100 g shaved ham
12 free-range eggs
toast, to serve

Melt a generous piece of butter in a large frying pan and toss in the shaved ham.

Crack in the eggs and gently mix through, breaking the yolks but not scrambling them.

When the bottom is cooked, turn off the heat (or remove from the campfire). Keep stirring and mixing until the whites start to firm. Sprinkle with salt and pepper if you like.

Serve with toast, nicely singed by fire flames if you are camping.

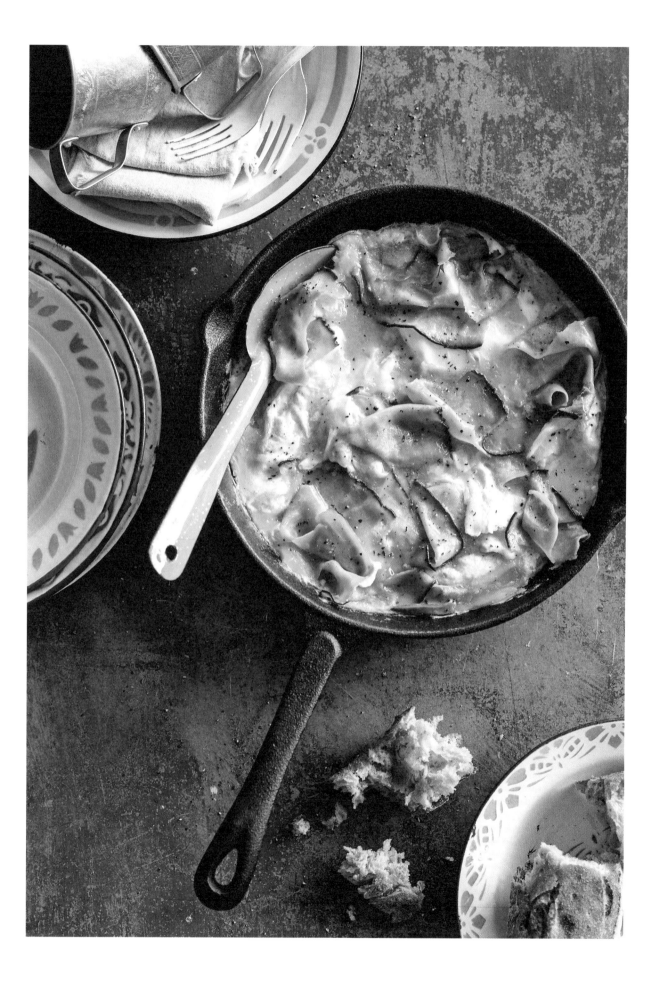

French toast

This is a family favourite (especially with grandson Dylan). It's quick and easy, and a great way to get an egg and some fruit into the little ones before a big day at school. You also get to use up day-old bread, so that is a bonus.

2 free-range eggs
dash milk
2 thick slices brioche or
 white bread
butter, for frying
berries, sliced banana and
 maple syrup, to serve

Beat the eggs with the milk in a shallow dish. Place the slices of bread into the mixture, one at a time, to soak up the egg mixture on both sides.

Melt a generous knob of butter in a frying pan over medium heat. Add the egg-soaked bread and cook for 2–3 minutes on each side, until nicely browned.

Serve with berries, bananas and a drizzle of maple syrup. You can even dust the berries with a little icing sugar for a treat.

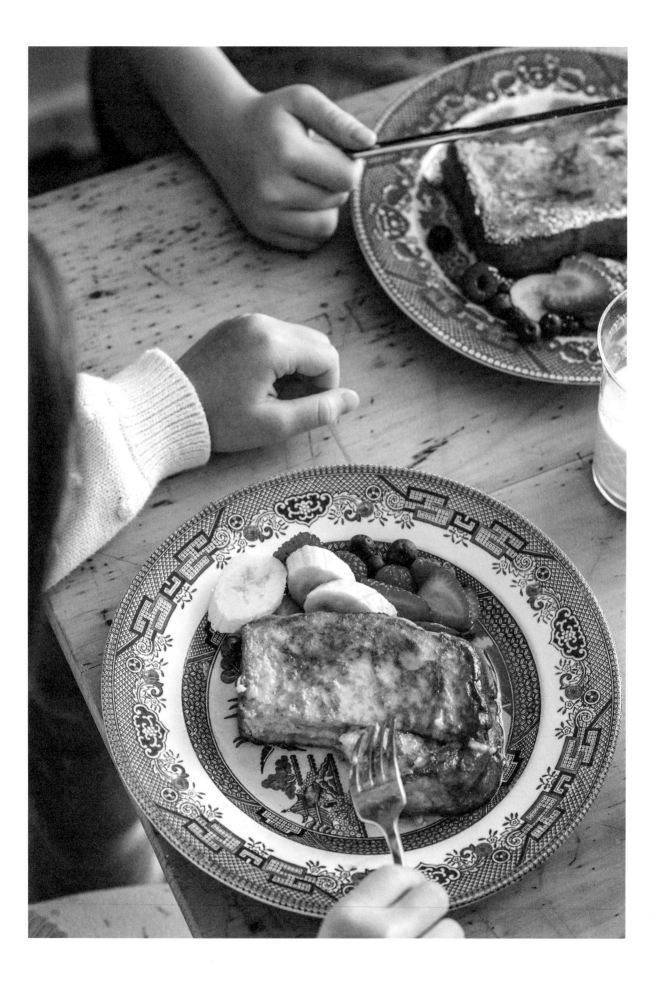

Anna's crêpes

[*MAKES* 12]

Anna is a Yugoslavian–Ukrainian Australian whose family migrated here more than 60 years ago. She has been part of our household since the children were toddlers and is like the tough aunt who keeps everyone in line. She makes a stack of 40 or so of these crêpes as soon as she arrives in the morning.

Depending on what is on the schedule on our 'to-do' blackboard, and which members of the family are home, she then sets to work on our favourite comfort foods: meatballs with mushroom gravy, chicken schnitzels, bolognese ragu, moussaka, minestrone, cream cheese lemon cake. Our house is like a boutique hotel with a revolving door – with four children, their children, their friends and band members, there can be 20 people through on a normal day!

2 eggs
1 tablespoon caster sugar
1 teaspoon vanilla essence
pinch salt
2 cups milk
1½ cups plain flour
1 tablespoon water
unsalted butter, for cooking
fresh berries, to serve

Put the eggs, sugar, vanilla essence and salt into a mixing bowl and use hand beaters or a whisk to mix until combined. Beat in the milk. Add the flour and beat until all lumps are gone, then stir in the water. Ideally, set batter aside to rest for 20 minutes.

Heat a medium frying pan over medium heat. Add a teaspoon of butter and swirl the pan as it melts, to coat evenly.

Ladle ¼ cup of the batter into the pan, immediately swirling and tilting from side to side to spread evenly. Cook the crêpe for a minute or until the underside is golden and small bubbles start to form on top. Flip with a spatula and cook the other side until golden. The first crêpe is always a bit dodgy, so be prepared to throw it out. Or feed to the dog (or husband).

Repeat until all the batter is used up, adding more butter to the pan between crêpes as needed. Wrap cooked pancakes in a clean tea towel as you cook them, to keep them warm before serving.

You can top these crêpes with whatever you like, but here are some of our favourite flavour combinations:
- Honey and yoghurt
- Freshly squeezed lemon juice and golden caster sugar
- Maple syrup and fresh cream
- Ham and cheese (if you're in the mood for something savoury)

[COOK'S NOTES]

We also make our version of a Japanese crêpe cake, layering a healthy dollop of chantilly cream and sliced mango between crêpes in a neat stack.

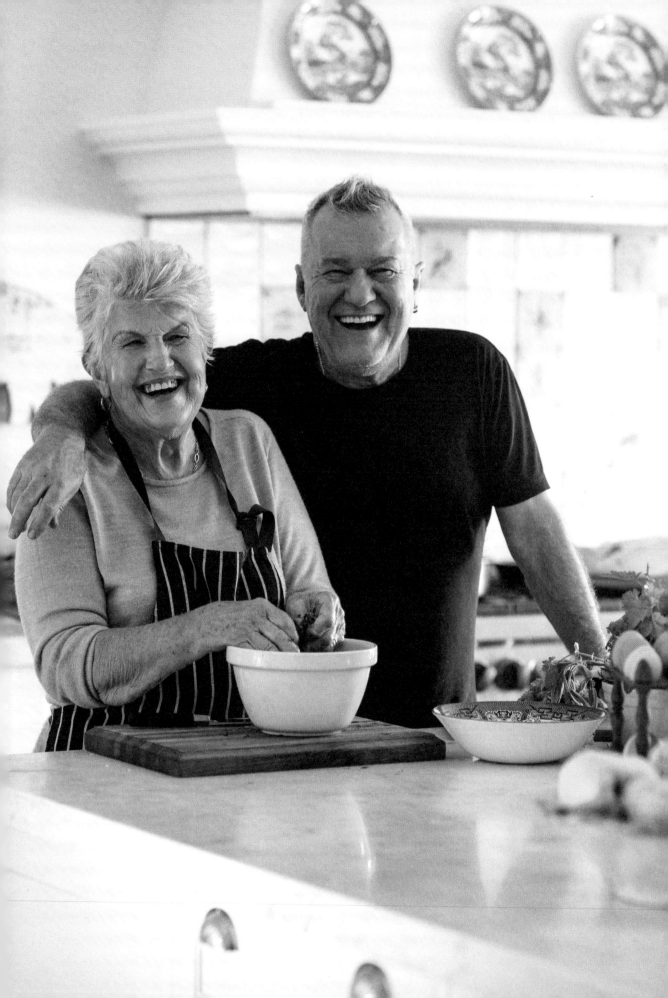

Porridge volcano

This recipe is especially for the little ones. Getting creative with food helps them engage with what they are eating.

**2 cups traditional
 rolled oats**
2 cups milk
2 cups water
½ teaspoon salt
**golden syrup, brown sugar
 and milk, to taste**
**berries or other fresh fruit,
 to serve (optional)**

Combine the oats, milk, water and salt in a heavy-based saucepan and place over medium-low heat.

Stir constantly with a wooden spoon for 6–8 minutes, until thick and creamy.

Divide the porridge between shallow bowls and pile into the shape of a volcano. Using the handle of the wooden spoon, make a hole through the centre of the 'volcano' and fill with golden syrup to taste.

Sprinkle the sides of the 'volcano' with brown sugar, and pour milk around the edge.

Add berries or any other fresh fruit, if desired.

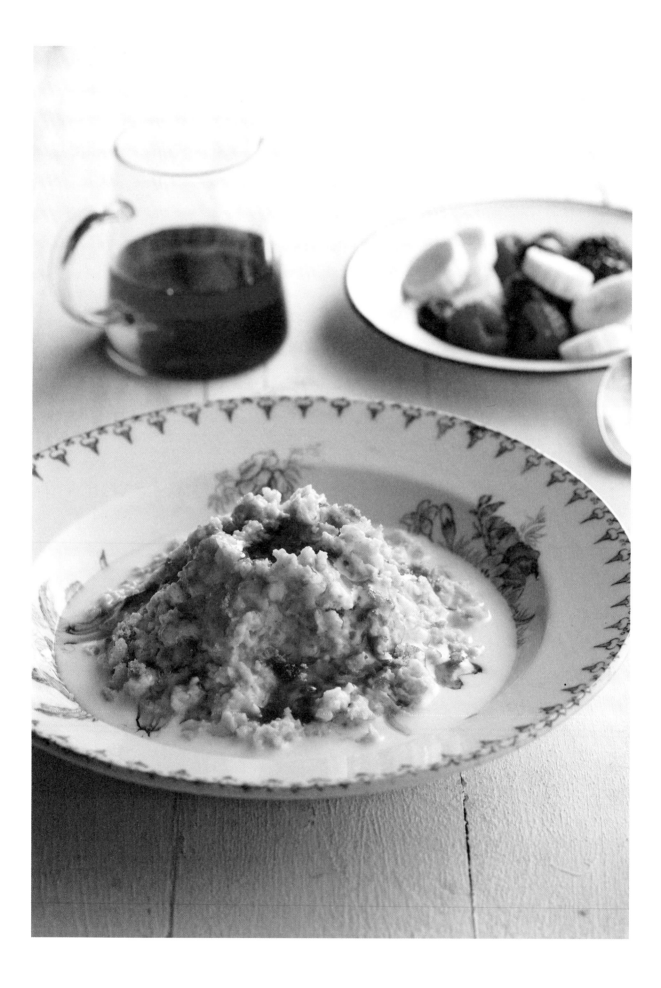

The day begins

EVERYBODY I KNOW LOVES THEIR breakfast and for the little ones, of course, it's the most important meal of the day. While I'm happy to cook breakfast for others, I personally struggle to eat before 11 am and generally need something a bit more potent than the typical Australian breakfast to get my day started.

On our arrival in Australia in the early 1960s, our first breakfast was cornflakes with milk and sugar. Not terribly enticing, but at least there was the attraction of a free plastic puzzle toy when we finished the whole box – that was a treat! Subsequent breakfasts included square slices of toast lightly spread with butter and topped with a layer of a mysterious black salty paste. This was, of course, Vegemite on toast, a compulsory part of growing up in Australia, and it was something of a test – which, I'm happy to say, we all passed.

We gained a new appreciation of breakfasts in the late 1960s, after Dad was posted to the Australian Embassy in Rome and we went to live there. Our first weeks were spent in a pensione, or bed and breakfast, where we would wake up each day to an amazing continental-breakfast buffet. There were small round doughnuts filled with custard or jam (bombolini), crunchy pastries with cream and fruit fillings (cannoli), bread rolls like I'd never seen before, pizza bianca, prosciutto cotto, salami, mortadella, and an array of cheeses – all piled on one table. And next to that was a smaller table stacked with cute mini bottles of fruit nectar, ceramic jugs of milk and fizzy San Pellegrino orange drinks. And this was just breakfast!

We then moved into an apartment in old Rome, Via di Monserrato 48, just off Piazza Farnese and next to Campo de' Fiori (meaning 'field of flowers'). Directly below us was a small café-delicatessen and, every morning, the heavenly smells of freshly made 'rosette' rolls and coffee would rise up through my window, so that I woke with a smile already on my face. Those crusty buns, filled with mortadella and provolone, were our breakfast on the school bus for years after.

Nowadays, however, I find myself yearning for the hearty breakfasts of my Thai childhood. I've included in this chapter a Thai rice soup recipe, khao tom goong. Little ones will enjoy this delicious savoury dish, and you can also add chillies to spice it up for adults. When I'm in Thailand, one of my favourite things to do is head to the markets at sunrise in search of kanom jeen nam ya. Now there's a breakfast: a fish curry sauce poured over rice noodles with herbs and bean sprouts and crunchy vegetables. That's the way I like to start my body's engine, generating some heat and spice to shock the belly and clear out any cobwebs in the head, leaving the eyeballs sweating and the ears burning from the inside.

Khao tom goong

[*SERVES 4*]

Khao (rice) tom (boiled) goong (prawns) is a typical Thai breakfast dish. Jimmy loves this more than anyone else in the family.

8 king prawns, peeled and
　deveined, tails left on
2 cups cooked jasmine rice
　(leftovers are fine)
4 cups vegetable stock
　(page 298)
1 teaspoon fish sauce
1 tablespoon grapeseed oil
½ brown onion, sliced
1 garlic clove, smashed
　and roughly sliced
nam pla (spicy fish sauce),
　to taste (optional)
4 eggs

PRAWN MARINADE
1 tablespoon oyster sauce
1 tablespoon fish sauce
6 coriander roots, crushed
3 garlic cloves, smashed
white pepper, to season

TO GARNISH
1 small knob (thumb-sized)
　ginger, peeled and cut
　into fine strips
6 green shallots, sliced
¼ cup coriander leaves,
　finely chopped
4 teaspoons garlic oil
　(page 294)
2 sliced chillies in white
　vinegar (optional)
sea salt and white pepper,
　to season

To make the prawn marinade, combine all the ingredients in a shallow bowl. Add the prawns, cover and refrigerate for at least an hour or even overnight.

Place the rice in a saucepan, cover well with stock, bring to a boil then reduce the heat to let simmer. Add the fish sauce. You don't want the rice to cook to mush, just heat through nicely.

Heat the oil in a heavy-based frying pan over medium-high heat. Add the onion and cook for about 3 minutes, until soft. Add the smashed garlic and marinated prawns. Cook for about 2 minutes on each side or until cooked through. Taste and season with salt or nam pla (spicy Thai fish sauce) if needed.

Meanwhile, boil the eggs for 2 minutes (they will be very soft-boiled).

To serve, set out four bowls. Scoop a boiled egg into each bowl. Stir the prawns into the soupy rice, then spoon over the egg.

Garnish with the ginger, green shallots and coriander leaves, and drizzle with garlic oil. Season with white pepper. Add chillies, if using, and more fish sauce to taste. Stir the egg through and serve.

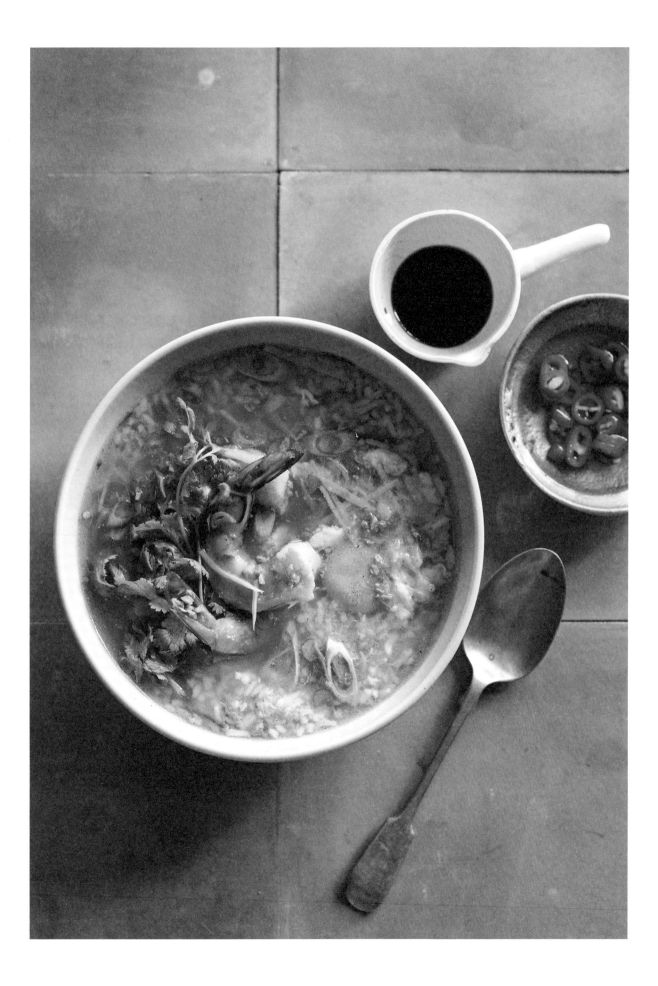

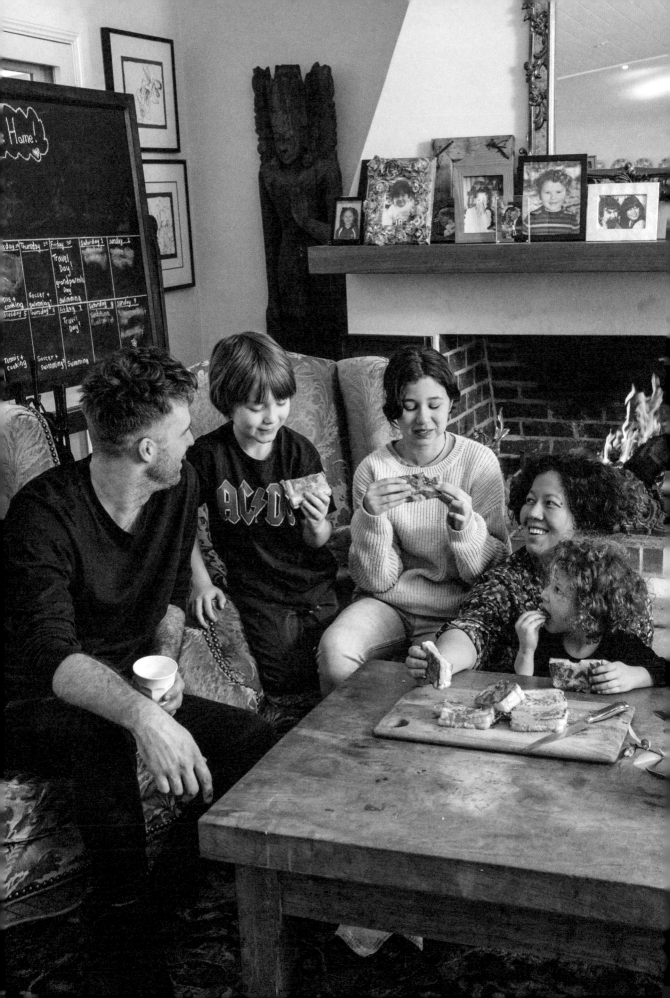

CHAPTER
TWO

Light
Lunches

LIGHT LUNCHES ARE OFTEN PLANNED in our family, but very rarely occur. Instead, one light lunch will end up being combined with four or five others, all swirling together in a kind of perfect storm, resulting in a sumptuous feast. Now, don't get me wrong here. It's not that we're being greedy when we make these super lunches, it's just that we can never decide what to have. So, we cook everything.

'Let's have a lobster omelette,' Jane will say as she starts to prepare a perfectly balanced light meal.

Then suddenly the door will open and in will come Mahalia. 'What are you guys cooking?' she'll ask. On finding out we're making lobster, Mahalia will immediately suggest that she cooks the tuna fillets she has just bought on the way over. We can all share the food and that way lunch will be more interesting. Great.

Then our granddaughter Rosie might arrive. 'What's that smell?' she'll say. Rosie has inherited the highly developed sense of smell of her grandmother, or yai yai, as she calls Jane in Thai, and guess what? She doesn't like seafood. 'I don't want to eat that, Yai Yai,' she will object.

Suddenly there are more plans afoot. 'Okay,' Jane will say reassuringly, 'you cook the tuna fillets, Mahalia, and I'll make the lobster omelette for us and chicken with soy sauce for the young ones.'

Seems simple enough, right? But then the door will open again. It's Jane's sister Jep. 'What are you cooking?' she'll ask.

Jane will read out the planned menu.

'Oh, but I really feel like rice.' Jep is, of course, Thai like Jane and wants to have rice with every meal.

'That's okay, Jep,' Jane will reply. 'I'll fry up some minced chicken with basil and chilli too. It will be perfect with the omelette and the tuna.' Now it's getting interesting.

'Do you have any greens?'

'Sure, I'll make some stir-fried cabbage with oyster sauce.'

So the menu has gone from one dish to five or six dishes in the space of a minute. After a frenzy of cooking, we all sit down to eat our quick little lunch.

I'm certainly not complaining. Every dish served up is cooked with love and happens to be a favourite of someone in the family. But any one of these dishes would suffice as a simple, nutritious meal.

We can never decide what to have, so we cook everything.

Every now and again, though, we do try to show some self-control and eat what would be a light lunch for a normal human being. Some days we even opt for a sandwich. Often one made with the leftovers from a roast dinner the night before. Jane builds the ultimate version, starting with fresh, thickly cut bread then filling it with roast beef or lamb, maybe some baked pumpkin, potato and onion, and a little lettuce, with mayo added for luck – and possibly topped off with a splash of gravy or a touch of tomato relish. By the time she's finished, the sandwich, sitting on a large dinner plate, is casting

a long shadow across the kitchen bench and you think: one person could not possibly eat all of this, could they? Not me, that's for sure, so I suggest you take this giant light meal of a sandwich, cut it in half and share it with someone you love.

A classic Thai light lunch is a bowl of rice or egg noodles, served with beef or fish balls with greens and tossed in gravy or thick soy sauce, either dry or in a delicious broth with a little chilli on the side. Another favourite lunch of mine is Jane's frittata. Eggs from our own chickens baked with cooked veggies, wild greens, loads of fresh herbs from our garden, and maybe a sprinkling of cheese. It's perfect with a simple salad. A glass of wine is optional, but I prefer cold water. You don't want me drinking with lunch. Or I'll be singing by the time dessert is served.

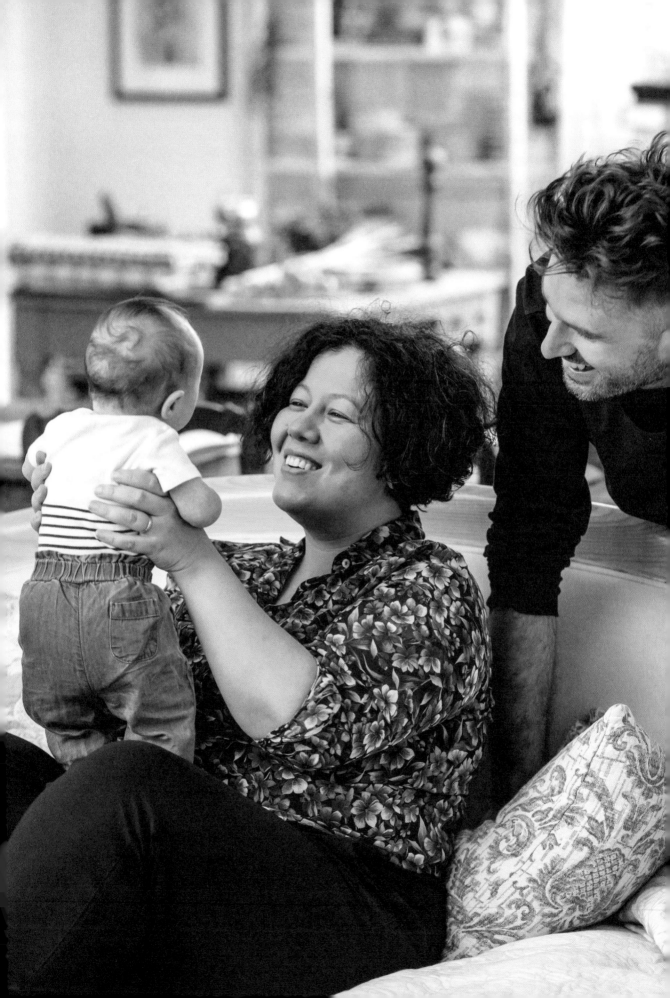

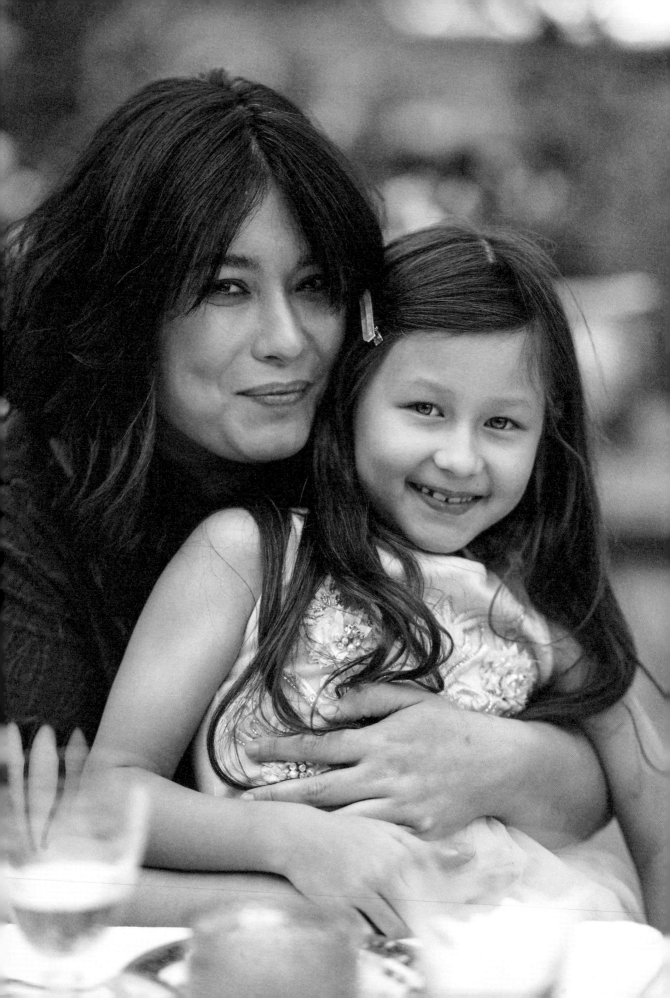

Lobster tail scrambled eggs

[*SERVES 4–6*]

This is terrific for brunch or lunch. It only takes 10 minutes to prepare and is a pretty special dish – fancy but quick and easy. I get the fishmonger to cook the lobsters and cut them in half for me, which helps! I use 9 eggs just because it's a magical number but you can use from 6 to 12, depending on how many you are feeding.

½ medium or 1 small
 lobster tail, cooked
9 free-range eggs
dash milk
sea salt and white pepper
butter, for cooking
finely sliced green shallots,
 coriander leaves and
 chilli oil, to serve

Pull the meat from the lobster tail and tear or cut into bite-sized chunks and shreds.

Beat the eggs with the milk until just combined (don't overbeat). Season with a pinch of salt.

Melt a generous spoonful of butter in a large frying pan over low heat and pour in the egg mixture.

Add the lobster pieces then use a wooden spoon to draw the egg mixture from the edges to the centre of the pan and let it slowly cook. We don't want the eggs to overcook, so keep stirring slowly and constantly. Add pepper to taste, and mix through.

Remove from the heat just before the egg is fully cooked – it should still have a shine and thin layer of softness. Keep stirring and the residual heat in the pan will finish the cooking.

Garnish with green shallots and coriander. Drizzle with chilli oil. Serve immediately, on its own or with a simple salad.

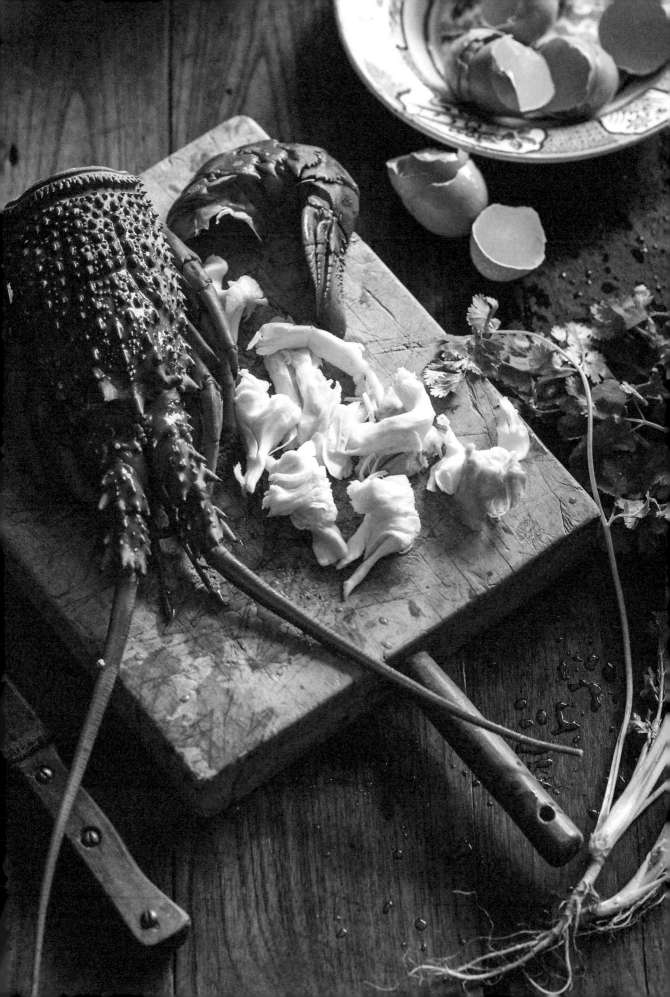

Potato, cheese and herb frittata

[*SERVES 6–8*]

I have a wonderful herb garden at home, so I love to use fresh herbs in a lot of my cooking. All the herbs are optional in this recipe. Some family members aren't too keen on dill, for example, so I don't use it if they're coming round. I like to use some dried herbs as well. Les Herbes de Provence are mixed dried Provençal herbs, usually a combination such as thyme, rosemary, oregano, parsley, sage, mint and lavender. I dry my array of herbs so we have our own version to add to all sorts of Mediterranean dishes, but you can buy the mix from a good deli. Dried herbs are stronger than fresh herbs, so a mixture of both is perfect. I like to serve this with a simple witlof and walnut salad, some persillade (page 295) or salsa verde, and, of course, a crusty baguette!

10 baby potatoes, halved

2 tablespoons olive oil

30 g butter

1 brown onion, sliced

sea salt and freshly ground
 black pepper

10 free-range eggs

100 ml cream

big handful grated gruyère
 or Comté cheese

pinch Herbes de Provence

big handful fresh herbs
 (such as parsley, sage,
 oregano, thyme and
 dill), finely chopped

Preheat the oven to 180°C (160°C fan-forced).

Cook the potatoes in salted boiling water for 15 minutes or until tender. Drain, then let the steam evaporate.

Heat the olive oil in a large ovenproof frying pan over medium heat, then add the butter and let it melt. Add the onion and a pinch of salt and cook for about 5 minutes, stirring occasionally, until the onion is soft. Add the potatoes and turn to soak up the butter. You can cook them a bit longer so they brown a little, if you like. Turn off the heat and set aside.

Beat the eggs with the cream. Stir in the cheese, Herbes de Provence then the fresh herbs. Pour the egg mixture over the potatoes and onion. Grind some black pepper over the top and sprinkle with more cheese.

Bake for 35 minutes, until set and golden brown. Serve warm or at room temperature.

[COOK'S NOTES]

If you don't have an ovenproof frying pan, you can simply transfer the mixture to a baking dish. I always use cold-pressed olive oil, but it can be expensive, so just use the best olive oil you can afford.

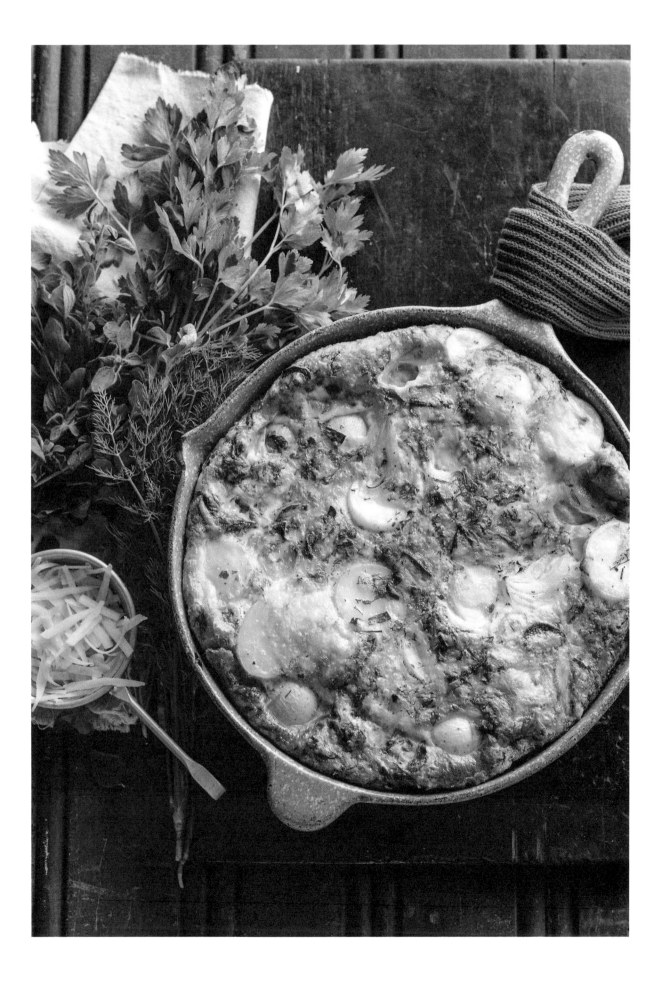

Riverbend spanakopita

[*SERVES* 8–10]

We grow English spinach, rainbow chard, silverbeet and warrigal greens in our little veggie patch, so this delicious wholesome pie has become a family favourite. We also love to use a similar mixture of garden and wild greens to make the gnudi on page 90.

leafy greens (see Cook's
 Notes), thicker stems
 removed
1 tablespoon olive oil
1 brown onion, sliced
sea salt and freshly ground
 black pepper
2 garlic cloves, crushed
2 tablespoons pine nuts
2 free-range eggs,
 lightly beaten
big pinch ground nutmeg
200 g feta, crumbled
finely grated zest of
 ½ lemon
¼ cup flat-leaf parsley,
 finely chopped
¼ cup dill sprigs, chopped
2 large sheets frozen puff
 pastry, just thawed (we
 use the Carême brand)
1 egg beaten with
 1 tablespoon milk

Preheat oven to 200°C (180°C fan-forced). Line a large baking tray with baking paper.

Bring a large saucepan of well-salted water to the boil and have a large bowl of iced water ready. To blanch the greens, add to the saucepan and cook for 2 minutes. Drain well, then add to the bowl of iced water to stop them cooking. Drain again, then use your hands to squeeze out excess water. Chop finely.

Heat the oil in a large, deep frying pan over medium heat. Add the onion, season with salt and cook for about 5 minutes, until soft. Stir in the garlic and cook for about 30 seconds. Add the chopped greens and mix well. Transfer to a mixing bowl to cool.

Add the pine nuts, eggs, nutmeg, feta, lemon zest, parsley and dill. Season with salt and grind over a few twists of black peppercorns. Mix through well, combining everything evenly.

Lay a sheet of pastry onto the lined baking tray. Spread the filling over the pastry, leaving a 2 cm gap around the edge. Cover with the second piece of pastry. Press the pastry edges together with a fork to seal. Paint the pastry with the beaten egg and milk. Prick with a fork here and there so steam can escape.

Bake for 45 minutes or until the pastry turns a beautiful golden brown. Serve on its own or with a Greek salad.

[COOK'S NOTES]

Greens such as English spinach, nettles, rainbow chard or silverbeet are great for this. You can use just one type of green or any combination. The quantity is pretty flexible; just don't forget that, once blanched, what looked like an enormous amount shrinks down a lot! Aim to use about the equivalent of 3 bunches of silverbeet bought from a shop.

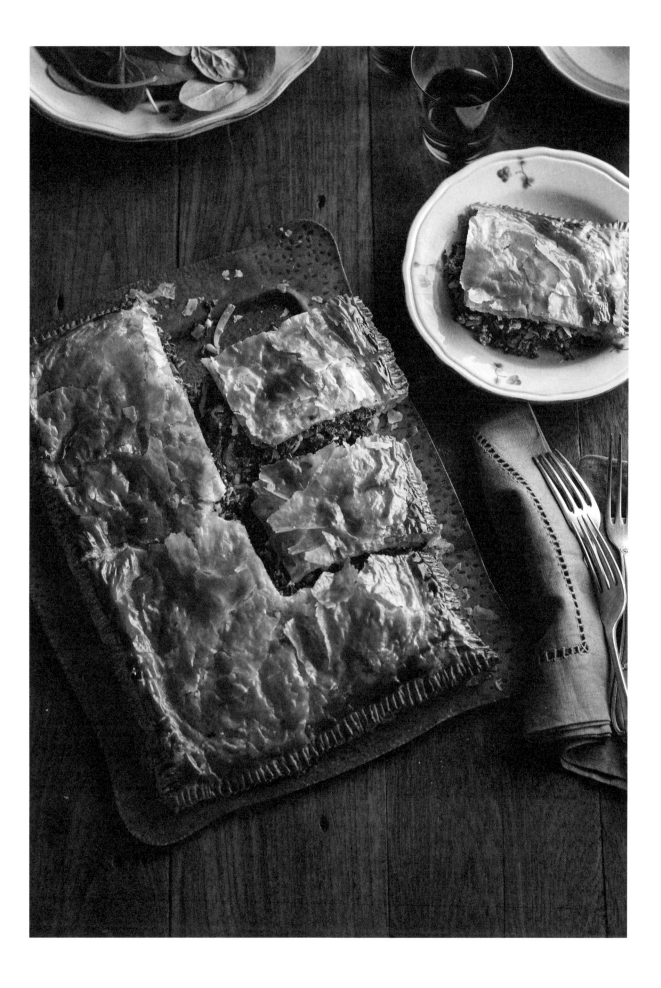

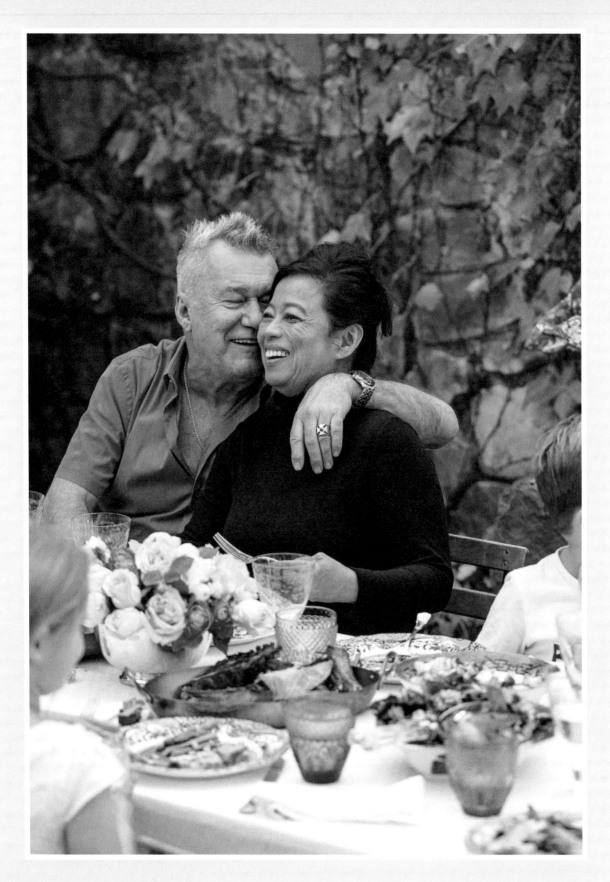

Lunch on the go

WITH OUR FAMILY FREQUENTLY ON the road, we've had to refine our approach to the light lunch. We need something that's easy and quick to make, given our often-limited facilities and tight schedule, but also filling and satisfying enough to keep us going until we have our early dinner prior to the next energetic show.

Another strategy we've adopted to help streamline our schedule is to hold meetings at lunchtime. That way, we get to eat and sort out business matters at the same time. When you eat together with workmates and business associates, you get to know each other in a different way, and it often reveals another side to colleagues. We find it creates a great atmosphere and brings positive results for all parties.

When we are abroad, we maintain our standard approach to light lunches, eating on the move and combining meals with meetings – unless we are in Italy, where the phrase 'light lunch' is pretty much an oxymoron, and then, well … when in Rome, as they say. In many countries, we have our favourite dishes and tried-and-trusted spots: laksa noodles at Fullerton Road, Singapore; gyoza in Shinjuku, Tokyo; fruits de mer at La Coupole, Paris; Schweinshaxe (pig knuckle) and a beer in Munich; and perfect fish and chips on the beach at Mount Maunganui in the North Island of New Zealand. We even seek out Scottish loch oysters at the seafood bar in Terminal 4 of Heathrow Airport in London.

As soon as we return to our home by the river, I can't wait to get back into my kitchen and be able to cook as much as I like. While I still try to keep things simple, I can take my time; I also try to use as many home-grown ingredients as possible. I'm blessed to have family and friends living nearby, so around lunchtime I always make sure there's some deliciousness on the stove, bubbling away with love, for when they drop in.

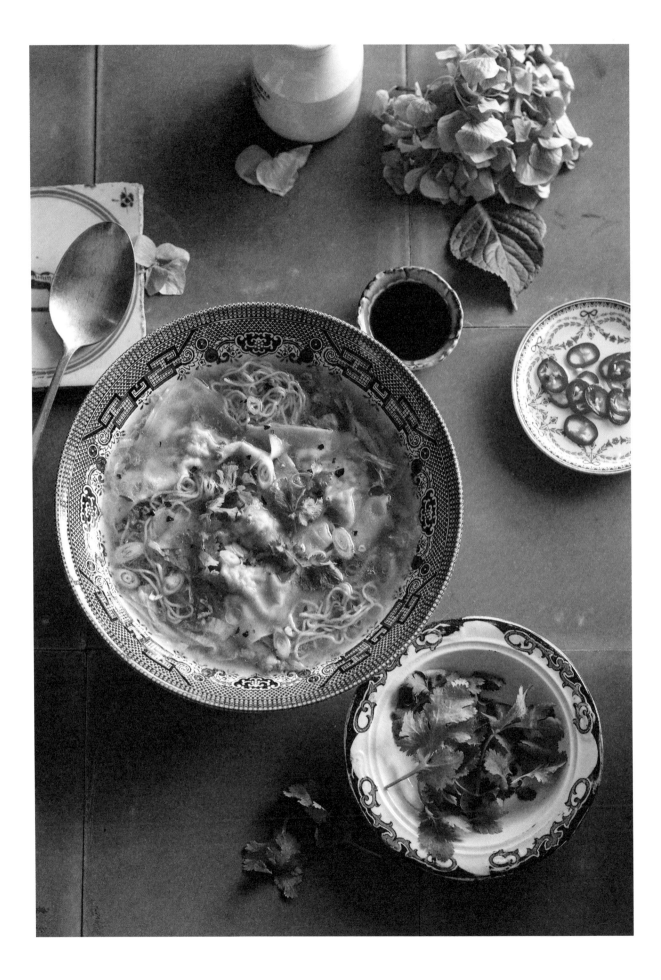

Egg noodle and wonton soup

[SERVES 4]

My mama taught me how to wrap wontons to add to egg noodle soup. I treasured special times like that when we got do something together. Life is so busy, but the kitchen seems to be the place where the generations meet, and food preparation is often a bonding experience. When I make wontons with my grandchildren, they really feel a sense of achievement: they think they have created the entire meal. Another great thing about these parcels is you can freeze them and then bring them out to add to a packet of 2-minute noodles – dressed with a handful of herbs, lettuce and chillies – and you've got an instant meal.

1.5 litres good-quality chicken broth
500 g fresh egg noodles
½ iceberg lettuce, finely chopped
4 green shallots (or 1 bunch garlic chives), sliced
2 tablespoons coriander leaves, chopped
sliced red chillies in vinegar, to serve
fish sauce and white pepper, to serve
garlic oil (page 294), to serve

WONTONS
100 g raw prawn meat, finely chopped
100 g pork mince
2 tablespoons oyster sauce
1 teaspoon sea salt
1 teaspoon white pepper
4 coriander roots, cleaned and finely chopped
20 wonton wrappers

To make the wontons, combine the prawn meat, pork mince, oyster sauce, salt, white pepper and coriander root in a bowl and mix well.

Lay the wonton wrappers on a chopping board and place a heaped teaspoon of the mixture in the centre of each. Using your finger, brush a little water around the edges of each square and fold over into a triangle to enclose the filling. Make sure all the air is squeezed out before sealing the edges tightly. Repeat until all the filling has been used.

Bring the chicken broth to the boil in a large saucepan, then reduce the heat so it simmers.

Bring another large saucepan of well-salted water to the boil. Cook the noodles and wontons separately for 3–4 minutes, until just tender (see Cook's Notes).

To serve, divide the lettuce among four bowls, top with the cooked noodles and wontons, and ladle the chicken broth over. Sprinkle with the green shallots (or chives) and coriander leaves. Offer with traditional Thai condiments – chillies in vinegar, fish sauce, white pepper and garlic oil – which everyone can add to suit their tastes.

[COOK'S NOTES]

I cook the noodles and wontons in a separate pan (rather than in the chicken stock), as the flour on them can make the liquid murky. I also use a deep wire basket to cook the noodles and wontons, immersing them in the boiling salted water. This makes it easy to lift them out and drain.

Stuffed zucchini flowers

[*SERVES 4*]

Zucchinis are so easy to grow and we love having them close to the kitchen in our vegetable patch. With our own beehives nearby, we are sure of an abundant yield through most of the summer. The male zucchini flowers are large and easy to stuff. The female ones have a small zucchini attached to them and are the ones featured here. Don't be afraid of tearing the petals – they are not as delicate as they look. Get creative with your stuffings: for vegan guests, use tofu, tahini, herbs and nuts.

16 zucchini flowers
olive oil, to shallow fry

RICOTTA FILLING
250 g fresh ricotta
1 tablespoon chopped
garlic chives, thyme
or basil
2 tablespoons grated
pecorino or parmesan,
plus extra to serve
1 teaspoon finely grated
lemon zest
sea salt and freshly ground
black pepper

BATTER
½ cup plain flour
½ cup cornflour
sea salt and freshly ground
black pepper
chilled soda water

Combine the filling ingredients in a bowl and season to taste.

Gently open the zucchini flowers and, using your fingers, take out the stamen or pistils inside. Fill the flowers with the ricotta mixture, taking care not to tear them. Twist the tips of the petals to hold everything in.

To make the batter, sift the flour and cornflour together into a mixing bowl and season with salt and pepper. Make a well in the centre and gradually add enough soda water to make a thin batter, stirring gently.

Pour about 2 cm oil into a large frying pan and heat over medium-high heat. Working a few at a time (you don't want to overcrowd the pan), dip the stuffed blossoms into the batter to coat lightly, and place straight into the hot oil.

Cook for a few minutes, turning to cook evenly, until crisp and golden. Drain on paper towel. Continue with the remaining flowers.

Serve with grated pecorino or parmesan cheese.

[COOK'S NOTES]

You can also add a little grated mozzarella to the ricotta filling, if you like.

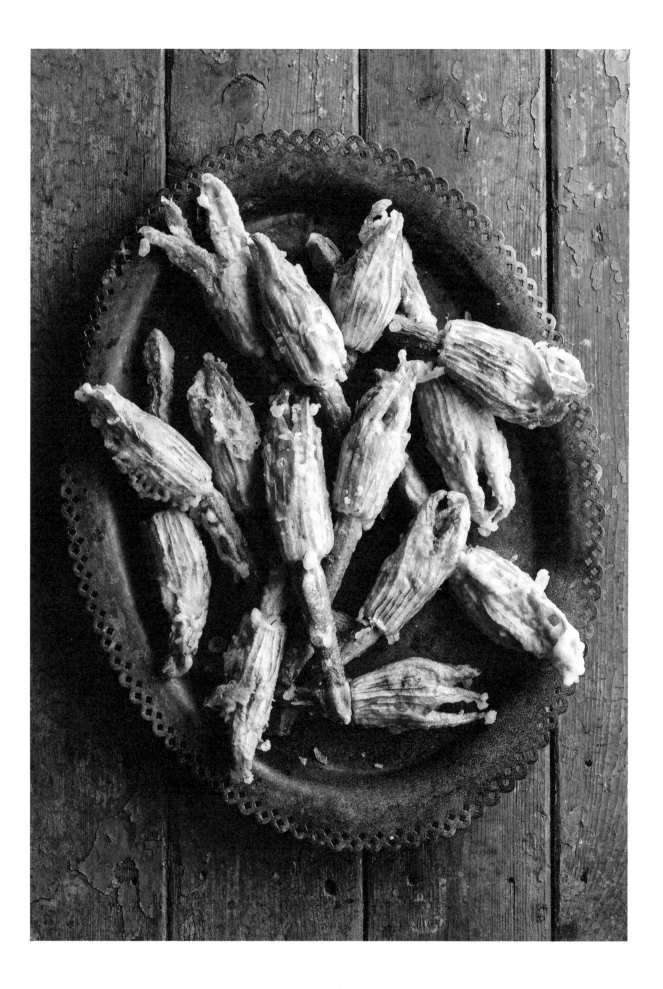

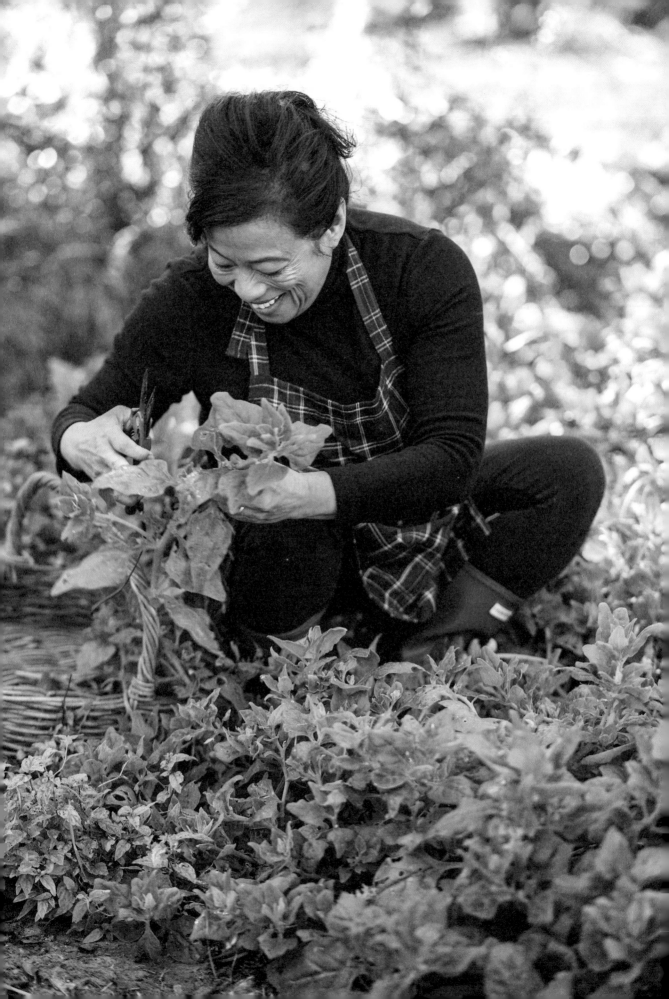

Seared tuna fillets with spinach, mushrooms and toasted sesame dressing

[*SERVES 4*]

We love this dish when we're after something quick and healthy. For the sesame dressing, you can either make your own or use Kewpie roasted sesame dressing. Either way, it's delicious.

300 g baby spinach leaves

Japanese toasted sesame salad dressing (page 302), plus extra to serve

½ cup furikake (see Cook's Notes)

500 g piece tuna loin

1 tablespoon grapeseed oil

200 g shiitake mushrooms, stem tips trimmed, cross scored in tops

1 tablespoon shoyu (Japanese soy sauce)

Place the baby spinach into a heatproof bowl and have another bowl of iced water next to it. Pour boiling water over the spinach, then drain and transfer to the iced water to stop cooking. Squeeze out the water and chop. Combine with sesame dressing to taste.

Spread the furikake on a plate and roll the tuna in the seasoning until all sides are well covered.

Heat the oil in a frying pan over medium-high heat. Add the tuna and cook for about 15 seconds in total, turning to just sear on all sides. Set aside on a plate.

Add the shiitake mushrooms, splash with shoyu and cook for a few minutes, until soft.

Slice the tuna and serve with the spinach and mushrooms, with extra dressing on the side.

[COOK'S NOTES]

Furikake is a Japanese seasoning made with a mixture of sesame seeds and dried seaweed.

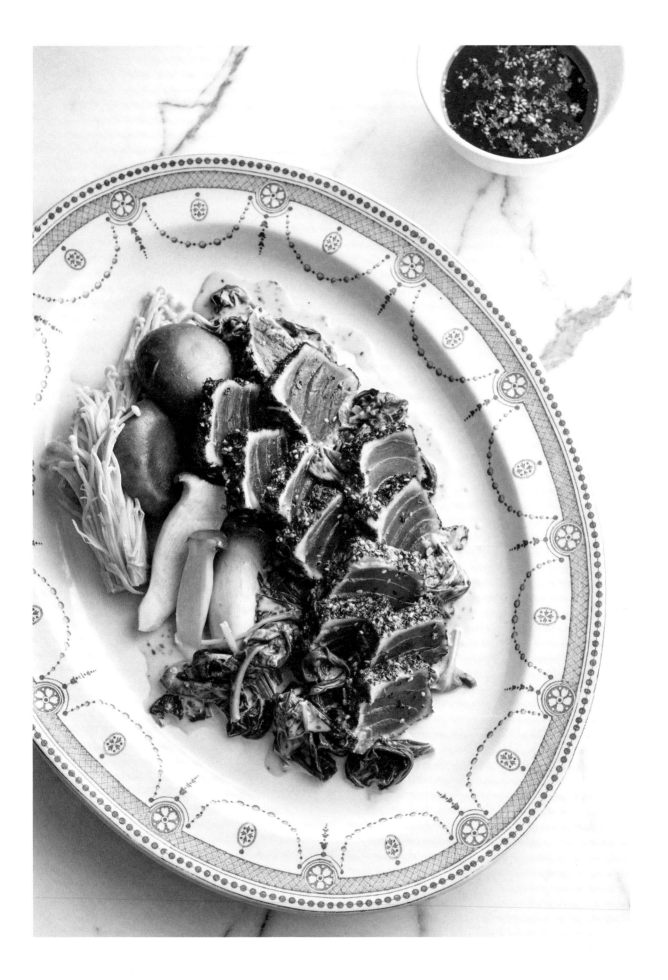

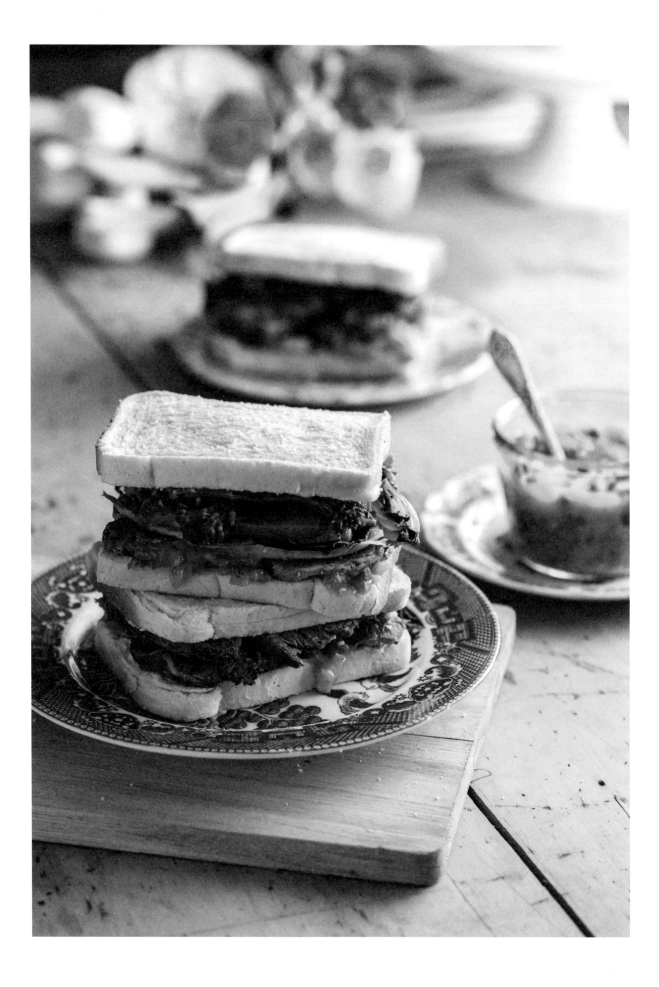

Leftover-roast sandwiches

[*SERVES 6*]

One of the best things about cooking up a big roast dinner is the leftovers, and there's nothing we love more than using them up the next day in a delicious sandwich. You can use any type of bread you like, but we like to use a soft and fluffy white sliced loaf, as it's perfect for soaking up all the roasting juices and gravy.

12 slices white bread
butter, to spread
sliced roast beef, pork,
** lamb or chicken**
leftover roast veggies
leftover gravy
chutney and/or pickles
Kewpie mayonnaise
** (great with chicken)**

There's nothing much to this recipe. You simply butter the bread and load up with all your leftover roast goodies. Add condiments, and that is it!

Cheese toastie

[*MAKES 2 TOASTIES*]

With Jimmy on a grain-free diet, a cheese toastie is a rare treat for him. We use whatever kind of cheese we have handy: tasty, Comté, gruyere – or even a mix of cheeses.

soft butter, for spreading
 and frying
4 thick slices white or
 wholemeal bread
hot English mustard,
 to taste
4 slices cheese, such as
 tasty, Comté or gruyere
freshly ground black
 pepper

Preheat the grill.

Butter each slice of bread, then thinly spread mustard onto two of the slices. Place 2 slices of cheese on top of each mustard-spread bread slice. Grind a little black pepper over each.

Place the cheese-topped bread onto a baking tray and pop under the grill for 1–2 minutes to melt the cheese. Place the other bread slices on top and butter the topside.

Heat a frying pan over medium heat, add a knob of butter, and swirl to melt and coat the base of the pan. Add one sandwich to the pan and reduce heat to medium–low. Use an egg lifter to press the sandwich, cooking until the underside is a dark golden (almost burnt) brown.

Turn the sandwich over. Listen for the sizzle and press again with the egg lifter. Cook until browned underneath, then remove from the pan. Cut and serve straight away, while still hot.

[COOK'S NOTES]

Unless you have a large hotplate, it's best to pan-fry just one toastie at a time.

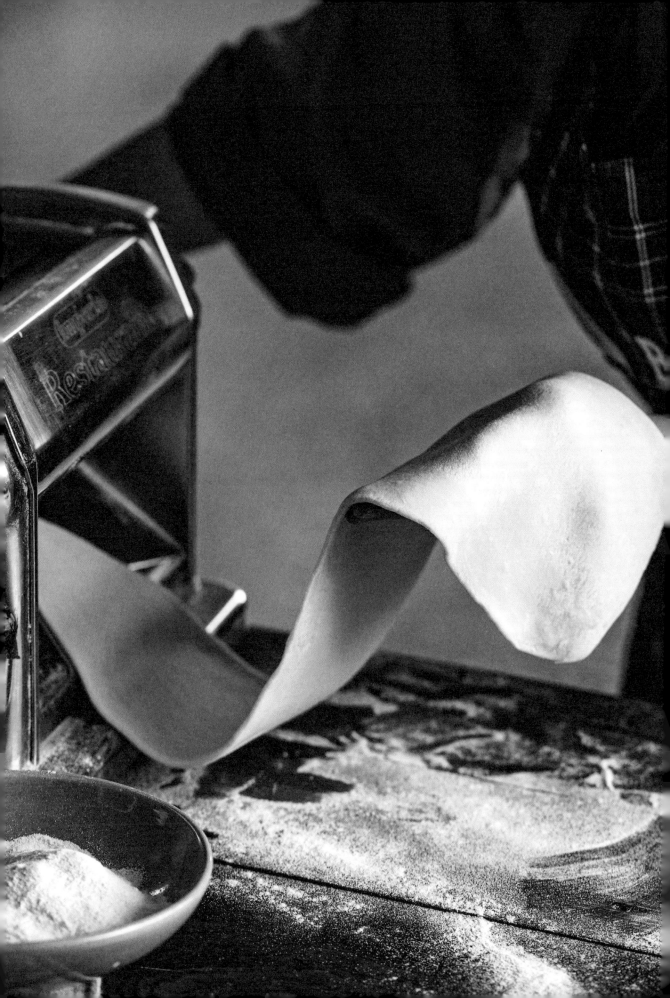

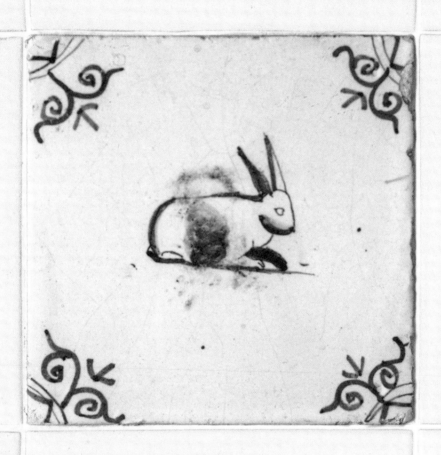

CHAPTER
THREE

Pasta
Classics

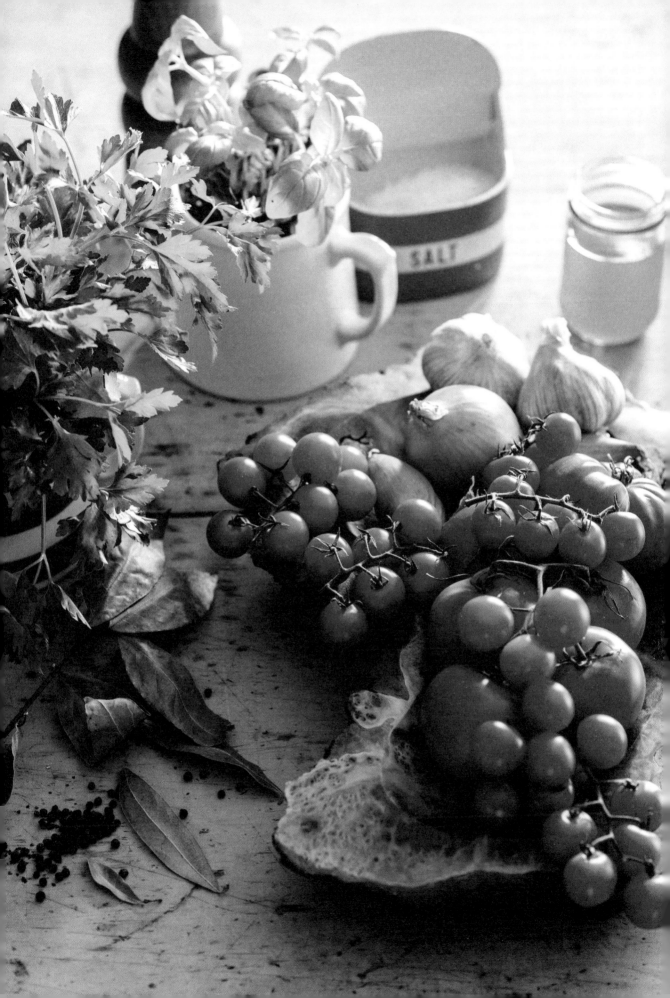

HAVING SPENT A NUMBER OF years living in Italy as she grew up, Jane has a great love of pasta. In many ways, she is just like an Italian – passionate about food and style to a degree that I am only just beginning to understand. The only spaghetti I knew as a child came straight from a can. Even then, despite the fact it was served on toast, it seemed exotic. In those days, though, I only really ate for fuel, not taste. I now know that my life pre-Jane was very, very sad. Food is one of the joys of life. How did I ever survive before I met her? I didn't really live, I just existed.

Since we met, Jane has taken it upon herself to open my mind to all things food, and these days I love all kinds of dishes, but particularly Italian cuisine and, especially, pasta. I would be very happy to spend a year or two with Jane, working our way from northern Italy all the way down to the tip of the boot, writing songs and books, sleeping in the afternoon and trying unsuccessfully not to get too fat. Then, after getting to the bottom of the country, go back to the top and start again. I can't think of anything better than days spent sitting under olive trees in Tuscany sipping wine, or eating cacio e pepe by the fountains of Piazza Navona, or strolling down the narrow streets of Capri as the sun sets over the Mediterranean.

We have already spent many of our holidays wandering through Rome, with the kids in tow, in search of the perfect pasta. Walking the same streets that Jane played in as a child, while she recounts her early life there and points out hidden treasures, including little shop fronts and doorways that lead through to tiny restaurants, often specialising in one specific pasta dish. Each of these places has a reputation to live up to, of being the best in the world at their chosen speciality. And very rarely do they disappoint.

On one holiday we travelled to a villa just outside Siena, in Tuscany, where the wonderful cook prepared a local delicacy for dinner: a ragu of wild boar served with wide homemade pappardelle, smooth and silky, smothered in freshly grated truffle. It was rich and satisfying – so good that we even tried to talk the cook into going back to Australia with us. Next day we jumped in the car and drove to Portofino on the coast, taking in the sights and scenery but mainly focused on our next meal, in this case a lunch of linguine alle vongole – thin ribbons of pasta with clams, sprinkled with a touch of chilli. We are never more content than when we are heading out somewhere in Italy in search of great food. So pasta is a big part of our lives.

Jane loves to make her own pasta. Not neat and perfect but roughly cut and uneven, yet still delicate and delicious all the same. Once it's cooked, she tosses it in her favourite sauce, adds maybe a small handful of grated parmesan cheese and some parsley for luck, with perhaps a little chilli if she's in the mood, and serves it up with a radicchio salad and a glass of good Italian red. The perfect lunch. Then it's time for a siesta.

We are never more content than when we are heading out somewhere in Italy in search of great food.

I like to make my own pasta too, but I take a different approach. I use a professional pasta-making machine, an Imperia, the kind of industrial-looking contraption that really belongs in a busy restaurant in Italy, churning out fresh pasta for fifty or a hundred people a night. I love appliances and gadgets, and this is a dream machine, allowing me to make just about any style of pasta in vast quantities. So I'm always ready to feed the masses when they turn up. Which, in case you haven't worked it out already, is most days at our house.

Homemade pasta

[*MAKES* 500 *g*]

When our Elly-May was still a teenager, we went as a family to Lucca in Italy to do an Italian cooking week, and the first thing they taught us was how to make your own pasta. We made ravioli and I still think it's the best I've ever tasted – no pasta is better than the first one you make fresh from scratch! And making pasta is still one of our favourite things to do together.

400 g type 00 flour
4 eggs
pinch salt

Pour the flour onto a clean work surface and shape into a 'volcano'. Make a well at the top, crack in the eggs and add the salt. Use a fork to beat the eggs, gradually incorporating them into the flour. Once combined, gather the dough together using your hands and knead until smooth. Form the dough into a ball, cover with plastic wrap and place into the fridge for 1 hour, to rest.

Divide the rested dough into eight even pieces. Working one piece at a time (keep the rest covered), lightly flour and press out to flatten slightly. Run through the widest setting on your pasta machine. Fold into 3 layers and run through again. Repeat the folding and rolling 6 times using the wide setting.

Reduce the setting one level and run the dough through. Reduce the setting again and run through (no more folding). Repeat, reducing the setting each time, until you finish on the second-last setting.

Attach the cutting attachment of your choice and cut into your desired pasta shape. Place or hang the pasta on a drying rack while you make your sauce.

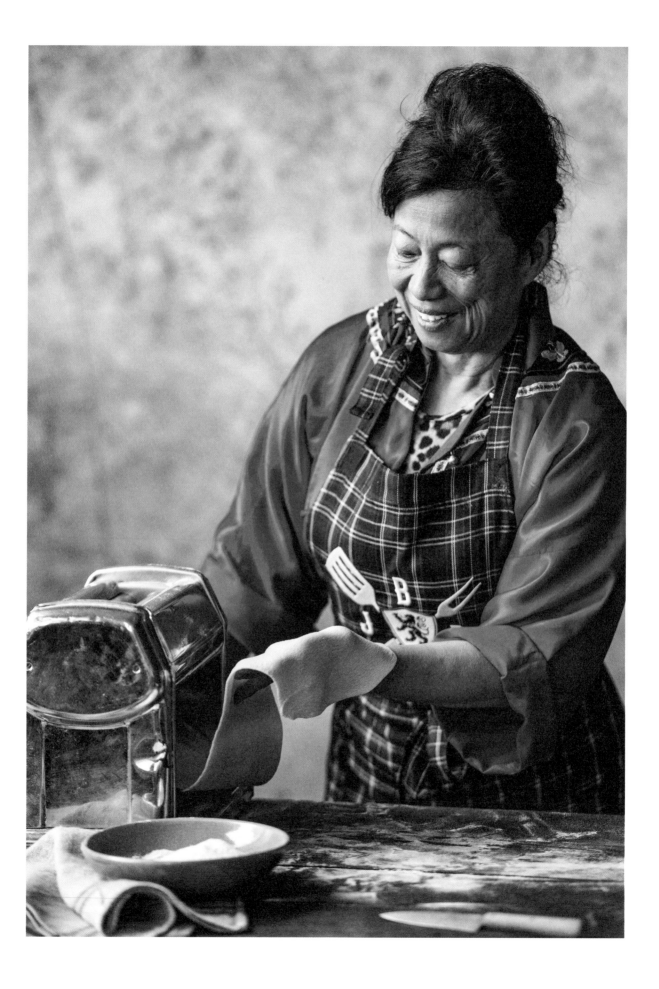

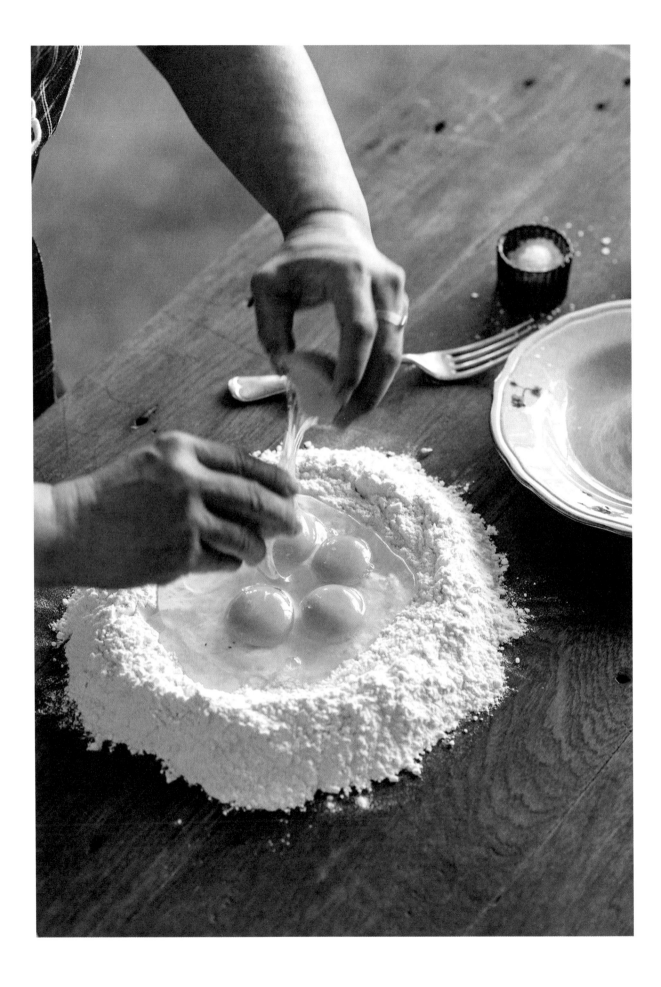

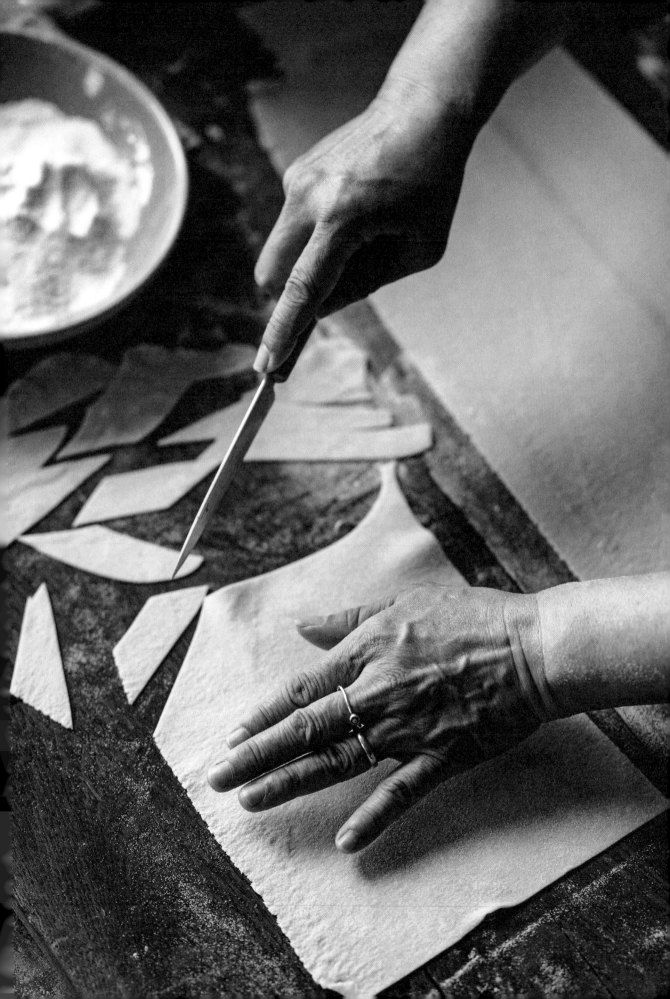

Tagliatelle in creamy porcini mushroom sauce

[*SERVES 4–6*]

We love making our own pasta for this dish, especially if the kids are around, but you can use a good quality fresh or dried pasta instead.

30 g dried porcini mushrooms
sea salt and freshly ground black pepper
2 tablespoons olive oil
1 tablespoon unsalted butter
2 garlic cloves, smashed and finely sliced
1 mushroom stock cube
400 g mixed mushrooms (king, shiitake, Swiss), sliced
300 ml pouring cream
500 g fresh homemade tagliatelle (page 80) or other pasta of your choice
½ cup finely grated parmesan
½ cup flat-leaf parsley, chopped
crusty baguette, to serve

Place the dried porcini mushrooms in a bowl, cover with hot water and leave to soak for 30 minutes. Drain and roughly chop. Meanwhile, bring a large pot of water to the boil and add a decent amount of salt.

Place a large frying pan over medium heat, add the olive oil and butter, and season with salt. Once the butter has melted, add the garlic and cook until soft. Add the porcini and crumble in the mushroom stock cube. Stir to combine.

Add the sliced mushrooms and cook for about 5 minutes, stirring occasionally, until soft. Stir in the cream and reduce the heat to low.

Add the pasta to the pot of boiling water and cook for 2 minutes (or as indicated on the packet), until al dente. Scoop the pasta from the boiling water using a pasta server and add to the creamy mushroom sauce. Mix thoroughly.

Stir through the parmesan and parsley, season with pepper, and serve with a crusty baguette to mop up all the delicious sauce.

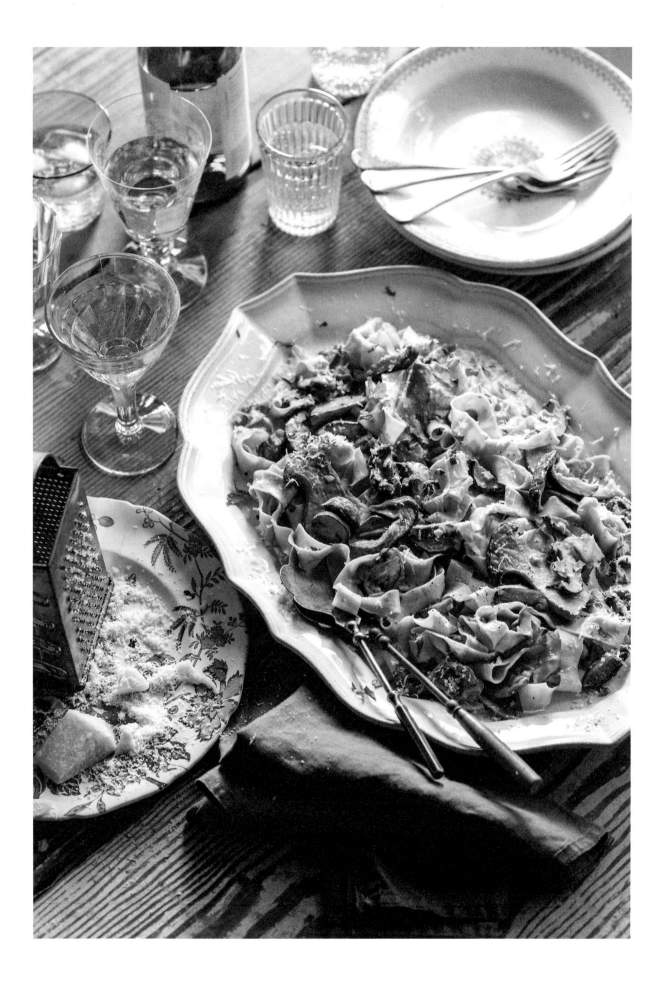

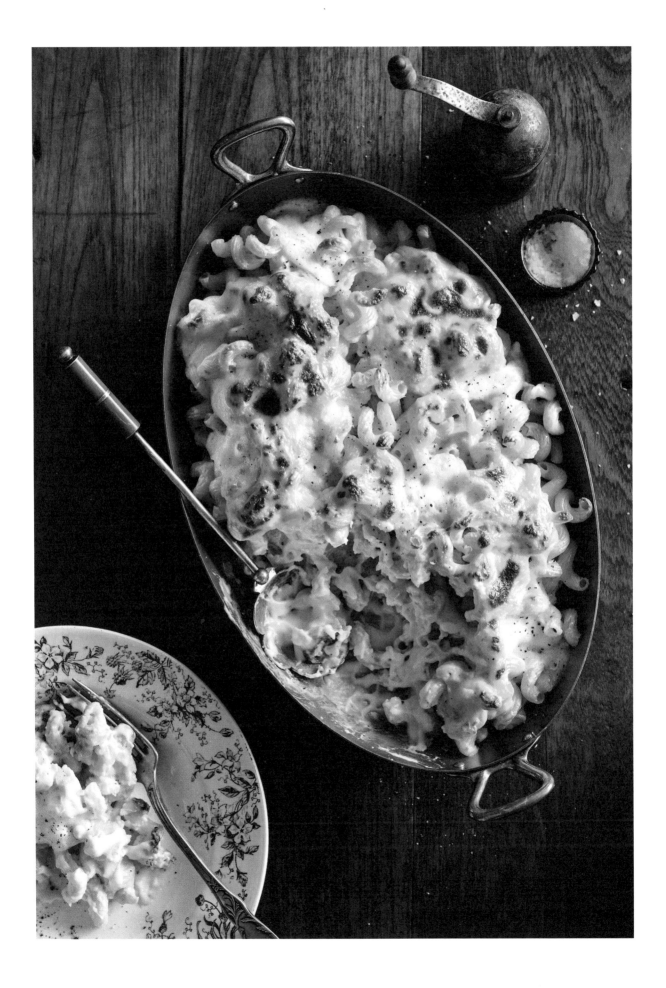

Mac and cheese

[SERVES 4–6]

Mac and cheese is not only an American dish and it doesn't just come in a cardboard package with a sachet of powder. We made it long before I went to an American school, and we used to cook it when we moved back to Australia from Rome in 1970. It was like an Aussie version of Italian 'quattro formaggi' (four cheeses) pasta. This was back in the day when chunks of Parmigiano Reggiano were not available in our supermarket delis and the only form of parmesan cheese came grated in a cylindrical metallic-green cardboard shaker, smelling like something out of this world (not in a good way). We made this dish using a white sauce base mixed with cheddar and Edam cheese. It's still a comfort food in our household, and our son, Jackie, who studied in Boston for three years, practically lives on this. We also have seven American-Australians in our family, so there's another strong connection right there.

2 cups pasta curls or macaroni
80 g butter
pinch salt
2 tablespoons plain flour
1½ cups milk
1 cup grated cheddar cheese
½ cup grated parmesan
1 cup pouring cream
125 g buffalo mozzarella
freshly ground black pepper (optional)
crusty baguette, to serve

Cook the pasta in a large saucepan of salted boiling water until al dente. Drain well and transfer to a baking dish. Preheat the grill.

Melt the butter in a saucepan over medium heat and add a pinch of salt. Add the flour and cook, stirring, for a couple of minutes without browning. Gradually add the milk, whisking constantly, until combined and smooth. Bring to the boil.

Add the cheeses and stir to melt, then whisk in the cream. Pour the cheesy sauce over the pasta.

Tear the mozzarella into pieces and scatter over the top. Cook under the grill until bubbling and golden brown on top. Grind some black pepper over, if you like.

Serve with a baguette for mopping up any leftover cheesy sauce.

[COOK'S NOTES]

You can replace the cheddar and parmesan with ½ cup each grated Comté and Red Leicester cheese, if you like.

Food heaven

ALTHOUGH I WAS THEN ONLY a child, our four-year stay in Rome in the late 1960s transformed my outlook on food. My culinary standards and expectations would never be the same again and, of course, my eyes were opened to the diversity of Italian cuisine, pasta included.

Rina, the cook at our apartment in Campo de' Fiori, was an Italian mamma who made us everything delicious her country was known for: fresh tagliatelle, bucatini and tonnarelli, lasagne, gnocchi, ravioli, spaghetti all'amatriciana, ragu alla bolognese, minestrone, antipasti, vitello, cotolette, bistecca e patate, crema caramella, panna cotta … The area we lived in was food heaven. A block away to the west, for example, across the river Tiber, was the district of Trastevere (which actually means 'across the Tiber'). Its narrow, ancient cobble-stoned streets were brimming with bars, trattorias and restaurants, as well as street art and music.

A particular treat for us kids was to walk for ten minutes through Campo de' Fiori and across Corso Vittorio Emanuele II to beautiful Piazza Navona, home to many famous pizza restaurants and gelato bars. I have such fond memories of this Roman icon, built over an ancient Roman stadium, with the great Bernini masterpiece, Fontana dei Quattro Fiumi (Fountain of the Four Rivers), at its centre, two smaller fountains at either end and, on one side, the magnificent seventeenth-century baroque Church of Sant'Agnese in Agone. The square was then, and still is today, a hive of activity, full of tourists, buskers and artists. I particularly loved it at Christmas time, when stalls sold decorations and nativity figurines, and country musicians played carols such as 'Tu scendi dalle stelle' ('From Starry Skies Thou Comest') on their mountain pipes, while handsome uniformed carabinieri rode through the square on tall horses, wearing polished helmets crowned with feathers, and church bells rang every quarter hour.

It was an experience for all the senses, and remains one of my most treasured memories of those times. It's perhaps rivalled only by my recollections of the endless, glorious hours we spent on weekends exploring the gardens and woods of Villa Doria Pamphili in the Monteverde district while Daddy's embassy team played cricket, gathering pignoli (pine nuts) from fallen pine cones that we cracked open with rocks, and pretending we were lost and might have to fend for ourselves for days to come.

Garden greens and ricotta gnudi with sage butter sauce

[*SERVES 4–6*]

We make this often, as our garden gifts us with an abundance of leafy greens all year round. Any greens will do, but make sure you have the equivalent of about 2 bunches of silverbeet, as they will shrink down once cooked.

leafy greens, thicker stems removed
1 tablespoon olive oil
1 onion, finely chopped
1 garlic clove, crushed
1 tablespoon chopped marjoram
250 g fresh ricotta
1 cup finely grated pecorino (or parmesan), plus extra to serve
1 egg, lightly beaten
50 g fresh breadcrumbs (made from day-old bread)
pinch ground nutmeg
plain flour, for dusting
sea salt and freshly ground black pepper
toasted pine nuts, to serve

SAGE BUTTER SAUCE
125 g butter, chopped
20 sage leaves

Bring a large saucepan of well-salted water to the boil. Add the greens and cook for about 4 minutes, until soft. Drain into a colander and leave until cool enough to handle. Use your hands to squeeze out as much liquid as you can. Chop finely and place into a large mixing bowl.

Meanwhile, heat the oil in a frying pan over medium heat and add the onion. Cook for a few minutes, stirring occasionally, until soft. Stir in the garlic and marjoram and cook for 1 minute. Add to the greens and leave to cool, then give it all another good chop. If it is too coarse, it may not hold together while cooking.

Add the ricotta, pecorino, egg, breadcrumbs and nutmeg. Season with salt and pepper and combine well. Dust a large tray generously with flour and season it with salt and pepper.

Roll the mixture into walnut-sized balls. Roll in the seasoned flour and dust off the excess. Transfer to another tray and refrigerate for about 30 minutes.

Bring a large pan of salted water to the boil.

To make the sage butter sauce, melt the butter in a frying pan over medium-low heat. Season with salt and freshly ground pepper. Cook until bubbling then add the sage leaves and let them crisp up in the butter. Once the butter has become a nutty brown, turn off the heat and keep warm.

Working in batches, gently add the gnudi to the saucepan, reducing the heat slightly so the water is simmering rather than boiling hard. When the gnudi balls float up to the top, they are cooked and ready to remove from the water. Lift out with a slotted spoon and place into a large warmed serving dish, spaced a bit apart. Don't pile them up on top of each or they might break up.

Pour the sage butter sauce over all the balls. Lightly sprinkle with toasted pine nuts and extra grated pecorino and season with ground black pepper.

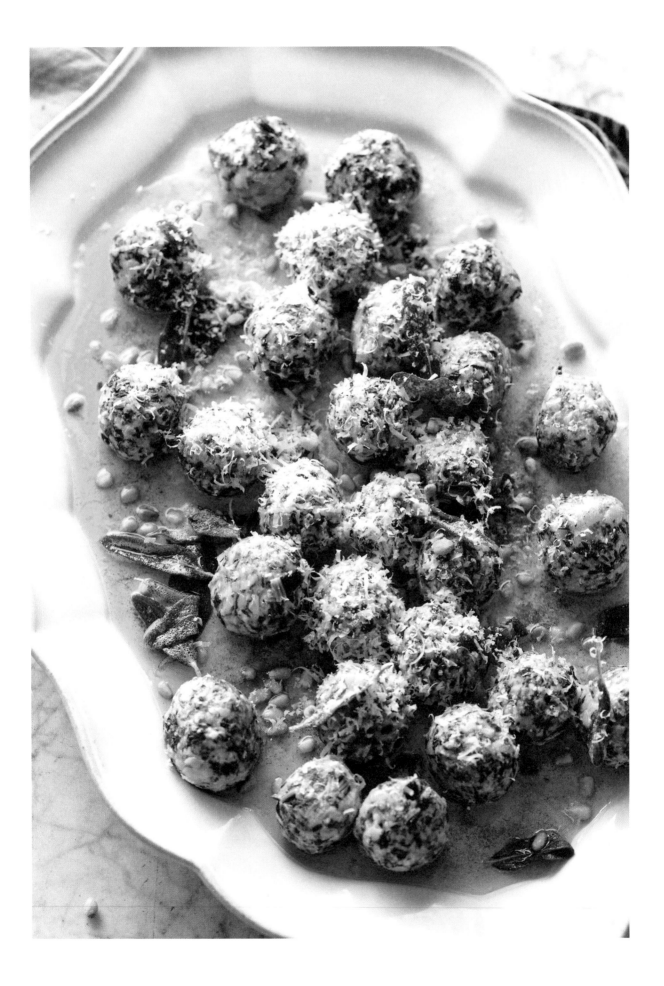

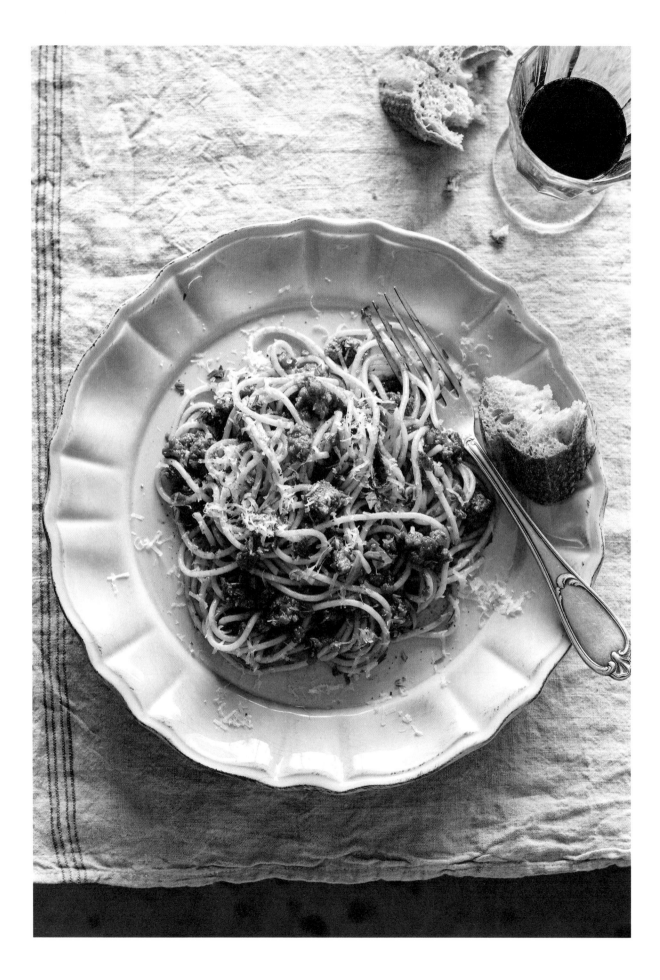

Comfort ragu

[*APPROX. 16 SERVINGS*]

We learned this dish from our wild Spanish friend Trinidad, and we refer to it as our 'comfort ragu'. A dear friend of the family, Trini has been in our lives for more than 25 years. When she married Giuseppe, her Sicilian beau, she had to move in with his mother for three months to learn how to cook this, his favourite sauce. To this day, we do big cook-ups of comfort ragu and stock up the freezer. Serve over any pasta you like: spirali, penne, spaghetti or bucatini, it's up to you! We often add peas to this dish too.

2 tablespoons olive oil

sea salt and freshly ground
 black pepper

2 brown onions, finely
 chopped

4 bay leaves

4 garlic cloves, finely
 chopped

1 kg beef mince

1 kg pork and veal mince

1 beef stock cube

1 cup frozen peas (optional)

3 x 400 g cans tomato
 polpa (Italian crushed
 tomatoes)

700 g bottle tomato sugo

¼ bunch parsley, tied
 for easy retrieval

1 cup brown sugar

½ cup caster sugar

cooked spaghetti (or
 any pasta), to serve

finely grated parmesan
 and chopped parsley,
 to serve

Heat the olive oil in a deep pan over medium heat and throw in a generous pinch of sea salt. Add the onions and let them soften for about 5 minutes before adding the bay leaves and crushed garlic.

Add the mince and mix well (breaking it up with a potato masher helps). Crack some black pepper over the mixture.

Break up the beef stock cube and sprinkle it over the mince. Mix through and cook for 15 minutes over a medium-low heat, stirring now and again.

Add the peas at this point, if you wish. It's a good way to get little fussy ones to eat some greens!

Meanwhile, combine the tomato polpa, sugo and parsley in a separate saucepan over medium heat. Throw in a pinch of salt, bring to the boil, then stir in the brown and caster sugars. Reduce the heat to medium–low and let simmer for 30 minutes.

Remove the parsley then add the cooked meat mixture to the sauce. Stir in well and let it all bubble away gently for another 10 minutes.

Serve over your pasta of choice, topped with chopped parsley and plenty of grated parmesan.

Italian sausage pasta

[*SERVES 6*]

Our Slovenian-Italian family friend Mili has been in my life since my high school days and has seen all our children grow up. She taught Mahalia how to make her first chocolate torta and it was around her kitchen table that we used to gather for many special occasions. Mili also taught Jimmy how to cook his first Italian dish, this sausage pasta. We all love it and it's one of those dishes that's better the next day.

4 celery stalks, roughly
 chopped
4 carrots, roughly chopped
1 brown onion, roughly
 chopped
1 tablespoon olive oil
sea salt and freshly ground
 black pepper
8 Italian sausages, cut into
 3.5 cm lengths
400 g whole peeled
 tomatoes, coarsely
 chopped
2 x 400 g cans tomato polpa
 (Italian crushed
 tomatoes)
1 cup grated pecorino
1 cup grated parmesan
dried chilli flakes (optional)
500 g paccheri lisci (or
 pasta of your choice)

Put the celery, carrot and onion into a food processor and process until finely chopped (this is your soffritto – the base for a lot of Italian sauces).

Heat the oil in a large, deep frying pan over medium heat. Add a good pinch of salt and the soffritto. Cook for about 10 minutes, until soft and lightly golden.

Add the sausage pieces and cook until browned. Add the tomatoes and polpa and bring to a simmer. Cook for 10 minutes. Stir in the pecorino and half the parmesan. Taste to see if you need salt, and season with pepper. Add chilli flakes, if you like.

Meanwhile, cook the pasta in a large saucepan of salted boiling water until al dente. Scoop the pasta from the boiling water using a pasta server and add to the sauce. Toss to coat.

Serve sprinkled with the remaining parmesan, with a simple Italian salad on the side.

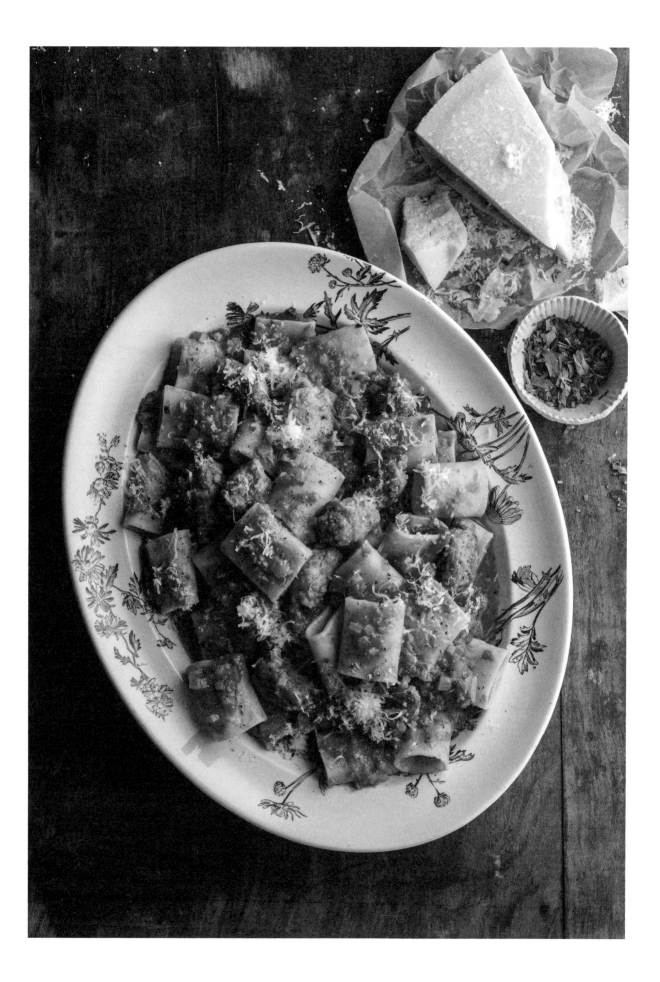

Jimmy's Sicilian eggplant pasta

[*SERVES 4–6*]

Salting the eggplant is kind of optional: not everyone feels they need to do this and the dish still works well without it. We were just taught to do it this way, and if you have time I think it's good to salt eggplants before cooking.

2 medium-large eggplants, thickly sliced

sea salt and freshly ground black pepper

¼ cup olive oil (you may need more)

45 g can anchovy fillets, chopped

½ brown onion, finely chopped

3 garlic cloves, chopped

400 g can whole peeled tomatoes

2 large ripe fresh tomatoes, chopped

10 caperberries, halved

1 tablespoon salted capers, rinsed

small handful flat leaf parsley, chopped

500 g reginette or mafaldine pasta (ribbons with a curly edge)

200 g fresh ricotta

basil leaves and finely grated parmesan, to serve

Lay the eggplant slices on paper towel and sprinkle with salt. Let sit for about 10 minutes, until you see bubbles of liquid appearing on the flesh. Wipe off with paper towel and turn over, repeating the salting on the second side. This will draw out the water and give the eggplant a less spongy consistency when cooked. Once dried, cut the eggplant crossways into a fat chip size.

Heat the olive oil in a large frying pan over medium-high heat and fry the eggplant in batches (heating more oil between batches as necessary) until golden brown. Set aside to drain on paper towel.

Add another tablespoon of oil, if necessary, and cook the anchovies for 1 minute. Add the onion and cook for 5 minutes, stirring occasionally, until soft. Stir in the garlic and cook for 1 minute, then add the canned and fresh tomatoes. Use a wooden spoon to break up the canned tomatoes.

Return the eggplant to the pan, along with the caperberries and capers. Season with pepper and scatter with parsley.

Meanwhile, cook the pasta in a large saucepan of salted boiling water until al dente. Scoop the pasta from the boiling water using a pasta server and add to the sauce. Toss to coat.

Serve topped with crumbled ricotta, basil leaves and plenty of parmesan.

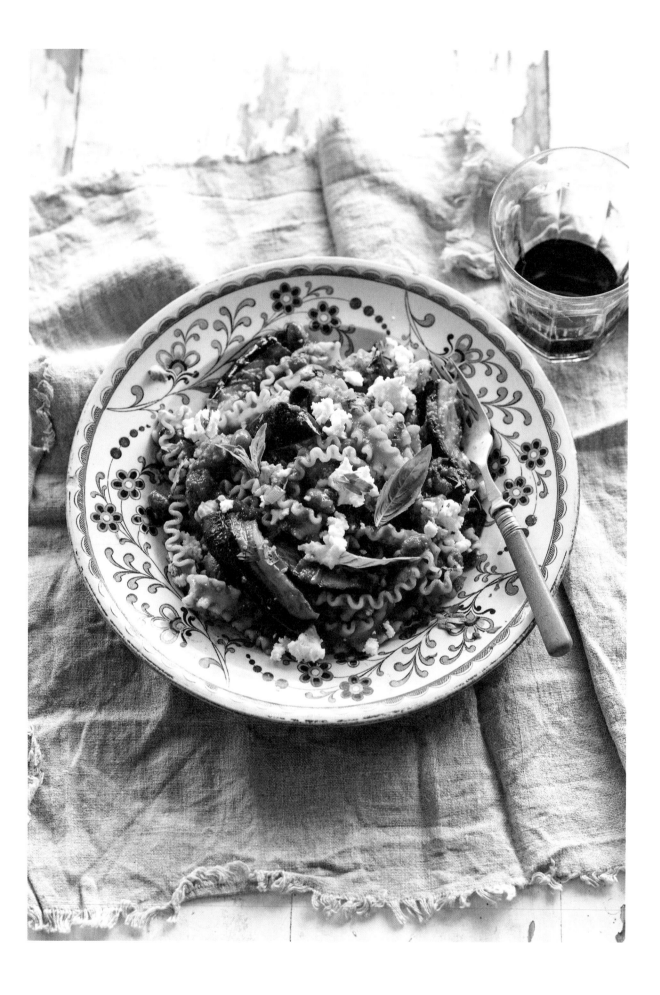

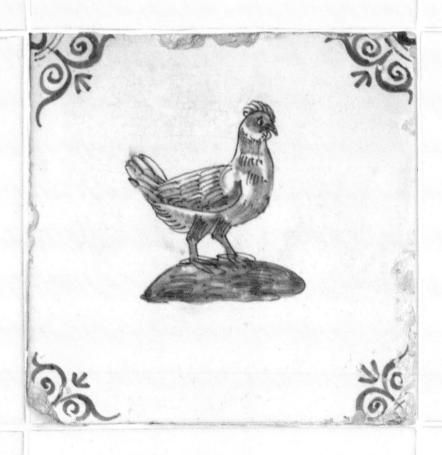

Thai
Favourites

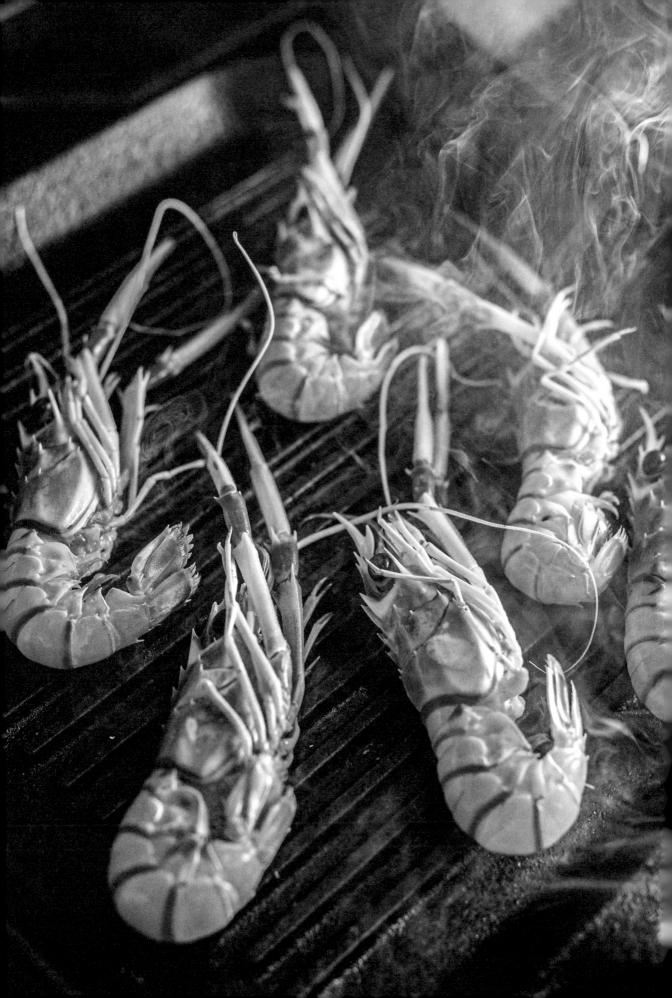

MOST PEOPLE, WHEN THEY HEAR the words 'Thai cuisine', think of hot and spicy fare. Food that is likely to strip the lining off your stomach and burn the tongue right out of your mouth. Well, it can do that if you want it to, and I know a lot of people who enjoy their Thai food blistering hot. But the truth is not all Thai food is like that.

Each region of Thailand has its own style of cooking. The food from up north tastes different from the food they cook down south, which is different from the food they cook in Bangkok. But the one thing they all have in common is that the dishes have very complex flavours. The balance of salt, sweet, sour, bitter, umami and, of course, spicy is the secret, and in Thailand crafting that balance has become an artform.

If you want to learn about these regional cuisines, I suggest you go on a long holiday in Thailand, drifting from town to town in search of the perfect meal. Get outside bustling Bangkok, or, if you can manage it, drag yourself away from the beautiful beaches of the south and travel inland. Head for the hills around Chiang Mai or up to the northeast. There's a lot to see – and taste – and it might take you a few trips.

> The balance of salt, sweet, sour, bitter, umami and, of course, spicy is the secret, and in Thailand crafting that balance has become an artform.

Anyway, I'm here to introduce you to the Thai food we share in our home. We have a few go-to favourites and a few we just couldn't live without. The first meal our children learned to prepare themselves was rice, egg and tuna. I think a lot of Thai students around the world have survived on this when living away from home, and I know our children all still love to settle down to a big bowl of this dish when they are too tired to cook. Open a can of tuna in oil, tip it over rice and add an egg, boiled or fried, not forgetting to throw in a big dash of Maggi sauce, and away you go. As our kids got older, fish sauce and chilli, and maybe a squeeze of lime, became integral parts of the dish too.

Like a lot of families, we look forward to sitting down to a Sunday roast, but we also love a big Thai feast at the weekend. Deep-fried fish, golden and crispy. Pork belly cooked with thick soy sauce and eggs, rich and sweet. Green chicken curry, complex on the palate and with just enough heat to keep you on your toes. Greens stir-fried with salted fish and a touch of chilli. 'Crazy eggs', our version of a Thai omelette, light and fluffy. Garlic pork fried with white pepper. Boiled prawns served with nam jim, a sauce made with fish sauce, palm sugar, coriander root, lime juice, garlic and chilli. All of it accompanied by a delicate broth made from pork bones and shiitake mushrooms with fine noodles and spring onion. And no feast would be complete without a Thai dessert. Maybe mango and sticky rice covered with coconut cream. Or bananas boiled in coconut milk with sago. The only thing you need after that is a place to lie down with a good book.

Jane is an amazing Thai cook. She starts the day of a feast by sitting on a low stool with her mortar and pestle, making the green curry paste – I think being close to the ground gives her the leverage she needs to bring the best out of the ingredients. The noise of her pounding is hypnotic and the smells wafting from the paste are comforting. These are family traditions. If I shut my eyes, I am transported to the seaside town of Hua Hin, my favourite place to relax in the world.

In Thai culture, most dishes are made for sharing.

I do my bit by heading to the fish markets to pick up a few baby snapper and some fresh prawns and then cooking them. I do that outside, on a small Thai wood-burning grill, heating the oil until a light smoke starts to rise from the big wok, then adding the seafood and watching it sizzle. (It's a good idea to cook seafood outside, as otherwise you'll find the house smells like fish for a week.) Meanwhile, inside, the pork belly will be bubbling on the stove, filling the air with its sweet aroma, as the family all start to gather, squeezing around the one big table in preparation for their feast.

Some mornings, if we are really lucky, Jane makes a Thai breakfast for us: rice soup (khao tom goong, page 44) with fresh prawns or even pork mince fried with garlic. This is served with coriander, garlic oil, pickles and mild chilli in vinegar, and usually has a lightly boiled egg floating in the broth. As soon as the soup is placed in front of me, I like to break the egg and watch the broth turn a beautiful golden yellow. It's a breakfast of champions, and a great way to start the day.

In Thai culture, most dishes are made for sharing. That way the whole family not only eat together but also interact in other ways: we chat, we tell stories, we listen, we laugh.

I think it's the best way to eat.

Charcoal barbecue marinated pork skewers (moo ping)

[*MAKES A LOT —
GREAT FOR A CROWD!*]

We often barbecue this pork in pieces, skewerless, and serve with fresh herbs and flowers wrapped in lettuce leaves, with a sauce of dried chilies and nam pla (fish sauce) on the side. Jimmy is our charcoal king, so he has the job of cooking these. It's all in the grilling, he says. He does a pretty perfect job, having learned from years of watching the moo ping man in the Hua Hin markets passionately tend to his pork skewers, turning them just at the right time, once the pork starts to caramelise and blacken on the edges.

**1 kg pork neck or pork
fillet, sliced (see
Cook's Notes)**

MARINADE
4 garlic cloves
3 coriander roots, cleaned
⅓ cup oyster sauce
⅓ cup condensed milk
**sea salt and freshly ground
white pepper**

To make the marinade, use a mortar and pestle to pound the garlic cloves and coriander root. Mix in the oyster sauce and condensed milk, and season with salt and white pepper.

Combine the pork and marinade in a shallow dish. Cover and marinate in the fridge for at least 4 hours, or overnight if possible.

Thread the meat onto skewers. If you are using wooden or bamboo skewers, make sure you soak them in water for an hour first, so they don't burn on the grill. It takes patience to thread the pork onto the skewers, so enlist a willing teenage slave perhaps. It is well worth the effort.

Preheat your chargrill or barbecue grill plate to medium-high heat. Cook the skewers for just a couple of minutes on each side, until cooked through and starting to caramelise on the edges. Move them to a cooler part of the grill as they cook, as needed, and keep moving them all so they cook evenly.

Serve as part of a feast, or just with some nice fresh salad.

[COOK'S NOTES]

Ask the butcher to thinly slice the pork in large bite-sized pieces — not cubes but slices. Pork neck is hard to handle, quite fatty, tricky to slice and is quite an effort to put onto skewers, but it is the best cut for this dish. Pork fillet is tender and much more lean, of course, and just as delicious in a finer way.

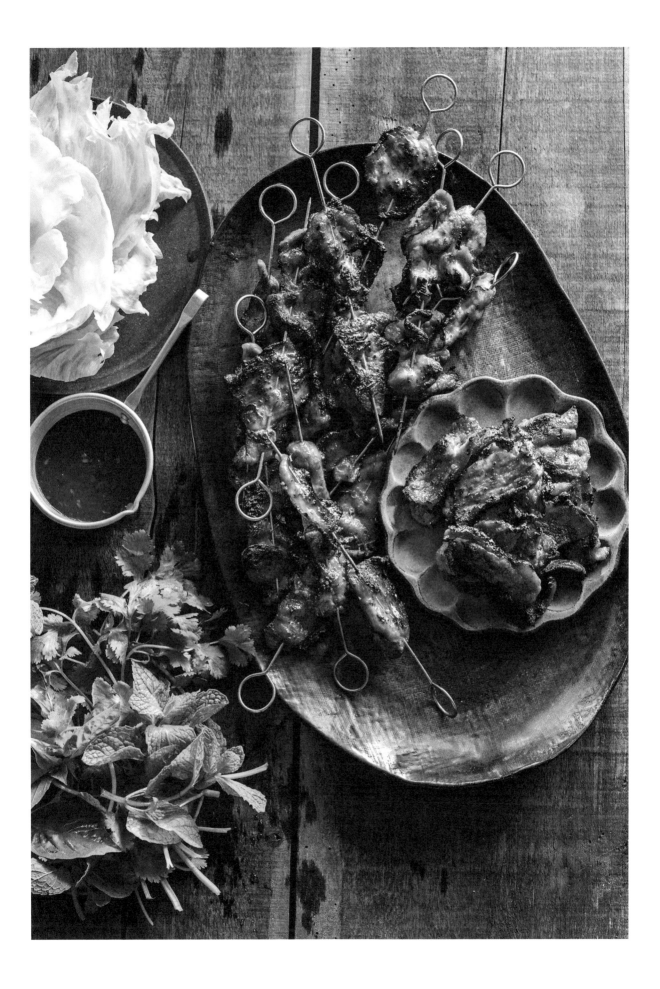

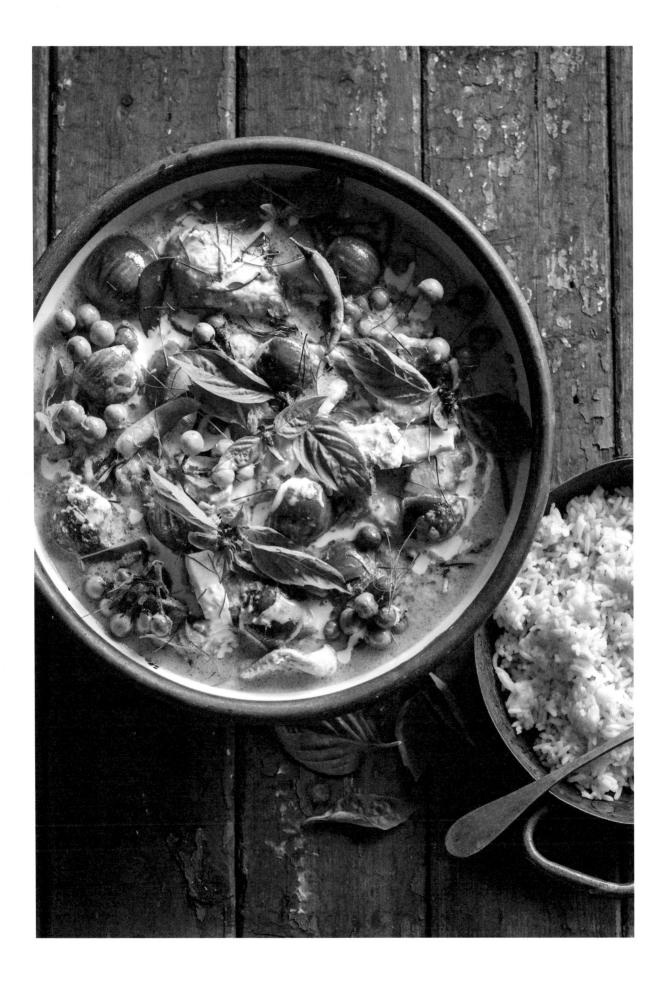

Thai green chicken curry

[SERVES 6]

I always brine my chicken for at least 4 hours, but overnight is best. It makes the chicken plump, juicy and tasty when cooked. Anything you like the taste of can go into the brine mixture, as long as it suits the final dish. If you like a milder curry, use less curry paste. A lot of people think that nam pla (fish sauce) is used in all Thai cooking, but we use it more like salt at the table, adding it to our plates of food.

1 whole chicken
3 garlic cloves, crushed
3 coriander roots, cleaned
 and crushed
1 bay leaf
dash soy sauce
dash lemon juice

CURRY
400 ml coconut milk
400 ml coconut cream
1–2 tablespoons green
 curry paste (page 300)
1 teaspoon chicken stock
 powder
225 g can sliced bamboo
 shoots, drained
100 g pea eggplants
250 g baby eggplants,
 cut into quarters
1 bunch Thai basil,
 leaves picked
20 whole small bush
 chillies
10 pieces soft young
 coconut flesh
palm sugar, to taste
10 makrut lime leaves,
 very finely sliced
steamed jasmine rice,
 to serve

Cut the chicken into 2 legs, 2 wings and 2 thighs, and cut the breasts off the carcass. Set the carcass aside for making stock (or freeze to make stock on another day).

Brine the chicken (page 305), adding the garlic, coriander roots, bay leaf, soy sauce and lemon juice to the brining liquid. Drain well and pat dry before using.

To make the curry, combine the coconut milk and cream in a large saucepan or wok and bring to the boil over medium heat. Add the green curry paste and chicken stock powder. Reduce the heat to medium-low and simmer for 15 minutes, stirring now and again, until reduced slightly.

Add all the chicken pieces except for the breast. Cook for 20 minutes. Slice the breast meat, add to the pan and cook for a further 10 minutes.

Stir in the bamboo shoots and leave bubbling away for 10 minutes. Add the eggplants and half the basil leaves. Cook for a further 10 minutes then turn off the heat. You can add the chillies and coconut flesh now.

Make sure you taste the sauce as you go along. If it's too hot, just add a little palm sugar to balance it out; if it needs to be saltier, just add salt.

Stir in the lime leaves. Transfer to a serving bowl and scatter with the remaining basil leaves. Serve with rice.

[COOK'S NOTES]

Look for young coconut flesh (sliced, sometimes frozen) and bush chillies at Asian grocery stores. You may find fresh bamboo shoots too. Makrut lime leaves used to be known as kaffir lime leaves.

Red curry with roast duck

[SERVES 4–6]

This is a really quick and easy curry – ready in 20 minutes! Grab a barbecued duck from any Chinese barbecue place, and ask them to cut it into pieces for you. If possible, buy a Thai brand of coconut milk and cream.

1 tablespoon unsalted
 butter
114 g can Thai red curry
 paste
400 ml can coconut milk
400 ml can coconut cream
1 barbecued duck, chopped
225 g can sliced bamboo
 shoots, drained
560 g can lychees
4 makrut lime leaves,
 finely sliced
fish sauce, to taste
Thai basil leaves,
 for garnish
steamed jasmine rice,
 to serve

Melt the butter in a medium-large saucepan over medium heat. Add the red curry paste and fry off for a few minutes. Make sure you turn on the exhaust fan, as the smoke can make your eyes water. If you don't like your curries too spicy, only use half the curry paste.

Stir in the coconut milk and half the coconut cream. Simmer for 5 minutes. Add the chopped roast duck, bamboo shoots and remaining coconut cream, and let simmer for a few minutes. Add the lychees (including the juice) and bring to the boil. Stir in the lime leaves and season with fish sauce to taste.

Garnish the curry with Thai basil and edible flowers, and serve with jasmine rice.

[COOK'S NOTES]

If you don't want to fry off the paste, you can also boil it off in the coconut milk. This will take a little longer: you start with the coconut milk first and add the paste, then boil for 10 minutes before adding the duck. You can try making your own red curry paste, referring to the green curry paste recipe on page 300. Use 2 chopped red chillies instead of green, selecting large ones for colour and smaller bird's-eye chillies if you want more heat.

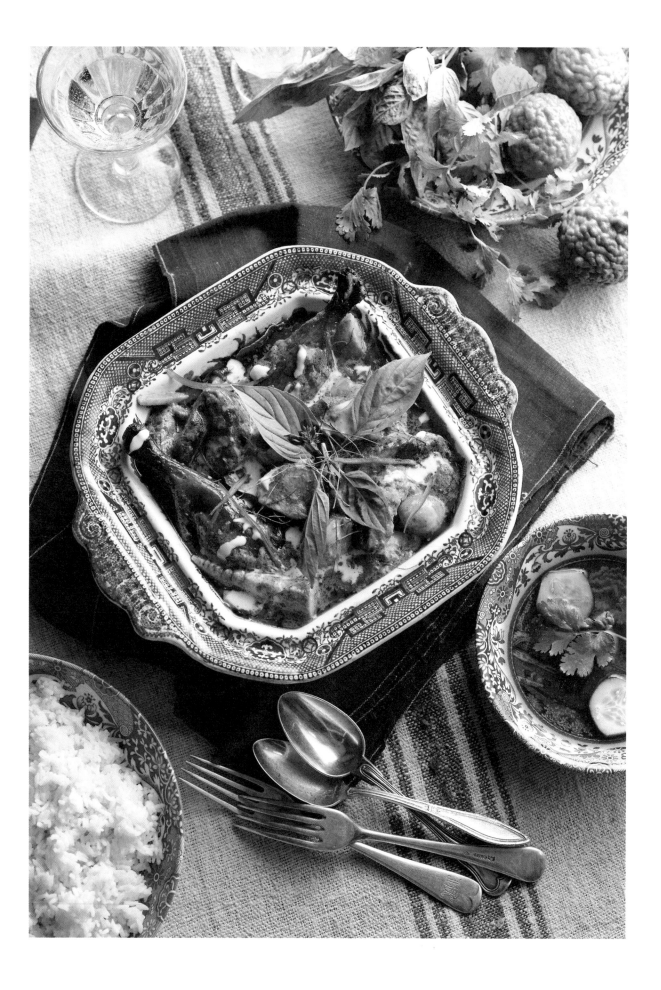

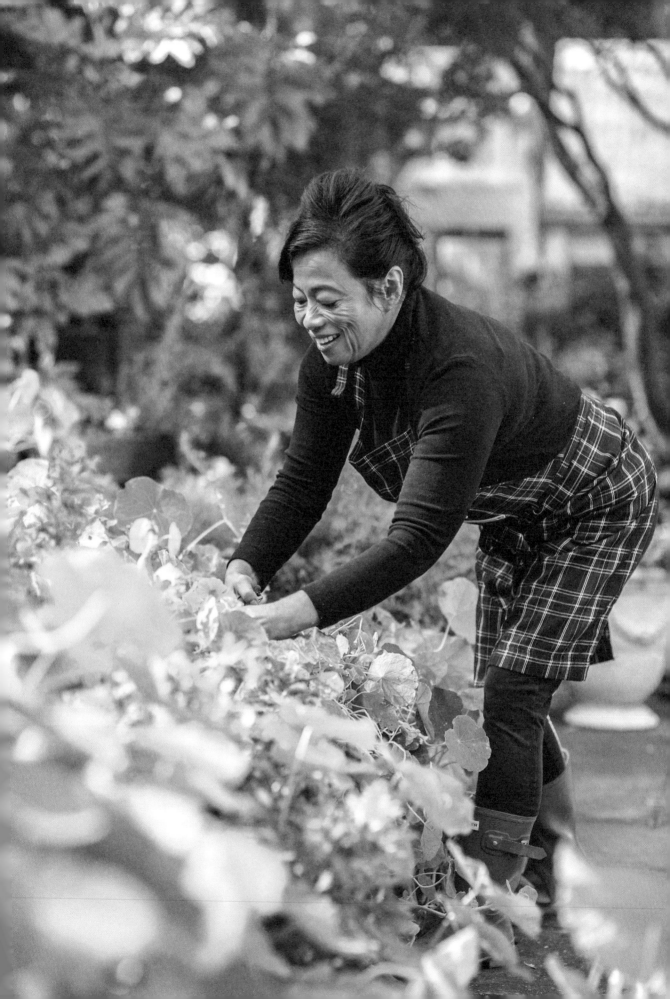

Thai deep-fried whole fish

[SERVES 4]

This is my favourite way of eating fish: fried crispy and served with a little Thai seafood dipping sauce (nam jim). The expert fish fryer in our family is Jimmy; he learned his technique from my aunty's Thai cook, who taught us many of our favourite Thai dishes over the years.

2 whole baby snapper or bream, 500 g each, cleaned and scaled
dash fish sauce
white pepper
canola or rice bran oil
banana leaves, to serve
Thai seafood sauce (nam jim, page 304)

Pat the fish dry with paper towel. Using a sharp knife, score the fish with 3–4 diagonal cuts on each side.

Place the fish on a plate, douse with fish sauce and season with white pepper.

In a large wok, pour in enough oil so it's one-third full. Place over a high heat. It's ready when it starts smoking, or if it starts bubbling when you throw in a coriander leaf, as Jimmy likes to do.

Cook the fish one at a time. This keeps the oil at a high temperature, which you need for the crispiness. About 4 minutes a side should see the fish turn golden crunchy brown and be perfectly cooked.

Lift out of the oil and place onto paper towel to drain.

Serve on banana leaves with Thai seafood sauce on the side.

[COOK'S NOTES]

To achieve crispiness with any protein, it is important to make sure that the skin is dry. For example with pork, the dryer the skin, the better the crackling, and it's the same with chicken. That's why we pat the fish dry at the start of this recipe.

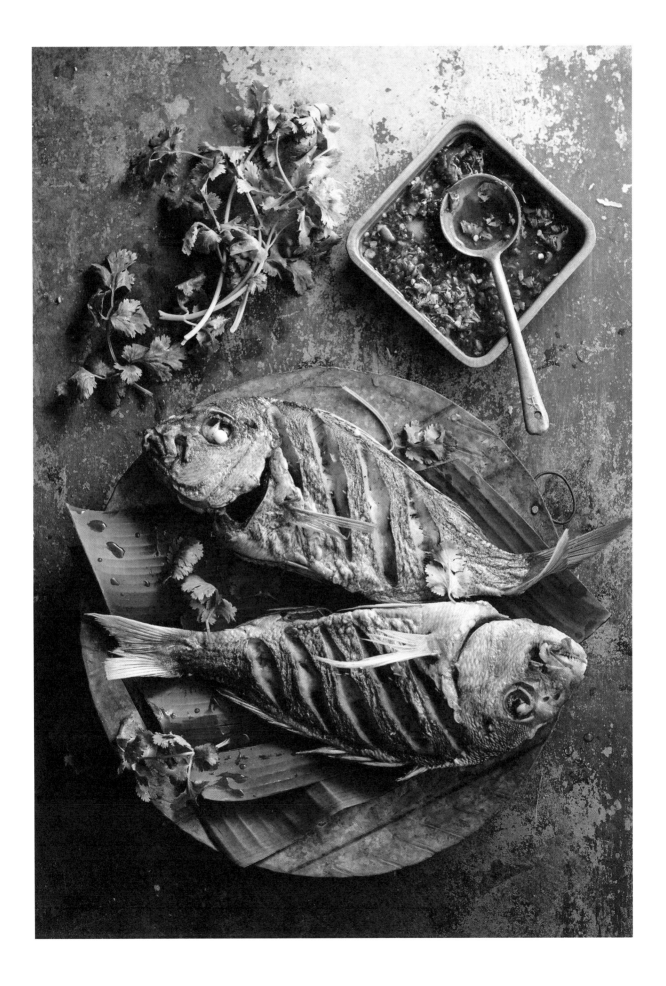

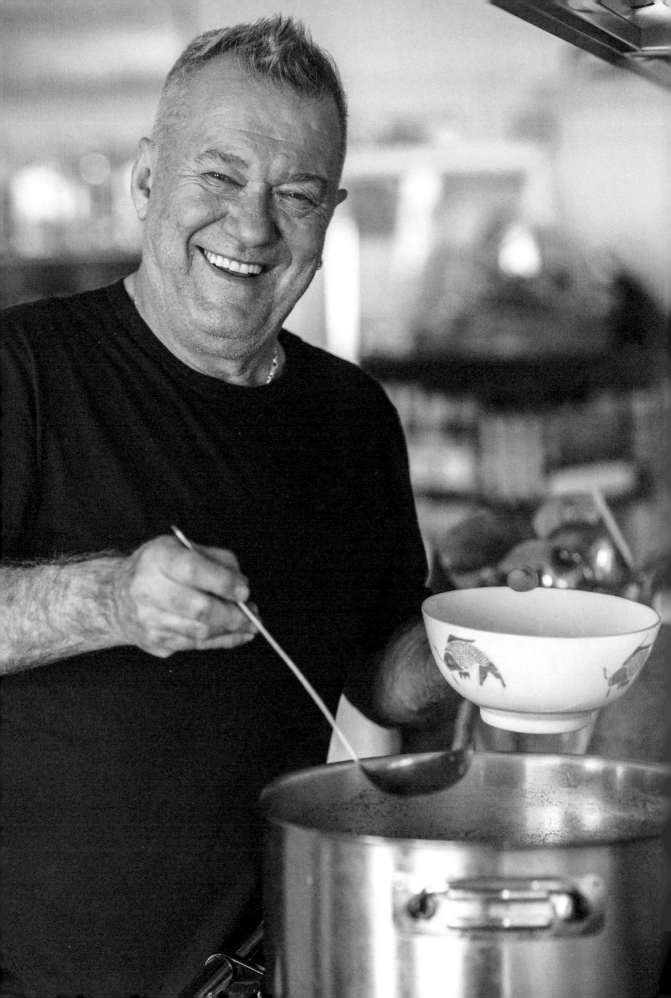

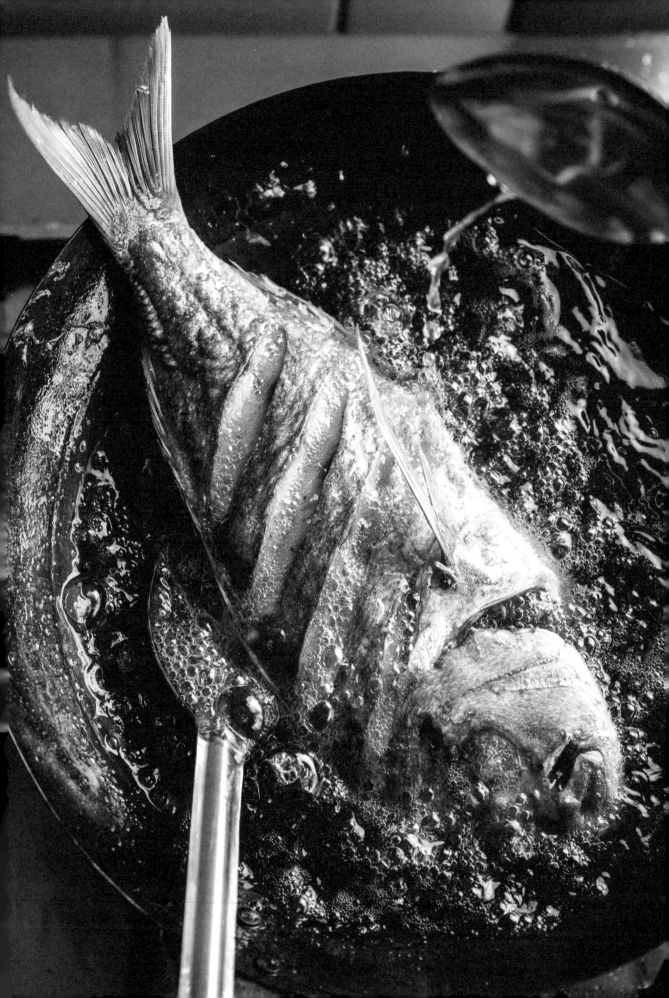

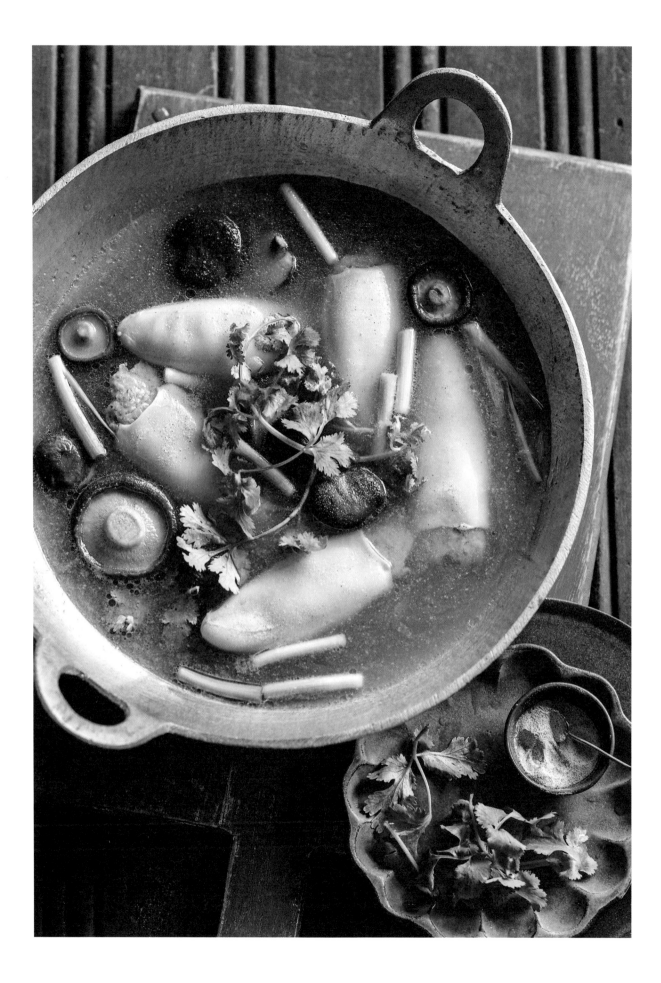

Baby squid stuffed with pork in chicken and shiitake broth

[*SERVES 4–6*]

Thais have clear soup with their main course dishes, to wash down the spicy and strong flavours of curries, for example, so the soup is not usually consumed on its own. You can substitute chicken or tofu for the pork. And you can also add some ginger and/or chopped green shallots to the mix. The list goes on. Be creative with it!

BROTH

2 chicken carcasses

1 brown onion, roughly chopped

2 garlic cloves, smashed

3 coriander roots, cleaned and crushed

1 chicken stock cube

fish sauce, to taste

300 g shiitake mushrooms, stalk ends trimmed

2 green shallots, cut into 4 cm lengths

STUFFED SQUID

350 g pork mince

3 stalks coriander, roots separated from leaves, both finely chopped

2 garlic cloves, crushed

1 tablespoon fish sauce

1 tablespoon oyster sauce

sea salt and freshly ground white pepper

12 baby squid (ask the fishmonger to clean them for you)

To make the stuffed squid, combine the minced pork, chopped coriander root, garlic, fish sauce and oyster sauce in a bowl. Season with salt and pepper. Mix well, cover and chill in fridge for an hour.

To make the broth, place the chicken carcasses in a large pot and cover with water. Bring to the boil. Add the brown onion, garlic, coriander root, crumbled stock cube and fish sauce to taste. Turn down to a simmer and cook for about 20 minutes, until reduced slightly.

Stuff the cleaned baby squid with the minced pork mixture.

Strain the broth through a colander and discard the solids. Return the liquid to a clean pan, add the shiitake mushrooms and let the soup bubble away on medium-low heat for about 10 minutes. You will see a change in colour as the mushrooms start cooking. Add the green shallots.

Once the broth is ready, turn the heat to its lowest setting, add the stuffed squid and remove from the heat. Stand for 10 minutes – this allows the squid to cook gently in the residual heat – but remember, it does need to cook the stuffing through.

Serve with a sprinkle of chopped coriander and white pepper.

Chicken and boiled eggs in sweet soy sauce

This Thai children's favourite is a dish you won't ever find in a restaurant. All the kids, even the grown-up ones in our family, love it. It's our comfort food. You can make it with chunks of pork belly instead, if you like, and even add some tofu puffs.

1 chicken, cut up into
 8 pieces (or use
 10 drumsticks)
½ cup kecap manis
 (thick sweet soy sauce),
 plus extra for eggs
4 coriander roots, cleaned
 and crushed
4 garlic cloves, smashed
1 star anise
2 cloves
2 tablespoons brown sugar
1 teaspoon chicken stock
 powder
1 teaspoon salt
1 tablespoon fish sauce
12 eggs
steamed jasmine rice and
 coriander leaves,
 to serve

Place the chicken pieces into a large pot and add enough water to just cover. Add the kecap manis, coriander root, garlic, star anise, cloves, sugar, stock powder, salt and fish sauce. Bring to the boil then turn down the heat and simmer for 30 minutes.

Place the eggs in a separate pot, cover with salted cold water then boil for 15 minutes. Drain and rinse the eggs with cold water. Once cool enough to handle, peel the eggs and roll them in a bowl of kecap manis. Add to the chicken pot and let simmer for a further 20 minutes.

Serve with jasmine rice, topped with coriander leaves.

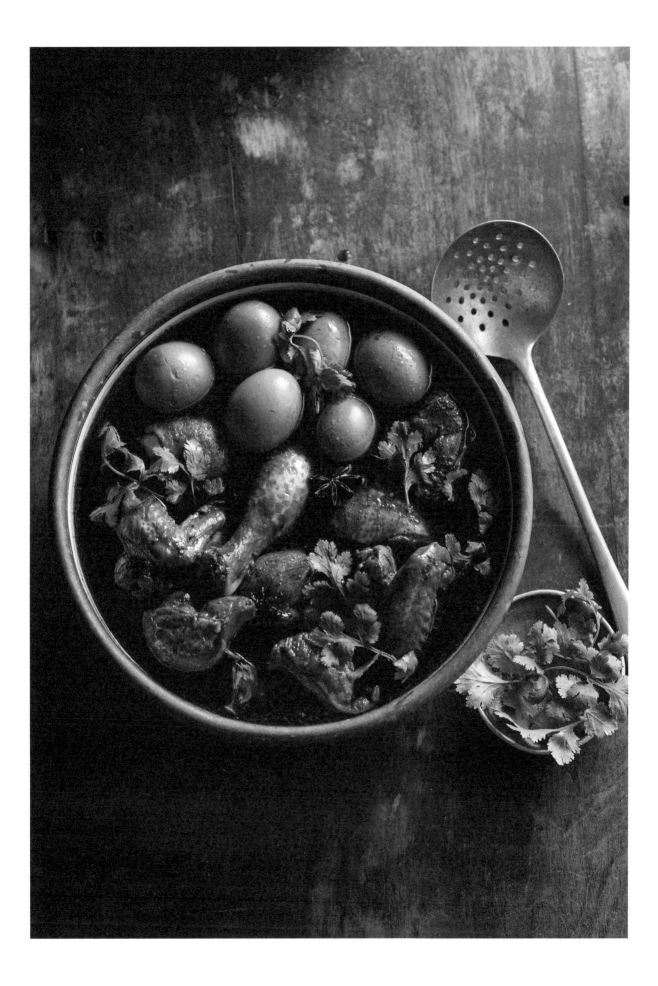

Local knowledge

AS A CHILD, I WOULD often accompany Grandmother and Aunty to the local market in the Bangrak neighbourhood of Bangkok, and it was always an enthralling experience. There really is nothing quite like an Asian fresh produce market, with the traders and hawkers bustling around from before dawn, selling everything from crunchy crickets to mango and sticky rice.

My favourite Thai market, however, which we have returned to regularly over the years, is the fresh produce market in Hua Hin, southwest of Bangkok on the Gulf of Thailand. The Thai royal family built palaces at Hua Hin from the 1920s onwards, and it later became the permanent residence of our beloved King Bhumiphol Adulyadej. In turn that made Hua Hin the prime holiday destination for Thais seeking a break from the oppressiveness of life in Bangkok. For as long as I can remember, members of our family have holidayed there every year.

Hua Hin's market is small enough to wander through easily without getting overwhelmed, yet offers everything one might find in a big-city equivalent. As soon as our children were old enough to tolerate the all-pervading odour of seafood, I would take them there to seek out culinary treasures. Now we all have our favourite stalls, and there are so many things to taste and see. Barbecued pork skewers caramelising over glowing coals, the smoke billowing and beckoning from grills diligently fanned by a proud Moo Ping man, who has been making his sticks for thirty years. Sweet custard buns that sell so quickly you'll miss out if you don't get there before 8 am. And the world's best kanom krok – small, round coconut pancakes – a treat our holidaying family cannot do without. My favourite part of the market round, however, is sampling and buying the amazing tropical fruits, whose flavours are astonishing. The pineapples are sweet and succulent, the mangoes plump, aromatic and juicy. Then there are red papayas, pomelos and several varieties of bananas – all tasting out of this world.

At Hua Hin and elsewhere in Thailand, some of my most-loved meals can be eaten at small specialist stalls or restaurants run by experts in one dish, to which their whole business is devoted: rice and egg noodles, chicken rice, stewed pork hock, duck noodle soup, and pad thai. One of Jimmy's favourite places is a stall in an alleyway in Bangkok's Chinatown, which is a loading bay for river boats by day, but at night serves the most sought-after fish-ball noodle soup. Our family took Jimmy there on his first trip to Thailand in 1980, and I believe he might have been the first Westerner ever to be served there. Local knowledge is the key in the Land of Smiles.

Thai chicken macaroni

This is very much a family recipe, something I grew up eating in early childhood days in Thailand. Because ours wasn't a country where tomatoes were produced in abundance, we would use ketchup (usually Heinz tomato sauce) in place of passata and tomato paste. The sweetness and saltiness make it a perfect combination for little ones. The now-big ones still love it.

500 g macaroni or penne rigate
2 tablespoons olive oil
1 brown onion, halved and sliced lengthways
pinch sea salt
2 chicken breast fillets, cut into thin bite-sized pieces
1 chicken thigh fillet, cut into thin bite-sized pieces
2 tomatoes, cut into thin wedges
1 garlic clove, crushed
fish sauce, to taste
½–1 cup tomato sauce (ketchup), to taste
freshly grated parmesan, to serve

Add the pasta to a large saucepan of well-salted boiling water and cook until al dente.

Heat the olive oil in a wok or deep frying pan over medium heat. Add the onion, sprinkle with salt and cook for about 4 minutes, until soft.

Mix in the chicken and tomatoes and let cook for 10 minutes. Stir in the garlic and splash a little fish sauce over the mixture, then mix in the tomato sauce.

When the pasta is cooked, transfer it straight from the pot into the wok or pan, using a large spoon with draining holes.

Mix through really well and let it all cook for another 5–10 minutes, while tasting to see if you need more salt or tomato sauce.

Serve sprinkled with parmesan.

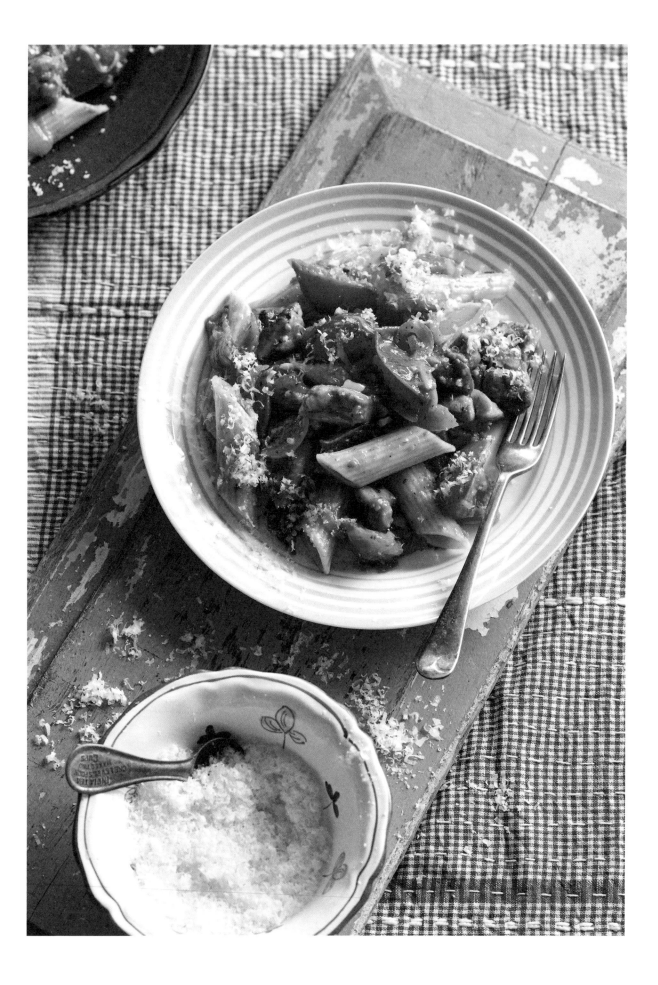

Hainan chicken (Thai style)

In Thailand this is served early in the morning. People on the way to work, or kids on the way to school, will stop for a plate of it. Our favourite spot for this dish in Hua Hin, where we have holidayed as a family for the past 40 years, can be sold out by 11 am on busy days. Most regular travellers to Southeast Asia will know this dish well, as it's available in various forms in most countries in the region. In Singapore they poach the chicken, but the Thais steam the chicken in a big steamer, with the water in the bottom pot catching the fat drippings, which are in turn made into a delicious broth to have with the chicken-fat rice. I always brine my chicken, even when I'm steaming, as I always get a better, juicier result. This is my go-to comfort food, a family favourite. And I love to take my time making this meal, because I think it's the time and love that add extra deliciousness.

STEAMED CHICKEN

4 cm knob ginger, flattened, plus extra for steaming
3 garlic cloves, smashed, plus extra for steaming
4 coriander roots, cleaned and crushed, plus extra for steaming
dash Chinese cooking wine
dash light soy sauce
1 whole chicken
1 tablespoon kecap manis (sweet soy sauce)
coriander leaves, to serve
4 cucumbers, sliced
ginger, green shallot and sesame sauce (page 302), to serve
sweet soy sauce with chilli (page 303), to serve

Brine the chicken (page 305), using the ginger, garlic, coriander roots, Chinese cooking wine and soy sauce in the brining liquid. Drain well and pat dry before using.

Rub the chicken with kecap manis. Put some flattened ginger, garlic and coriander root inside the body and place into a large steamer over a large pan of simmering water. Cook for 50–60 minutes, until the chicken is tender and cooked through. Let the chicken rest in the steamer until you are ready to serve (reserve the liquid underneath).

Meanwhile, to make the chicken-fat rice, place the chicken fat in a frying pan over medium heat and heat until rendered (melted). Add the rice and stir to coat well with the fat. Transfer to a rice cooker and mix through the garlic, coriander roots, ginger and pandan leaf. Season with salt and add the stock or water. There will be less liquid than when you usually cook rice, but we want this rice to be a little drier and not over-cooked. Not under-cooked or al dente either; chicken rice should be on the firmer side. Cook according to your rice cooker directions.

CHICKEN-FAT RICE

chicken fat (see Cook's
 Notes)
3 cups jasmine rice, rinsed
 and drained
2 garlic cloves, smashed
3 coriander roots, cleaned
 and crushed
4 cm knob of ginger,
 flattened
1 pandan leaf, tied in a knot
sea salt, to taste
2½ cups chicken stock
 (page 298) or water

SOUP

1 heaped teaspoon chicken
 stock powder
½ brown onion, sliced
2 coriander roots, cleaned
 and crushed
2 garlic cloves, smashed
6 Chinese cabbage leaves,
 chopped
200g shiitake mushrooms,
 sliced or halved
white pepper

To make the soup, reserve 1–2 tablespoons of the steaming liquid from the chicken and set aside. Add the chicken stock powder, onion, coriander root, garlic, cabbage and mushrooms to the remaining liquid. Bring to the boil then simmer over medium-low heat for 10 minutes. Taste to see if you need salt or soy sauce, and season with white pepper.

Break up the chicken and take out the bones and carcass. Slice into large bite-sized pieces and place on a platter. Mix the reserved steaming liquid with the kecap manis and pour over the chicken. Garnish with coriander.

Serve the chicken, rice and soup with the cucumbers and two sauces. Kids will probably prefer just kecap manis (sweet soy sauce) over their chicken and rice.

[COOK'S NOTES]

Inside the chicken cavity you will find small deposits of fat – use these. You can also ask the butcher to keep chicken fatty bits for you. I keep small sandwich bags of chicken fat stored in the freezer. There is also a deli product called schmaltz that I have used, which is perfectly fine if you don't have any chicken fat lying around.

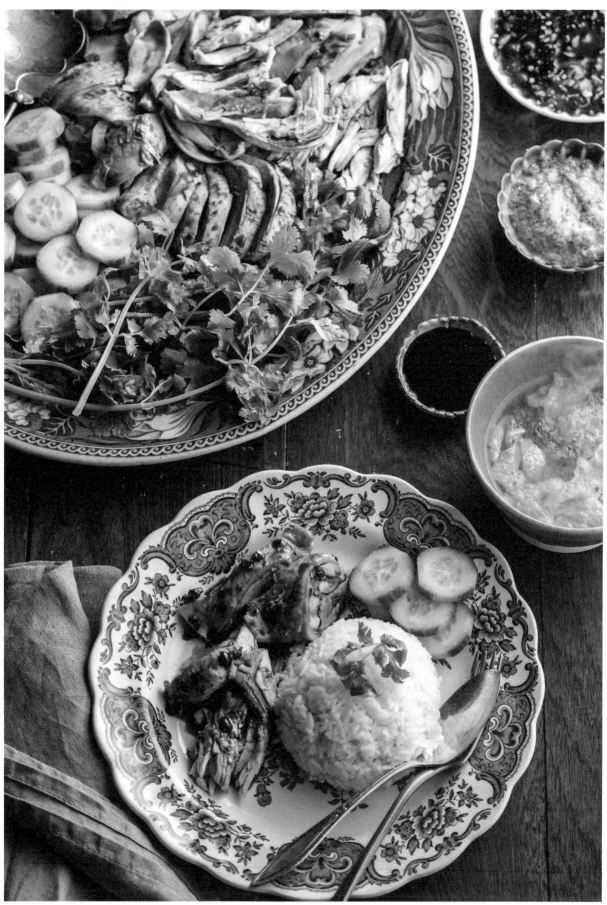

HAINAN CHICKEN [THAI STYLE], PAGE 130

CHAPTER
FIVE

Everyday
Dinners

JANE AND I MET ON 29 November 1979. It was four o'clock in the afternoon, if you are interested, and she was so beautiful that she took my breath away. On that fateful day, who would have guessed that this girl would change my life forever? But she did.

Our first actual dinner date happened not long after. I remember her asking me to come to her place, because she wanted to cook for me. 'When I was younger I found a recipe for apricot chicken,' she said. 'Would you like to try it?'

The truth be known, I wasn't that keen on the idea. It sounded like a dessert and a main course mixed together. But I wanted to be with her so much I quickly replied, 'Mmm, that sounds good. I'd *love* to try it.'

I was lying. I wasn't going to let on that I only ate meat and potatoes. Not to Jane. Not yet anyway. I'd wait until she really liked me, then I'd tell her how limited my tastes were. I didn't want to scare her off straight away.

This, of course, meant that I would have to eat whatever she served up. It would be a challenge, but I was sure I could get away with it. Move it around the plate until she wasn't looking then slip it to the dog – Jane had a big black Labrador called Theo and I was sure he would help me out. At that time in my life, dogs liked me more than people did.

I wasn't a huge eater at the best of times. I really only ate for fuel. This might have been because my mum's cooking skills were a bit limited. No offence, Mum. You see, I grew up eating the same sort of thing every day, mainly the Scottish national dish, mince and potatoes. It was nutritious and filling. Well, it was filling anyway. Even my mum could throw a pile of minced beef and chopped-up onion and carrot into a pan, cook it to death and end up with something that might still be almost edible. And potatoes were practically indestructible. Even I could cook mince and tatties.

But apricot and chicken? *Together?* This could be tricky, I thought.

I remember my granny coming out to Australia years later and we took her out for fish and chips. The restaurant made the mistake of placing a slice of orange on her plate. She wouldn't eat any of it.

'Am no eating fruit wi' ma dinner, Jim,' she said, scowling at me. 'It's barbaric.' And she pushed her plate away. Wouldn't touch it again.

I guessed I was a bit like that.

Jane went on to tell me more about the dish. 'I think you'll like it. My good friend and I found these two recipes and we've cooked them ever since. Her dish is veal with bananas and mine is apricot chicken.'

I suddenly felt lucky. If Jane had made veal and bananas, we might have been in trouble. Probably wouldn't have made it to a second date.

On that fateful day, who would have guessed that this girl would change my life forever? But she did.

That night, I sat down at the table for dinner. It smelled really good. I had an open mind and an empty stomach, so I'd probably have eaten anything.

'There you go. Enjoy. Bon appétit!'

I peered at the plate. At least I couldn't see any whole apricots. And it didn't look like fruit, just a kind of gravy. Stalling, I moved things around on the plate as Jane sat watching me.

'Come on Jimmy, try it. I'm sure you'll love it.'

I piled my fork with potatoes and smeared a little bit of the sauce on top, then shut my eyes and quickly put the fork in my mouth without thinking about it.

I waited for the taste to hit me.

I was surprised. 'Oh … oh. It's pretty good, isn't it?' I said, reloading my fork. 'Actually, I like it a lot.'

I wolfed down another bite.

'I told you you'd like it.' Jane turned her beautiful face to me and smiled.

It was at that very moment that a voice inside my head said, 'Jimmy, you should marry this girl.' That voice had no accent. It certainly wasn't Scottish. And it sounded like it knew how to cook. So it couldn't have been me.

All I knew was Jane was the best girl I had ever met and this was the best thing I'd ever eaten up to that moment. I loved it.

Jane, I soon worked out, was an amazing cook and she went on to make so many great dishes for us, most of them even more impressive than apricot chicken. Every now and then, though, she would cook my new favourite dish for me.

To this day, I still occasionally ask for apricot chicken, much to Jane's surprise. I guess it reminds me of how lucky I was to find such a stunning girl with such incredible culinary skills.

> Jane went on to make so many great dishes for us, most of them even more impressive than apricot chicken.

It was only later that she told me she'd found the recipe on the back of a French onion soup packet. It didn't matter. Because Jane had cooked it with love.

Nowadays my taste buds have matured and I eat just about everything. I was right, though: Jane is one of the best cooks I have ever met. And I'm forever thankful she didn't opt for veal and bananas. Who knows where that would have led?

Bangers and mash with onion gravy

[SERVES 6]

We like to use a traditional Cumberland sausage coil, but any good-quality sausages will do for this classic recipe. To add even more flavour, we often boil our potatoes in stock.

1.5 kg mashing potatoes
(such as sebago), peeled
and cut into quarters
sea salt and white pepper,
to taste
1 tablespoon butter
100 ml pouring cream
100 ml milk
1 tablespoon olive oil
1 large Cumberland sausage
coil (or 12 good-quality
sausages)
3 large brown onions, sliced
2 tablespoons plain flour
1½ cups beef stock
(page 298)

Place the potatoes into a saucepan and cover with water (or stock if you have it). Season with salt and bring to the boil. Cook for 15 minutes or until completely cooked through. Drain and return to the pan. Add the butter, cream and milk and mash until smooth. Season with salt to taste.

Heat the oil in a large heavy-based frying pan over medium heat and add the sausage coil. Cook for about 10 minutes on each side, until well browned and cooked through.

Remove the sausage from the pan and cover with foil to keep warm. Add the onions to the pan and cook for 5 minutes or until soft. Whisk in the flour and cook for 1 minute, then gradually add the beef stock and continue to stir until the gravy thickens. Season with white pepper.

Serve the sausages and onion gravy with the mashed potato.

[COOK'S NOTES]

When cooking everyday Aussie sausage sanger snags, it's a good idea to stab holes in each sausage with a fork to let the fat out. But I find with thick European-style sausages that it's better to leave them intact and let the fat help to cook them from the inside.

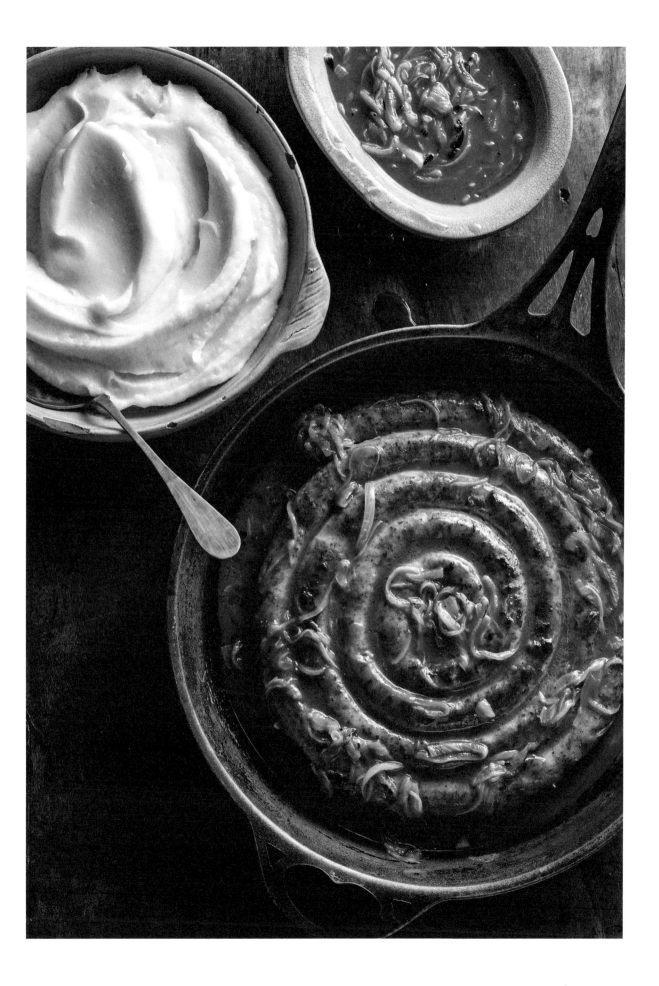

Chicken schnitzels stuffed with Comté cheese and spinach

[*SERVES 4*]

These are delicious served with a side of good-quality anchovy fillets (yes, as a condiment), potato salad and cabbage salad.

1 cup plain flour
sea salt and freshly ground black pepper
2 eggs
2 cups dried breadcrumbs
4 smallish chicken breast fillets (ask the butcher to butterfly and beat for you)
4 slices Comté cheese
handful baby spinach leaves
4 slices prosciutto
olive oil, to shallow fry

Preheat the oven to 180°C (160°C fan-forced).

Scatter the flour onto a baking tray. Season with salt and pepper and mix around. Use a fork to beat the eggs in a wide shallow bowl. Scatter the breadcrumbs onto another tray.

If you haven't got butterflied fillets, you can easily do it yourself. Make a horizontal cut along the length of the breast, taking care not to cut all the way through. Now you can open them out like a book. Beat the thicker part of the chicken with a rolling pin, so the thickness becomes more even.

Open the chicken fillet flat on your board and place a slice of cheese on one half. Top with a few baby spinach leaves and a piece of prosciutto, then grind over some black pepper. Fold the other half of the chicken over to enclose the filling. Repeat with the other pieces.

Carefully coat the stuffed fillets with seasoned flour, then beaten egg, then breadcrumbs, pressing gently.

Pour enough oil into a large heavy-based frying pan so it is about 1 cm deep. Heat over medium-high heat and cook the chicken for a few minutes on each side, until golden brown. Transfer to a baking tray and bake for 20 minutes to cook through.

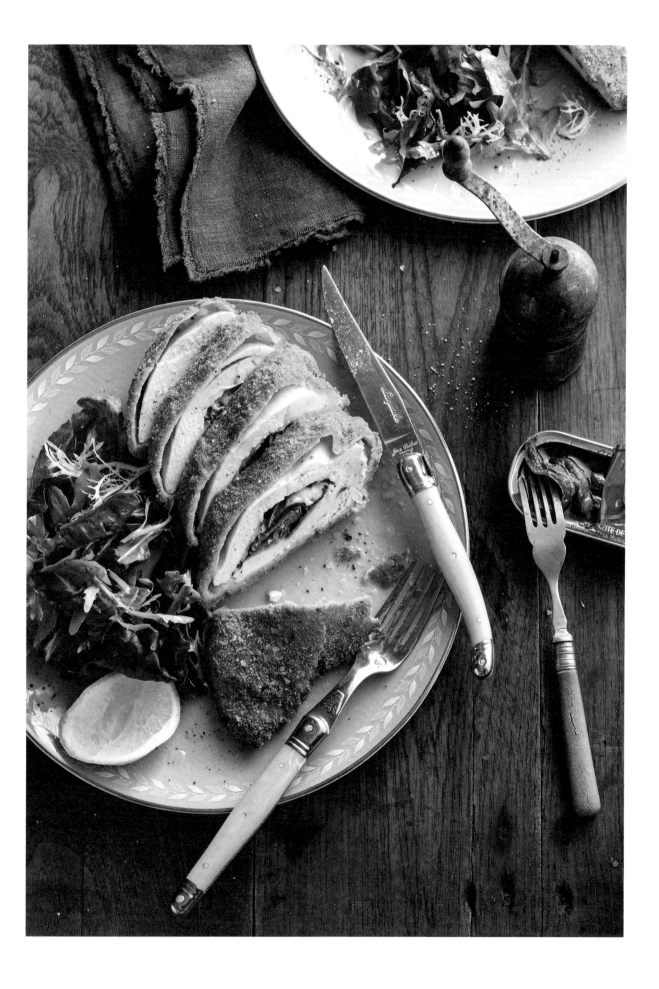

Anna's meatballs with mushroom sauce

[SERVES 6]

We love this recipe served with mashed potato, white rice or on a bun with gravy. The meatballs also go brilliantly with pasta and a simple tomato-based pasta sauce.

MEATBALLS
2 slices bread
⅓ cup milk
¼ cup pouring cream
 or sour cream
2 eggs
2 teaspoons vegetable stock
 powder
1 teaspoon fish sauce
3 garlic cloves, crushed
sea salt and freshly ground
 black pepper
500 g beef mince
500 g pork and veal mince
28 cheese cubes (optional,
 the kids love it!)
1 tablespoon olive oil

MUSHROOM SAUCE
2 teaspoons unsalted butter
600 g mushrooms
 (any kind), sliced
½ cup pouring cream
¼ cup chopped flat-leaf
 parsley (optional)

To make the meatballs, tear up the bread into a large mixing bowl and add the milk. Soak until completely absorbed.

In a separate bowl, whisk together the cream, eggs, stock powder, fish sauce, garlic, salt and pepper, then add to the soaked bread and stir to combine.

Add the mince and use your hands to knead together until evenly combined. Roll the mixture into golf ball–sized meatballs. If you like, press a cube of cheese into each meatball and mould the meat around it to enclose.

Heat the olive oil in a large frying pan over medium heat. Add the meatballs and cook for 15 minutes, shaking the pan so they roll around and cook evenly on all sides. Remove the meatballs from the pan.

To make the sauce, melt the butter in the pan and add the mushrooms. Cook for about 7 minutes, stirring often, until soft. Stir in the cream and cook until heated through. Add the parsley, if using. Return the meatballs to the pan to coat with the sauce and reheat.

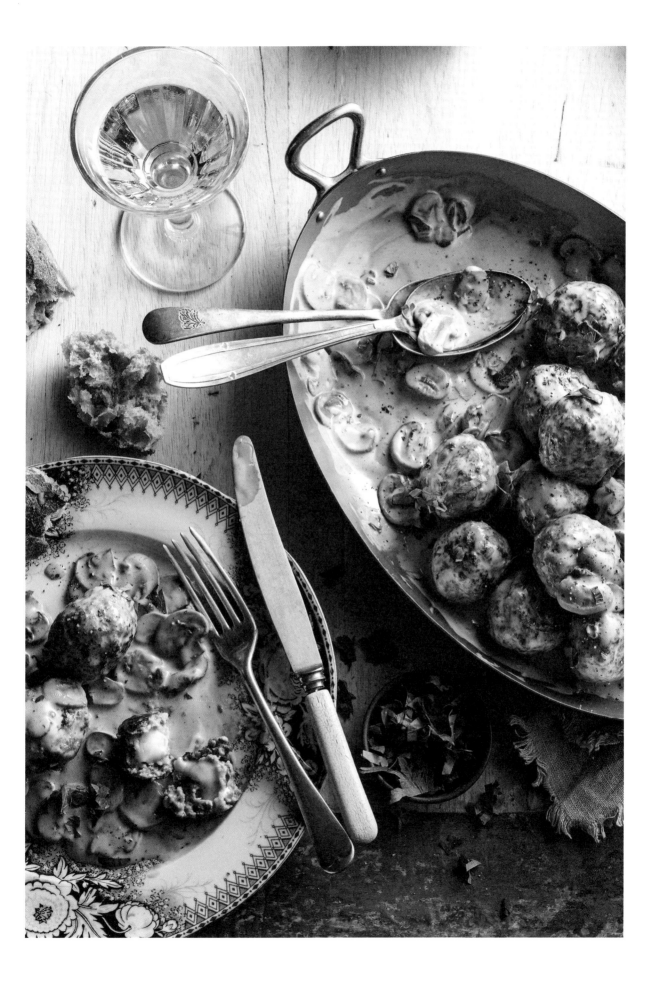

Cottage pie

[*SERVES* 8]

This must be the English cousin to Scottish mince and tatties. Or perhaps the British spaghetti bolognese. Sometimes when I have leftover bolognese ragu, I use it as the filling for cottage pie and top it with cheesy mash. Shepherd's pie is, of course, made with lamb mince.

FILLING

1 tablespoon unsalted butter

1 brown onion, diced

2 garlic cloves, smashed and sliced

1 kg beef mince

1 kg pork and veal mince

1 beef stock cube

2 fresh bay leaves

2 carrots, peeled and diced

2 cups frozen peas or chopped green beans

½ cup plain flour

1 cup stock (beef, chicken or vegetable; page 298)

1 teaspoon Maggi seasoning sauce, or to taste

2 teaspoons Worcestershire sauce

½ teaspoon soy sauce

sea salt and freshly ground black pepper

TOPPING

4–6 medium-large desiree potatoes, peeled and chopped

2 orange sweet potatoes (kumara), peeled and chopped

100 g butter, plus extra for top

2 tablespoons cream

1½ cups grated cheddar (or Comté cheese), plus extra for top

To make the filling, melt the butter with a pinch of salt in a large, heavy-based saucepan over medium heat. Add the onion and cook for about 5 minutes, until soft. Add the garlic and stir to combine (be careful not to burn the garlic, as it will turn bitter).

Add both minces and cook until browned, breaking up the meat with a wooden spoon as it cooks (I find a potato masher helps with this too). Crumble in the stock cube and stir through.

Give the bay leaves a twist and add to the pot, along with the carrots and peas or beans. Reduce the heat to medium-low and let simmer.

In a small bowl, make a roux by slowly adding enough water to the flour to make a runny paste. Whisk with a fork until smooth. Stir into the mince mixture and let it bubble away until thickened. Add the stock and sauces and mix in well. Add more stock, if it needs thinning out, and season with salt and pepper to taste. Remove the bay leaves and spoon the mixture into a large ovenproof dish.

Meanwhile, for the topping, boil the potatoes and sweet potato in well-salted water until cooked through. Drain, then return to the pot and mash with butter and cream. Stir in the cheese.

Spread the mash over the mince. Using a fork, make a nice pattern on top. Sprinkle with more cheese and scatter with scrolls of butter. The ridges will trap the melted cheese and butter and make it look homey and delicious.

Place under the grill for 5 minutes or until golden brown on top. Serve immediately, with a simple green salad or buttered green beans.

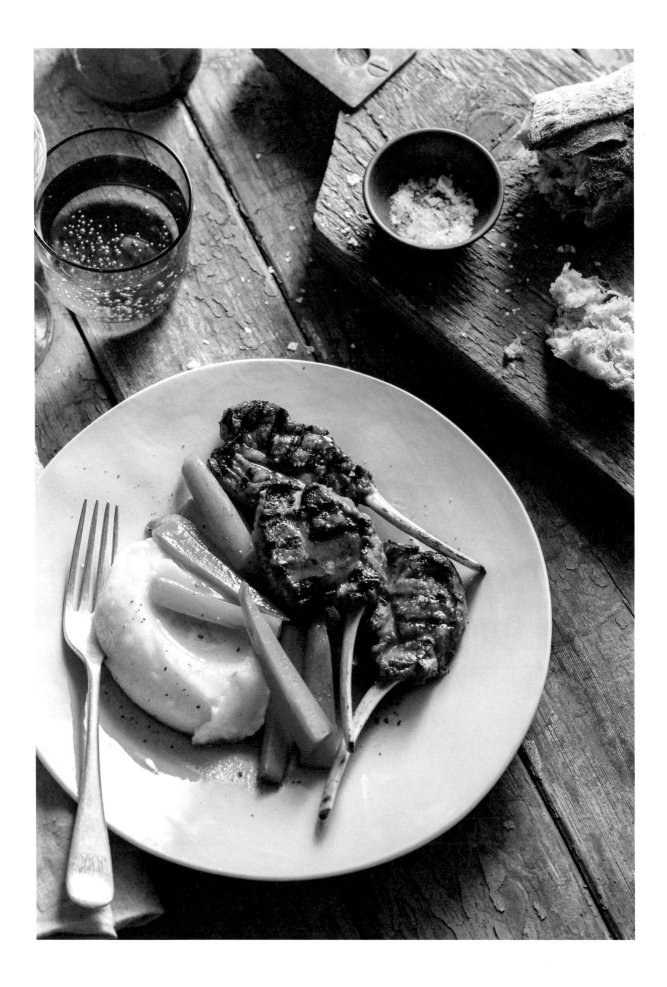

Grilled lamb cutlets with brown sugar carrots

[*SERVES 4*]

This is a hearty, quick and easy meal to serve up anytime, but especially great when you have a houseful of kids starving after a Saturday of sport. Our favourite cutlets are French-trimmed lamb cutlets, available from some supermarkets – they look and taste the best!

12 French-trimmed lamb cutlets
extra virgin olive oil and sea salt, to serve
mashed potatoes, to serve

BROWN SUGAR CARROTS
2 carrots
80 g butter
1 heaped tablespoon brown sugar

Peel the carrots and cut into rough rods the size of your little finger. Boil in well-salted water for about 10 minutes or until soft.

Drain the carrots and return to the pot. Add the butter and brown sugar straight away so they melt through the carrots. Keep warm.

Meanwhile, heat up a chargrill pan until it's smoking. Sear the cutlets for 1½–2 minutes on each side. I usually judge by looking at the bone – when the blood disappears, I turn the chops over.

Once the chops are cooked to your liking, set them out on a platter, drizzle with a little olive oil and generously sprinkle with salt.

Serve the cutlets and carrots with mashed potatoes, and spoon any remaining butter mixture over the top.

Seafood
sang choy bow

[*SERVES 4*]

This is basically frying up chopped ingredients that you have on hand, or fillings that you like, then wrapping them up in a lettuce leaf.

10 green king prawns,
 peeled and deveined
1 tablespoon oyster sauce
2 coriander roots, cleaned
 and crushed
2 garlic cloves, crushed
dash fish sauce
sea salt and white pepper
1 small iceberg lettuce
1 tablespoon grapeseed oil
1 small brown onion,
 finely diced
225 g can bamboo shoots,
 drained and finely diced
225 g can water chestnuts,
 drained and finely diced
 (optional)
8 Swiss brown mushrooms,
 finely diced
dash soy sauce
dash Maggi seasoning
fresh herbs, such as
 coriander, Thai basil
 and Vietnamese mint,
 to serve
finely sliced red chillies,
 to serve

Finely dice the prawn meat and combine with the oyster sauce, coriander root, garlic, fish sauce, and salt and pepper to taste. Cover and refrigerate for 30 minutes.

Pull the lettuce apart, keeping the leaves whole. Wash and spin dry with a salad spinner. Use kitchen scissors to trim the dark outer parts off the leaves. Arrange on a serving dish.

Heat the oil in a wok over high heat and stir-fry the prawn mixture until it changes colour. Add the onion, bamboo shoots, water chestnuts (if using) and mushrooms. Stir-fry for another couple of minutes, then splash on a little soy. Taste, and if you like, season with salt, white pepper and Maggi seasoning.

When everything is cooked, well tossed and combined, and the taste is to your liking, the dish is ready.

Serve the filling in a bowl alongside the lettuce leaves, for people to make their own wraps. Serve with the herbs and have chillies on the side for anyone who likes a little heat, or make up some chilli oil (oil with chilli flakes) or a bowl of soy sauce and fresh chillies to dip into.

[COOK'S NOTES]

This filling is very flexible. You could add carrots, zucchini, beans ... anything you like. Just make sure everything is chopped into small, even pieces. You can replace the prawns with any other seafood you like, or use chicken or pork mince. For vegetarians, just leave out the protein and use double the quantity of mushrooms.

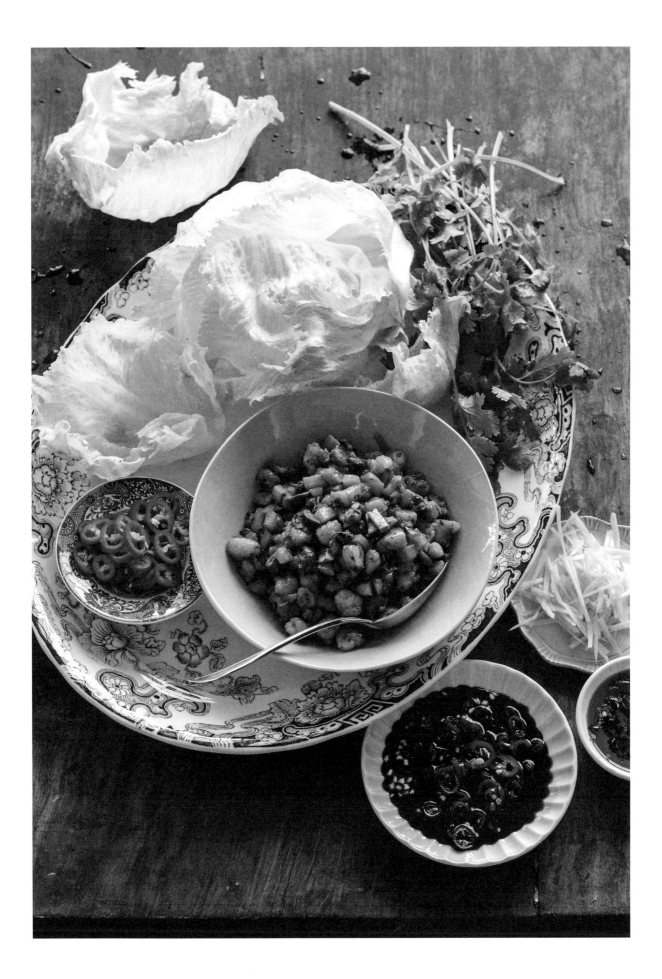

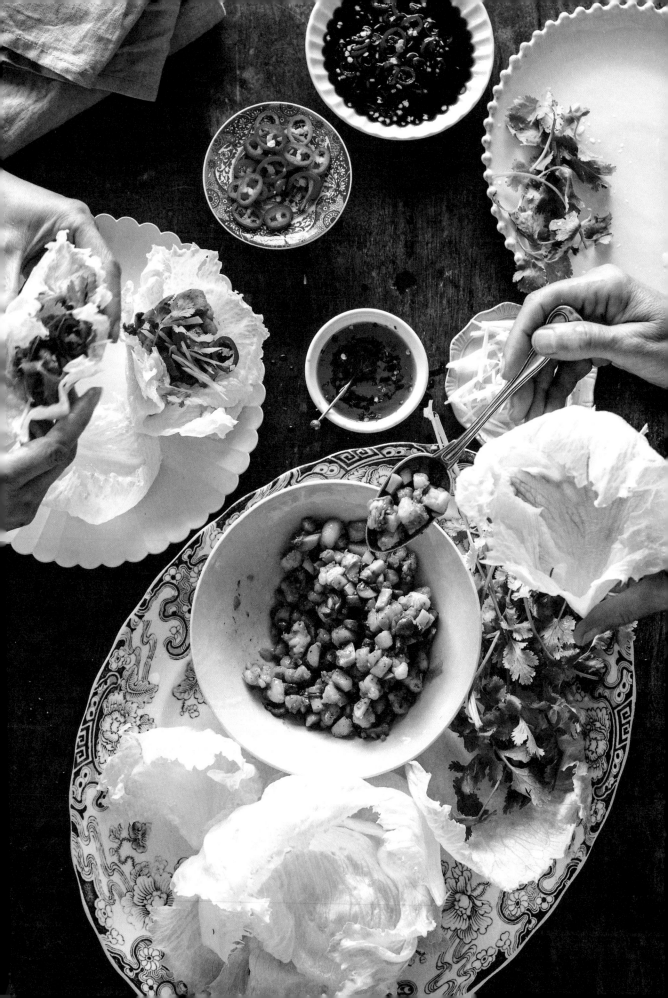

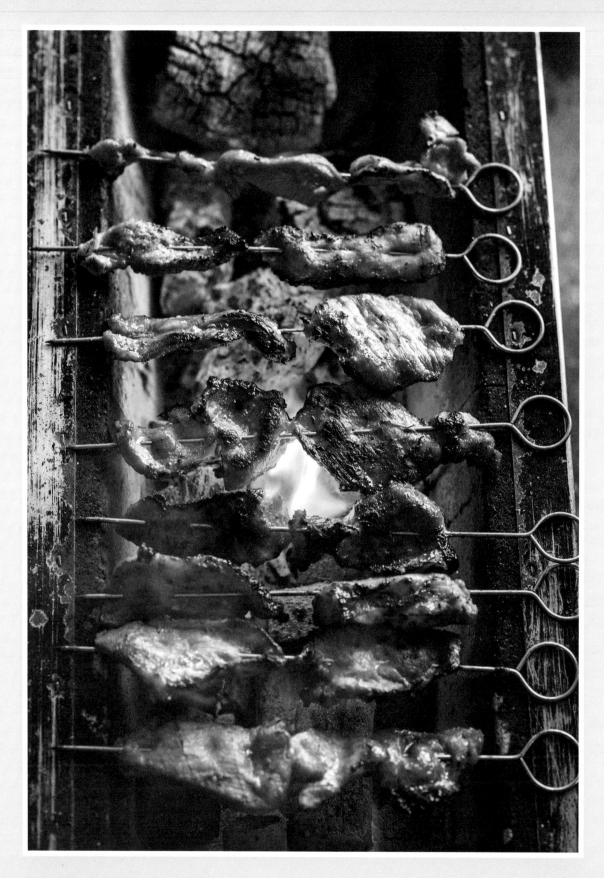

Streetwise

IN 1974, MY PARENTS MOVED to tropical Malaysia, and Kuala Lumpur became my home for the next two years. Food-wise, it was something of a relief, as it meant no more boarding-school slop and a return to lighter Asian cuisine – to dishes accompanied by rice or noodles as the staple carbohydrate; to eye-watering curries, satays and laksas; to fruits sweeter than sugar; and to the old familiar smells of Southeast Asian street food.

I finished my high-school education in the American system at the International School of Kuala Lumpur. At that time, it was an old building with no air-conditioning, just table fans to keep us cool. That meant we had to start classes early and finish at lunch time, when the sweltering humidity and heat became so overwhelming it sent us all to the comfort of our homes. Ah Ying, our Chinese cook, would have noodles or fried rice waiting, and sometimes spring rolls or curry puffs, too. I was never so hungry as at the end of a school day – indeed, ravenous better describes how I felt after the enormous effort of concentrating and learning all morning.

We were allowed to do homework with other expatriate friends at the Royal Selangor Club, even poolside, where we could order Welsh rarebit, French fries, roasted peanuts with chilli and ikan bilis (crunchy dried anchovies), cucumber sandwiches, hamburgers, or cakes for afternoon tea. But it was our dinners that were the biggest treat, as we'd often head out to the city's night markets and sample Malaysia's melting pot of Malaysian, Chinese, Indian and British cuisines.

The streets would come alive with hawkers selling their speciality dishes, including fried kway tiew (large flat white rice noodles) with seafood and vegetable gravy topping; prawn or chicken laksa; thin egg or rice noodles in a spicy coconut soup dressed with chilli paste, bean sprouts and tofu; roti canai, an Indian-style flatbread for dipping into dahl or curry; and chilli mud crab. In these colourful, lively but humble street markets, you could eat some of the best food in the world – truly delicious yet inexpensive. I felt so at home there and, just like in Thailand, you'd have had to have been terribly unfortunate to experience a bad meal – I certainly don't remember a single one. To this day, any time we go to Kuala Lumpur, as soon as it's night, we head to those markets. Standing at a rickety table serving chicken satay or chilli mud crab, on a balmy tropical night, with a beer in hand, you can't do much else but smile.

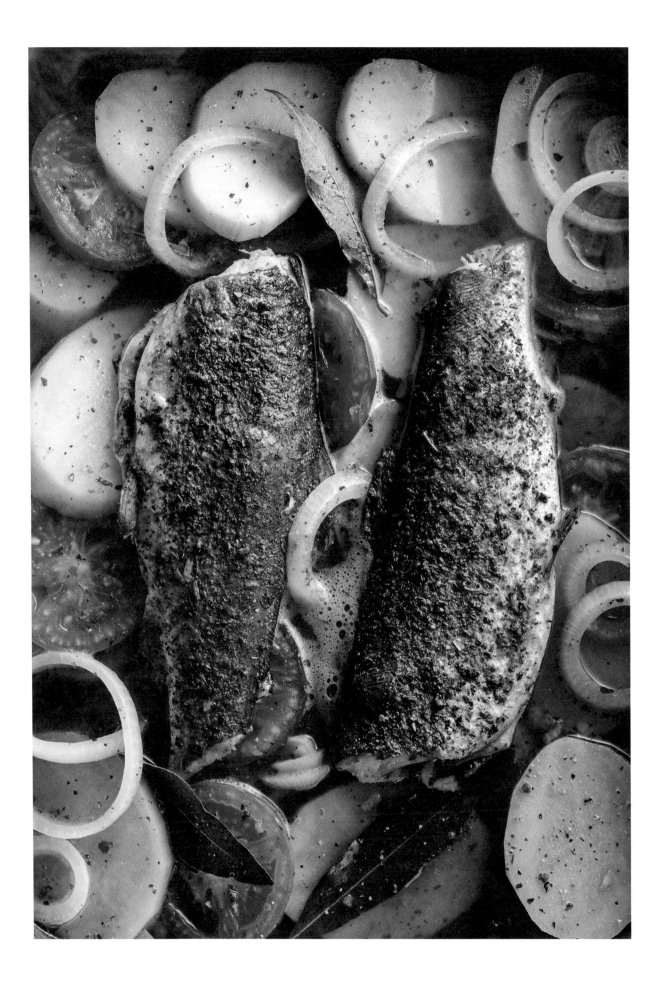

Rainbow trout tagine

[*SERVES 4*]

In the South of France in the early 1990s, I was taught how to cook trout tagine by an Algerian acquaintance. We had never had couscous or tagine before, but it was surprisingly simple and so delicious. With this first taste of Middle Eastern cuisine, a whole new world of food opened up to us.

2 tablespoons olive oil
sea salt and freshly ground
 black pepper
2 brown onions, sliced
 into rings
2 potatoes, peeled and
 cut into 5 mm slices
2 medium-large ripe
 tomatoes, sliced
2 pinches Moroccan
 spice mix
2 pinches Herbes de
 Provence (see
 Cook's Notes)
2 bay leaves
2 slices lemon
2 whole rainbow trout,
 gutted and cleaned
fish or vegetable stock
 (page 298), as needed

Preheat the oven to 220°C (200°C fan-forced).

Lightly cover the base of a tagine or shallow baking dish with olive oil and sprinkle with salt. Layer the onion, potato and tomato slices into the dish. Sprinkle with salt and a pinch each of Moroccan spices and Herbes de Provence. Add the bay leaves and lemon slices.

Cut off the head and tail of the trout and place the fish on top of the vegetables. Sprinkle with salt and a little more of the Moroccan spices and Herbes de Provence. Grind some pepper over. Pour in enough stock to come about three-quarters of the way up the side.

Cover and bake for 25 minutes, until the vegetables are tender and the fish is cooked through. Serve with a simple green salad.

[COOK'S NOTES]

Les Herbes de Provence are mixed dried Provençal herbs. You can buy this mix from a good deli.

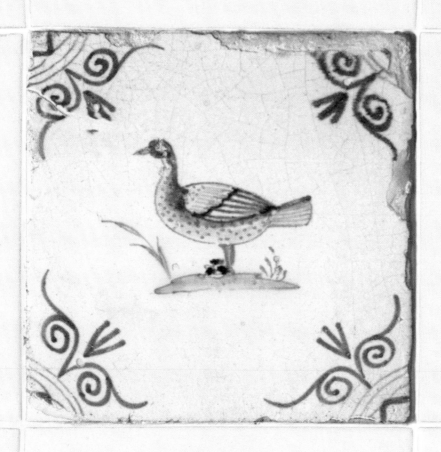

Sundays
& Roasts

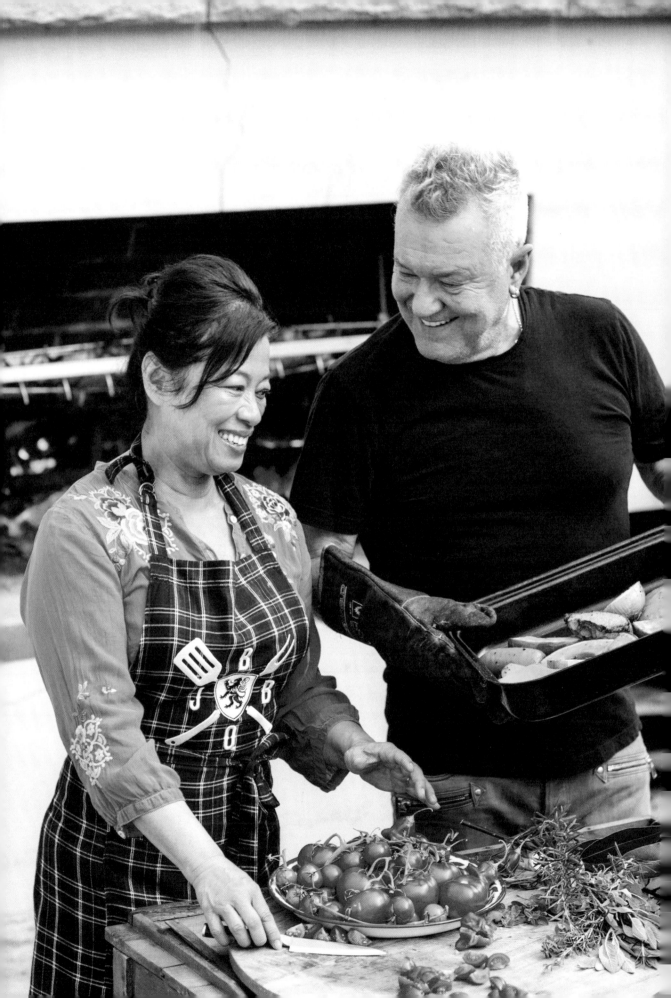

AS IT IS FOR MANY people, it's important for our family to all sit down together for a grand feast, usually featuring some kind of roast, at least once a week. For us, though, the typical Sunday roast can happen almost anywhere and at any time. That's because, as a touring family, we often find ourselves away from home, and our 'weekend' could be any day of the week.

> For us, the typical Sunday roast can happen almost anywhere and at any time.

After a show, a bus ride in the dark and a heavy sleep, we might wake up in a quaint little inn nestled by the sea. Or in a cavernous grand hotel balanced precariously on the edge of a mountain range, with spectacular views into deep valleys. It just depends on where our shows have taken us. It sounds glamorous and beautiful, but some hotels aren't that great. You might pull back the curtains and find, there in front of you, just the blank wall of the next building, or an alleyway cluttered with parked cars and bins overflowing with rubbish. Then you have to quickly shut the windows and blinds and hope the next place is better. That's life on the road.

Even at home, it's hard for us to have days off, particularly as we often work Sunday nights. Any day or two we do manage to keep free we like to call a 'rock 'n' roll weekend'. It might be a Monday, or a Tuesday and Wednesday. But it feels like the weekend to us.

Whatever the place and time, on one of those days we will prepare a feast. That can be tricky in some hotels, as even if they have a kitchen it's often just for show, and we might start to prepare the food then realise we don't have the right pans or plates or knives. But somehow,

led by Jane, we usually manage to whip up something fabulous. Then we sit down for our big family meal, reflect on the week gone by and prepare for the week ahead. It means so much to us, and is a huge part of what holds us together as a family.

We feel that food, and making food together, is an expression of the love we share, so we all like to get involved in its preparation. My role in the weekly feast has long been making the gravy. Of course, no roast feast is complete without gravy, and for years I was convinced it was the most important part of our roast dinners. Jane would say something like, 'Oh, Jimmy, we need you to make the gravy because no one makes it as well as you do.' And I would leap to the stove and do my thing.

It's only recently that I realised I was being lovingly conned. I know this because I finally worked out that you could train a monkey to make my gravy. Now don't get me wrong. It would need to be a very smart monkey, because my gravy is pretty damn good. But I know I'm not the only one in the family who can make it. The family just wanted me to feel needed.

It's a bit like stirring the risotto. Both my brother-in-law Mark Lizotte – you probably know him better as Diesel – and I have been fooled into stirring the risotto for years. Our wives are sisters, and use the same methods to get things done, particularly those jobs no one else wants to do. 'Oh, Mark, can you stir the risotto?' I heard Jep, Jane's sister, say to him one night in a soft, loving voice. 'No one can make it taste like you do.' That sounded so familiar. And Mark, just as I would do, leaped to the stove and began to stir with love and conviction. Only to be told, 'No, don't stir it that way. This is the way I want you do it.'

One night, we were both tied to the stove while our wives and the guests were all enjoying cheese and wine. The girls had worked all day getting everything together. Music was playing and everyone was laughing and dancing, except Mark and me. We were sweating over a steaming, bubbling cauldron of hot food, stirring steadily and struggling to get things finished so we could sit down. That's when Mark and I had a little chat, and came to the conclusion that we were being taken for a ride.

My role in the weekly feast has long been making the gravy.

Nobody wants to stand at the cooker in the kitchen, stirring the pot, while a great party is going on. It really is the worst job. And guess what? Making gravy is much the same. By the time the gravy needs to be prepared, the guests have usually arrived, the wine has been opened and whoever was cooking is well and truly over it. So, if they are really smart, what do they do? Yep, handball that job to some poor unsuspecting fool who doesn't know any better and needs to be liked. Then turn the music up loud so they can't hear him whine. That's where we husbands often end up: tethered to the stove, waiting for our girls to smile at us and tell us how great we are. Pathetic, aren't we?

So now I am officially passing on my secret gravy recipe (page 178), so that I can sit back and watch as one of the younger guys in the family takes over this vital but lonely job. My gravy will work with roast chicken on Sundays or turkey at Christmas. And, with a few little twists, it will work a treat with roast lamb too. It's a gravy for all seasons.

But a word of warning. If you make it too well, you'll paint yourself into a corner, and you could be making gravy for the rest of your life. There are worse fates, though. Because everybody loves the gravy king.

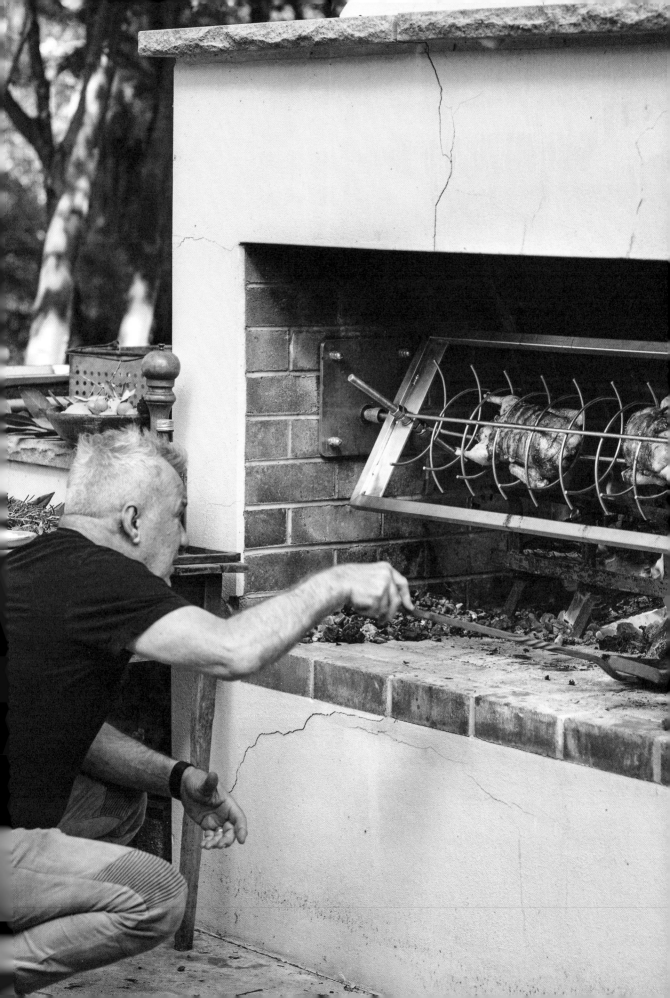

Slow-roasted Greek lamb shoulder with lemon and oregano potatoes

[*SERVES* 12]

Serve this with tzatziki and a traditional Greek salad – you'll feel like you're feasting under olive trees on a Mediterranean island.

2 x 2 kg lamb shoulders (on the bone)
10 garlic cloves, thickly sliced
12 sprigs rosemary
¼ cup freshly squeezed lemon juice
2 tablespoons olive oil
12 sprigs oregano, leaves removed
5 teaspoons sea salt
freshly ground black pepper
2.5 kg kipfler or Dutch cream potatoes

Preheat the oven to 160°C (140°C fan-forced).

Using a sharp knife, cut slits all over the lamb shoulder and fill each with a garlic slice and sprig of rosemary.

Place each lamb shoulder into its own baking dish. Drizzle each with a quarter of the lemon juice and olive oil then sprinkle each with a quarter of the oregano leaves and sea salt. Season with pepper.

Cover the lamb with foil and roast for 1 hour. Remove from the oven, lift the foil and baste all over with the pan juices. Re-cover with foil and place back into the oven for a further hour.

Peel the potatoes and cut into even pieces (about 4 cm). Toss the potatoes in a bowl with the remaining lemon juice, olive oil, oregano and salt.

Remove the lamb from the oven and discard the foil. Baste again and add the potatoes to each baking dish. Put back into the oven for another hour.

Remove from the oven, turn the potatoes and baste the lamb again. Return to the oven for a final 30 minutes.

You'll know the lamb is cooked when the meat easily falls off the bone when prodded with a fork.

POPPY DELEVINGNE

ncy a round of one of Poppy

evingne's favourite ice breakers?

AME GAME

ou need is a packet of Post-its and a marker.

e are a couple of variants, but at its most basic,

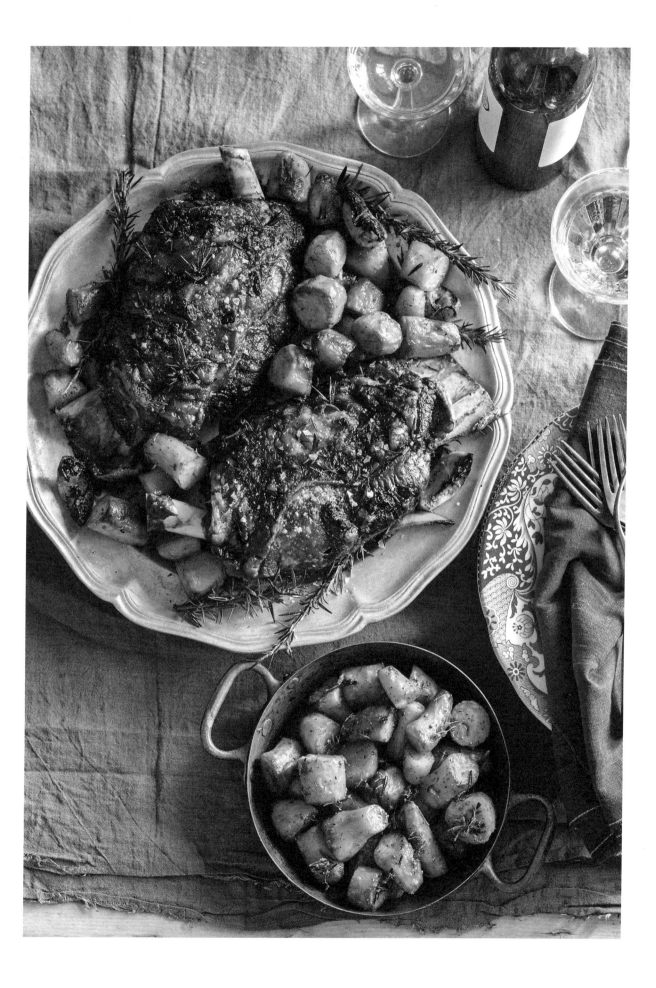

Roast fillet of beef with porcini and wild mushroom jus, roasted eschalots and peas

[*SERVES* 12]

You can't go wrong with this recipe, so don't be afraid of trying it. For the meat, I recommend using the most tender cut of all, the eye fillet.

2 kg beef fillet
2 tablespoons olive oil
sea salt and freshly ground
** black pepper**
30 g butter

MUSHROOM JUS
2 tablespoons olive oil
1 tablespoon butter
2 garlic cloves, smashed
** and sliced**
30 g dried porcini mushrooms,
** soaked in hot water for**
** 30 minutes**
1 beef stock cube
400 g mixed mushrooms
** (king, shiitake, Swiss),**
** cleaned and sliced**
¼ cup red wine

ROASTED ESCHALOTS
10 eschalots, peeled and
** chopped in half**
3 garlic cloves, smashed
¼ cup flat-leaf parsley leaves,
** chopped**
2 tablespoons rosemary
** leaves, finely chopped**
2 tablespoons olive oil
1 tablespoon butter, chopped

Preheat the oven to 180°C (160°C fan-forced).

Rub the beef all over with olive oil and season with salt and pepper. Place a cast iron pan or heavy-based flameproof roasting pan over medium-high heat and add the butter. Once the butter has melted, add the beef and brown all over, until it begins to look delicious.

Transfer the pan to the oven and roast for 15 minutes (for rare). You can check if it's cooked by inserting a meat thermometer. The meat is done once the centre reaches 48°C; it will keep cooking as it rests, so this is the right time and temperature to take it out. If you like your meat closer to medium, cook for 20 minutes.

Meanwhile, to make the roasted eschalots, place the eschalots, garlic and herbs into a small roasting dish. Douse with olive oil, dot with butter and season with salt and pepper. Roast for 10 minutes.

Transfer the beef to a plate and cover with foil. Set aside to rest while you make the jus and cook the peas.

To make the porcini mushroom jus, place the roasting pan over medium heat and add the olive oil, butter and salt. Once the butter has melted, add the garlic and cook for about 5 minutes or until soft. Drain and roughly chop the porcini and add to the pan with the crumbled beef stock cube. Stir to combine. Add the sliced mushrooms and cook for about 5 minutes or until soft. Add the red wine and cook, stirring, for 1 minute to deglaze the pan. Stir in 1½ cups water, bring to a simmer then reduce the heat and cook for a few minutes, until the mixture is reduced and thickened.

PEAS

1 tablespoon olive oil
1 tablespoon butter
1 brown onion, diced
2 cups frozen peas
¾ cup chicken, vegetable
 or beef stock (page 298)

To make the peas, place a frying pan over medium heat. Add the olive oil, butter and a pinch of salt. Add the onion and cook for about 5 minutes, until soft. Add the frozen peas and stir to combine. When the peas turn a brilliant green colour, add the stock and simmer until the liquid is mostly gone.

Slice the beef and serve drizzled with the porcini mushroom jus, with roasted eschalots and peas on the side.

[COOK'S NOTES]

If you don't have a meat thermometer, you can just check the meat's readiness by pressing down on the roast. If it bounces back like the fleshy part of the palm of your hand, it is ready to take out to rest. Allow the meat to rest for the same time as the cooking time. This will stop it bleeding out when you carve it up.

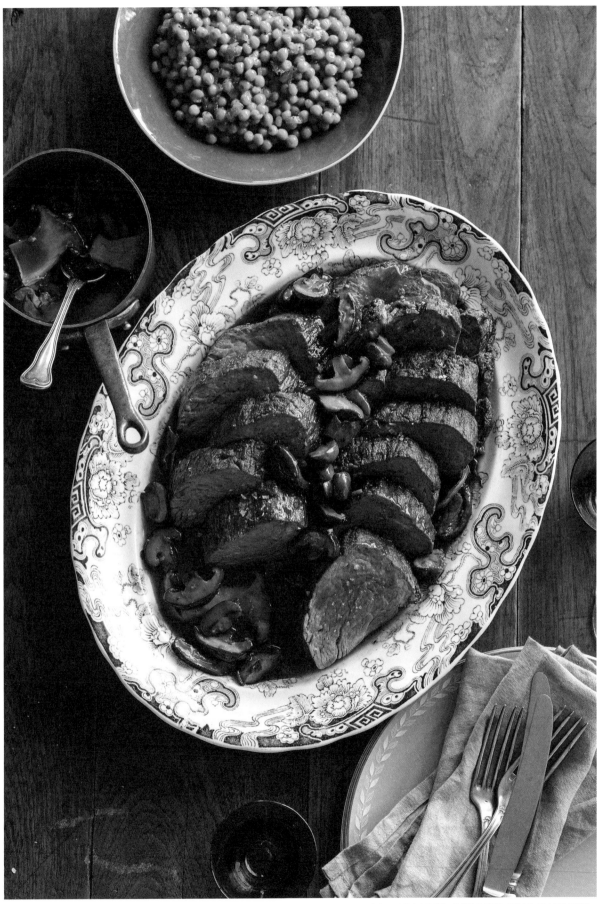

ROAST FILLET OF BEEF WITH PORCINI AND WILD MUSHROOM GRAVY, ROASTED ESCHALOTS AND PEAS, PAGE 170

Perfect roast,
with all the trimmings

I LOVE GROWING DAPHNE IN my garden and its scent always takes me back to my childhood days, to Canberra in the winter and, especially, to Sunday roasts at my Aunty Laurel's house. The Sunday roast was usually an early dinner. Aunty Laurel and Uncle Geoff had two children, our cousins Julie and Tim. Granny and Grandpa would come, too, as well as the five of us: Mum and Dad, my sisters Kaye and Jep, and me. Gathered around the table, we'd share the week's stories and a fine array of delicious food.

Aunty Laurel cooked a perfect roast: the meat, whether it was lamb, beef, chicken or pork, was always succulent. Usually, it was accompanied by baked root vegetables, such as pumpkin, swedes, carrots, parsnips and potatoes, all crisped to perfection, and, sometimes, peas, beans or Brussels sprouts served with a sauce poured from a gravy boat with a delicate silver ladle.

As for the desserts, ooh … I tasted my first pavlova there, a large circular meringue covered with a bed of luscious whipped cream, into which sank wedges of strawberries and banana rounds, topped with scoops of passionfruit that dripped down the meringue crust. At other times, we'd have just a simple bowl of peaches and ice-cream, with perhaps some extra richness in the form of fresh cream poured from a small floral jug. Jelly was always a favourite, and we all hoped quietly for the red jelly. And who could not look forward to Aunty's humble apple pie – with its perfect short-crust pastry, sprinkled with sugar crystals and concealing steaming stewed Granny Smiths spiced with cinnamon and cloves – crowned with the king of toppings, runny custard?

Aunty Laurel's table was always immaculately laid: a crisp white tablecloth with embroidered edges; a small bunch of garden flowers, freshly picked and arranged in a crystal vase at the centre of the table; polished silver forks and knives with bone handles, carefully positioned in their correct order; and small serviettes that matched the tablecloth, folded neatly and placed to the left of each setting. It was around this beautiful table, with this amazing family, that I learned my first English sentences, including how to say grace and give thanks, and what it meant to grow up Australian. And, at the end of every meal, I always marvelled that, somehow, every dish, utensil and pot would be washed up and tidied away before any of us had been allowed to leave the table.

Roast saltbush chicken with root vegetables

[*SERVES 6*]

Saltbush is an Australian native plant. You'll find dried saltbush in packets where good dried herbs or Aussie 'bush tucker' ingredients are sold. It's easy to find suppliers online. We grow it ourselves, so you could too!

1 large chicken, brined
(page 305)
2 tablespoons olive oil, plus
extra for cooking
1 tablespoon crushed dried
saltbush
½ teaspoon chopped fresh
rosemary
1 garlic clove, crushed
sea salt and freshly ground
black pepper
75 g butter, sliced
3 garlic cloves, skin on,
smashed
2 brown onions, chopped
3 small carrots, halved
3 small parsnips, halved
Jimmy's gravy (page 178)

Preheat the oven to 220°C (200°C fan-forced).

Remove the chicken from the brine and use paper towel to pat completely dry. Using your fingers, gently separate the skin from the breasts and legs and insert the butter slices.

Rub all over with the olive oil, saltbush, rosemary and crushed garlic. Season with salt.

Put the smashed garlic inside the cavity.

Scatter the onions, carrots and parsnips over the base of a flameproof roasting pan. Drizzle with olive oil and season with salt and pepper. Place the chicken on a roasting rack over the vegetables.

Roast for 15–20 minutes, until the skin begins to turn golden, then turn the oven down to 180°C (160°C fan-forced) and roast for a further 50 minutes.

Once cooked – you'll know if you insert a knife into the breast and the juices run clear – remove from the roasting pan and set aside to rest for 10 minutes before carving.

Meanwhile, transfer the veggies to a warmed serving dish and cover with foil. Use the roasting pan to make Jimmy's gravy.

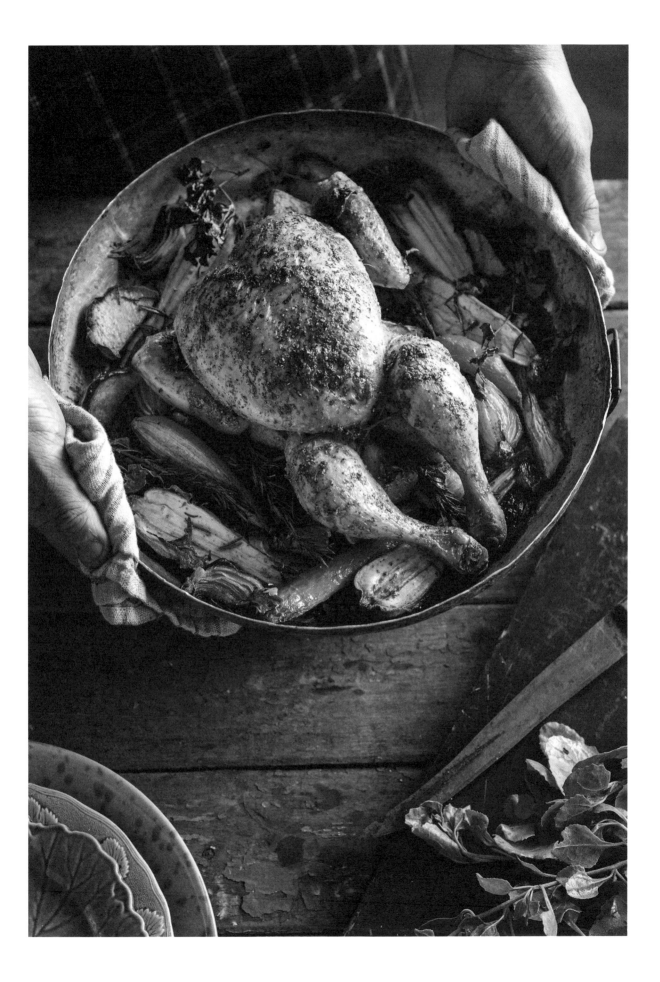

Jimmy's gravy

[*MAKES 2–3 CUPS*]

Jimmy is the gravy king in this family. This is how he makes gravy for our big family roasts. There is no roast without gravy!

½ cup plain flour
2–3 cups homemade or
 good-quality chicken,
 vegetable or beef stock
 (page 298)
Maggi seasoning sauce,
 to taste
1 teaspoon soy sauce
sea salt and white pepper
Worcestershire sauce
 (see Cook's Notes)
knob of butter

After cooking, remove the meat from the roasting pan and set aside to rest.

Place the pan on the stovetop over medium-high heat. The 'makings' – the sticky cooked goodies left on the pan – are the basis of a great gravy.

Scatter the flour over the makings, and use a whisk or wooden spoon to mix well. Don't worry about lumps, as they will disappear as you cook (worst-case scenario, you can strain them off at the end).

Let the flour cook for a few minutes. This stops the gravy being too 'floury' in flavour. Gradually add the stock, ½ cup at a time, stirring into the flour mixture until well combined before adding more. Repeat until all the stock is used.

Generously sprinkle with Maggi seasoning sauce. Add soy sauce for colour and taste, and check you if need any salt.

Season with white pepper and add a small knob of butter to make it shine. (If necessary, strain at this point to get rid of any lumps.)

[COOK'S NOTES]

If you're making a gravy for roast beef or lamb, you can add a dash of Worcestershire sauce, as that gives it a tiny bite that suits red meat. We leave it out of gravy for chicken and pork.

Jus

Jus is sauce made from the juices of meat that has been roasted. It is a thin, French-style gravy, as opposed to gravy that is thickened with flour.

For a roast beef jus, for instance, we add wine to the 'makings' left in the tray after you remove the meat.

Cook off the alcohol and deglaze by scraping off all the best bits sticking to the bottom of the tray. Let the mixture bubble for a couple of minutes. Add a crumbled stock cube and 1–2 cups of stock or water. Cook until reduced by half, and season with freshly ground black pepper.

Zuppa di pesce (seafood soup)

[*SERVES 6–8*]

This is such a lush dish and for seafood lovers it's very hard to beat. The fun starts with an early-morning trip to the fish market to pick out the best catches of the day. If you establish a good relationship with a passionate fishmonger, they will happily point you in the right direction. I love going to the fish markets with Jimmy: I can always tell he's wishing he'd caught everything that's on display!

2 x 800 g lobsters, boiled and cut in half lengthways

10 scampi, cut in half lengthways

500 g scallop meat

2 tablespoons olive oil

1 brown onion, chopped

2 garlic cloves, crushed

400 g can peeled tomatoes

400 g can tomato polpa (Italian crushed tomatoes)

2 cups shellfish stock (page 299)

500 g ling fillet, chopped

500 g blue-eye trevalla fillet, chopped

500 g clams or pippies

1 kg large mussels

1 cup white wine

baguette, extra virgin olive oil, butter, to serve

confit garlic (page 295), to serve

chopped parsley, to serve

Pull the meat from the lobsters and tear into chunks. Save the heads and shells to make the shellfish stock.

If there is a barbecue or hibachi helper handy, it's a luxury to quickly chargrill the scampi halves (alternatively, use a smoking-hot chargrill pan on the stove). Brush them with a little olive oil so they don't stick to the mesh. Place the scampi flesh-side down over the hot charcoal and cook for 1 minute on each side, until the flesh is just browned. Set aside. Cook the scallops the same way – just sear for no more than 1 minute on each side. Set aside.

Heat the olive oil in a large shallow saucepan over medium heat. Add the onion and cook until soft, then stir in the garlic and cook for a minute. Stir in the peeled tomatoes and bring to the boil. Give a good stir to combine the juices, then stir in the tomato polpa. Let it all bubble away gently for 10 minutes, then add the shellfish stock and bring to a simmer.

Add the fish and clams, then add the rest of the seafood that you prepared earlier and the mussels. Let the soup heat up to the boil again and splash in the wine. Cover the saucepan with a lid and cook until the shells start to open. It will only take a couple of minutes, so be vigilant, making sure not to overcook. I turn off the heat as soon as the shells pop open.

Meanwhile, slice the baguette and toast. Brush with olive oil, butter and confit garlic, and pop in the oven or under the grill for a minute. Frying the bread is naughty but delicious too.

Transfer the zuppa to a large serving dish and sprinkle with chopped parsley. Grind black pepper over and serve with the toast.

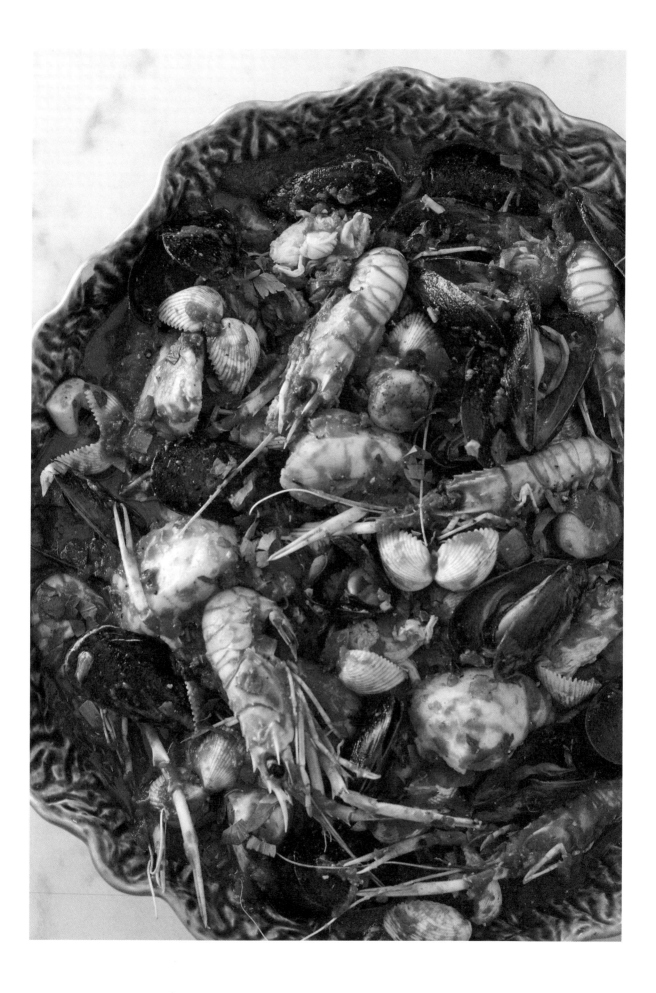

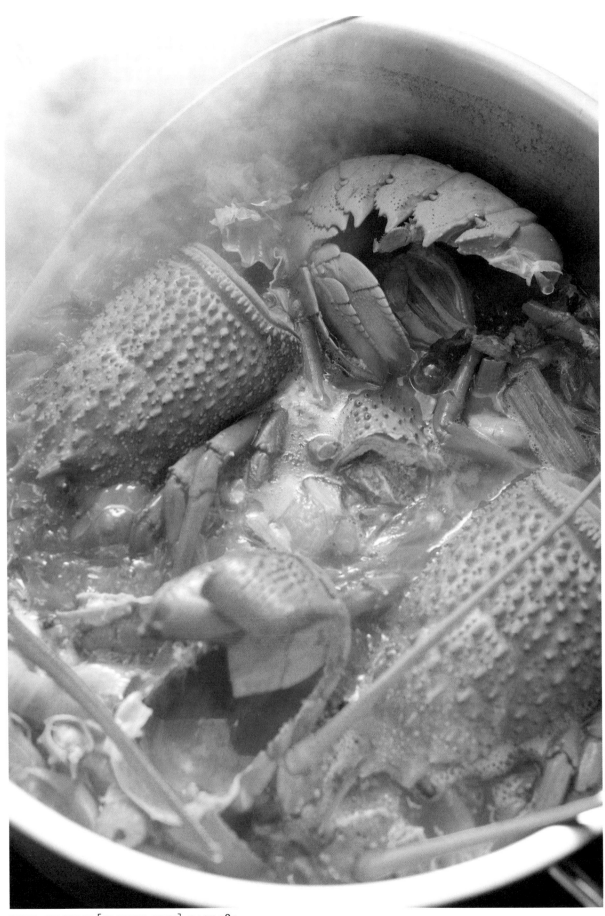

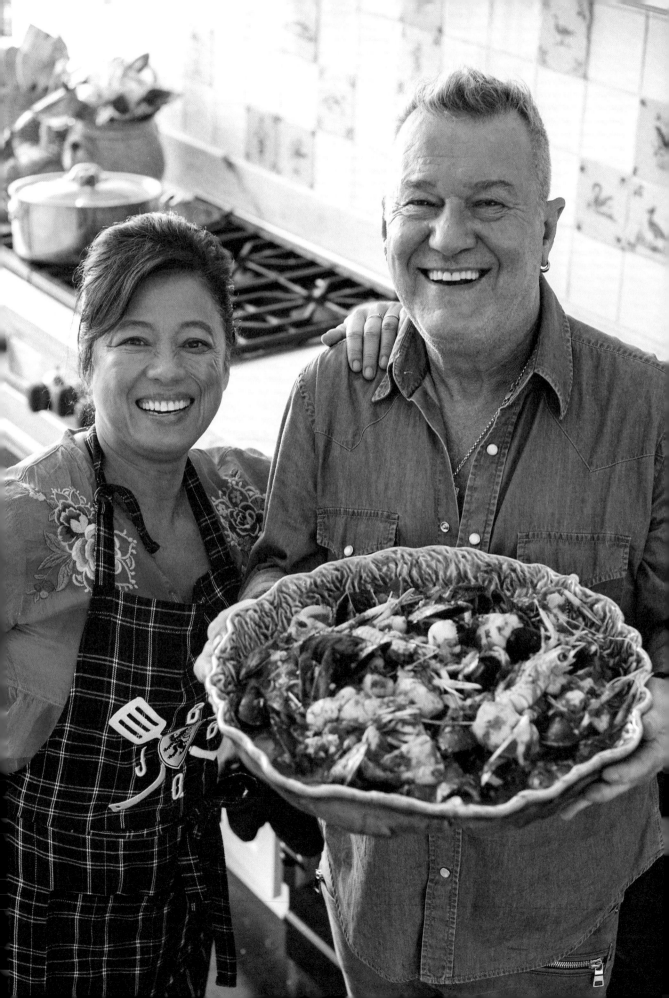

Osso buco

[*SERVES* 8]

A hearty, easy, comforting winter favourite. A lot of recipes for this Italian classic require you to coat the veal shanks with seasoned flour and fry them before adding them to the sauce. But my version is much simpler: I just dust the shanks and put them straight into the sauce.

1 tablespoon olive oil

20 g butter

2 brown onions, thickly sliced

2 garlic cloves, smashed and chopped

2 carrots, coarsely chopped

2 celery stalks, sliced

2 tomatoes, cut into wedges

sea salt and freshly ground black pepper

3 bay leaves

8 pieces osso buco (veal shank)

plain flour, for dusting

1 beef stock cube

½ cup dry white wine

400 g can whole peeled tomatoes

fresh thyme and chopped parsley

mashed potato, to serve

Heat the olive oil and butter in a large heavy-based pan over medium heat.

Add the onion and cook for about 5 minutes, until soft. Stir in the garlic and cook for a minute, then add the carrot, celery and tomatoes. Season with salt and pepper and add the bay leaves.

Cook for about 15 minutes, stirring often, until soft and golden.

Meanwhile, spread flour onto a plate and season with salt and pepper. Dust the veal with flour and shake off the excess.

Crumble the stock cube into the sauce, add the wine and canned tomatoes and mix well. Then add the veal and move around to cover with the liquid.

Cover the pan and reduce heat to low. Cook for 2 hours, checking and moving every 20 minutes or so, to make sure that nothing is sticking or burning on the bottom of the pan. Sprinkle with fresh thyme and parsley at the end of cooking.

Serve with creamy mashed potato.

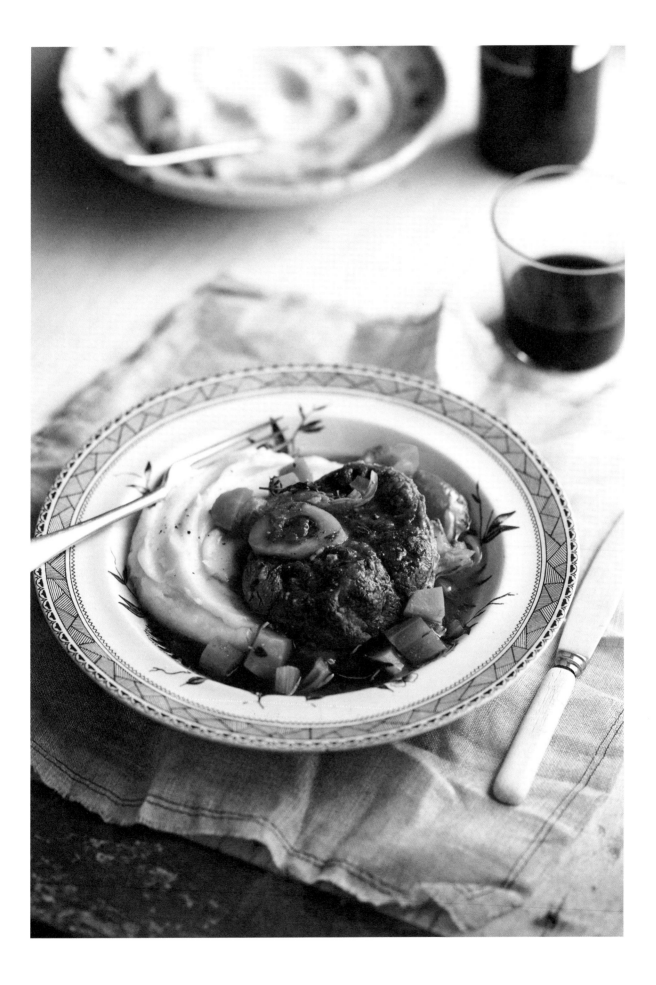

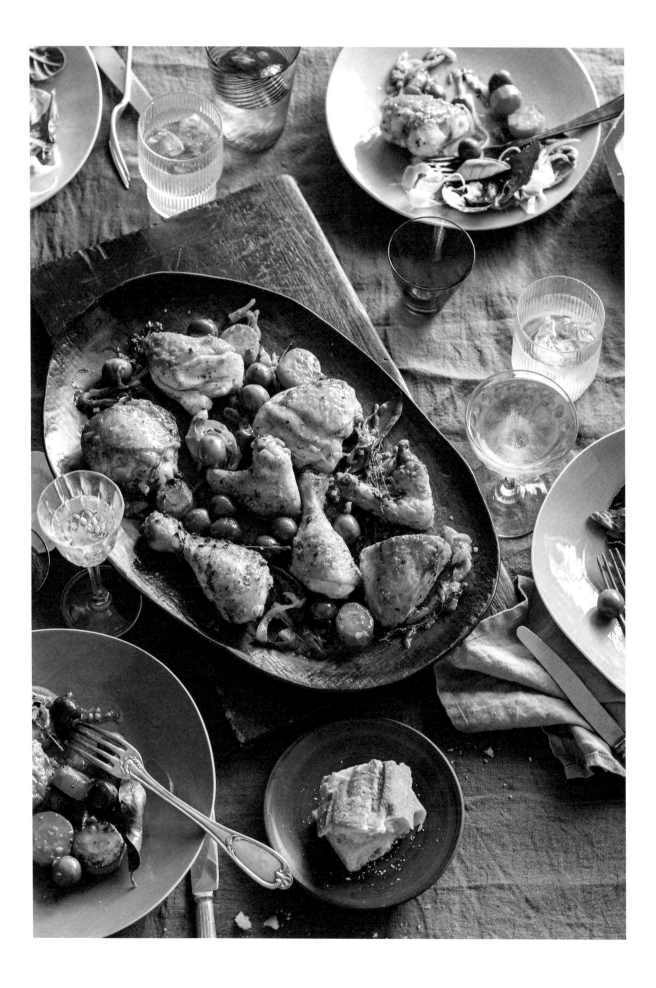

Champagne chicken

[*SERVES 6*]

We created this recipe when we came home one night from touring and found we didn't have any wine to make coq au vin. We did, however, have a bottle of bubbly and a tub of olives in the fridge. It was one of those fortuitous accidents that led to discovery and what, for us, has become a much-loved regular chicken dinner.

1 chicken, cut into 8 pieces, brined (page 305)
2 tablespoons olive oil, plus more for the roasting pan
80 g butter, chopped
1 brown onion, sliced
4 garlic cloves, smashed and chopped
4 glasses champagne (and one to drink, if you like)
sea salt and freshly ground black pepper
3 bay leaves
small handful thyme sprigs
2 carrots, thickly sliced
small tub green Sicilian olives
salad, to serve

Preheat the oven to 200°C (180°C fan-forced).

Remove the chicken from the brine and use paper towel to pat completely dry.

Heat the olive oil and butter in a large heavy-based frying pan over medium-high heat. Cook the chicken in batches, skin side down, for 5 minutes or until golden brown. Turn over and cook the other side for 3 minutes. Set chicken aside.

Reduce the heat to medium. Add the onion and cook for 5 minutes, until soft. Add the garlic and cook for another minute. Add a glass of champagne to deglaze the bottom of the pan, stirring and scraping to combine with the stuck-on bits and pan juices.

Drizzle a large baking dish with oil and sprinkle with salt. Arrange the chicken pieces in the dish, skin side up. Scatter with bay leaves and thyme, and season with pepper. Pour in the liquid from the frying pan and the remaining champagne, and scatter with the carrots and olives.

Bake for 30 minutes, until the chicken is cooked through and the carrots are tender. Serve with salad.

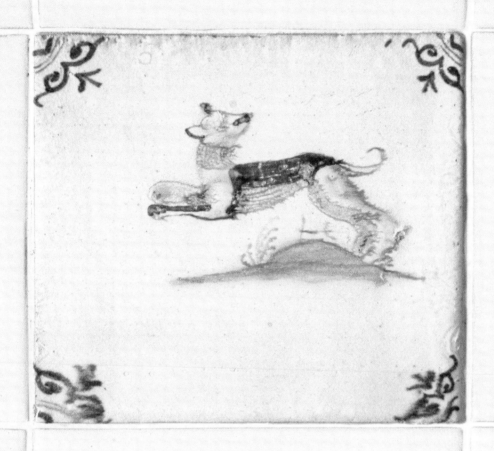

Potatoes,
Spuds & Tatties

POTATOES. PATATE. KARTÖFLUR. SPUDS.
Prátai. Tatties. Pommes de terre. Kartoffeln.
Mun farang. Call them whatever you like,
but for a Scotsman like me, they are a gift
from God.

You see, Scots love potatoes. We like them
boiled, fried, steamed, baked, sautéed, grilled,
even microwaved. We love how you can mash
them, toss them in butter, roll them in oil,
sprinkle them with rosemary and salt, and
cook them on the barbecue. How you can
serve them hot or serve them cold. As a side
or as a main. You can put them in a sandwich,
and I've even heard of people juicing them,
although that did sound a bit much, even for
me. If you really wanted to, you could scoop
them out and feed us just the skins. We Scots
will eat them however they are served to us.

> We Scots will eat potatoes
> however they are served to us.

As a young boy, I would have starved to death
if it wasn't for the humble, lifesaving potato.
Even the worst cook can put potatoes into a
pot of boiling water and turn out something
edible. But potatoes cooked perfectly are truly
a thing to savour. The simple potato can be
transformed into not just a mere side dish but
the absolute star of any plate of food. And it's
not only Scots who think that these days.

The other night, we were sitting at dinner
and Jane announced, 'I think potatoes are
the best vegetable of all time. In fact, one
of the best things to eat ever. I know I could
live without a lot of things ...' I could have
sworn she threw a quick glimpse my way,
but then I thought maybe I was just being
paranoid. I watched and listened even more
closely as she smiled lovingly at me and

continued. 'I could live without pumpkin or
peas or even corn, if I had to. I could even
live without ...' She paused for a second, took
a deep breath and looked up. 'I might ... I
might even be able to live without rice –
there, I've said it! – but *not* without potatoes.'

I too then looked up, expecting the heavens
to open and Jane to be struck down by an
angry god. But nothing happened. I would
have thought that, for a Thai girl, rice would
have been top of the heap, the big one,
numero uno in the Food Top Ten. But it
appeared I was wrong.

I would like to take all the credit for
converting Jane to being an avid potato
lover. But I know she was enjoying them
long before she met me. She has eaten
potatoes prepared by the best cooks in the
world – sautéed French potatoes, oven-
roasted Italian potatoes, even Thai potatoes
in curry – and she has learned from them all.
In fact, I think Jane has completely mastered
the art of cooking potatoes. Although of
course – spoiler alert! – I am her biggest fan.

Quite often when we have guests around,
I hear them asking, usually just before
dinner, why Jane has prepared so many
potatoes. Only to see them, minutes later,
hungrily filling their plates with perfectly
cooked, golden, crunchy-on-the-outside,
soft-and-fluffy-in-the-middle roast potatoes.
She also makes the best mash – smooth and
creamy. And potatoes baked with chestnuts,
full of deep, rich flavours. In fact, name
any potato dish you like, and Jane will have
perfected it.

> Jane has completely mastered
> the art of cooking potatoes.

I've learned a lot of Jane's best potato recipes by heart, and some nights I get to cook them for our friends. If I, even for a minute, try to take the glory, they will be quick to correct me. You see, they know – and I know – where I learned to make such delicious spuds.

This book contains some closely guarded family secrets that will help you master the art of the perfect potato. Try them out in your own kitchen and you'll be a smash hit at the dining table. But don't be afraid to add your own touches: a pinch of this, a dash of that. The world needs more potato recipes. So spread the word!

Be warned, though: you'll never be the same again. For a start – and we take no blame for this – you may have a little trouble fitting into your clothes. But, hey, what's a few kilos between friends? So eat up and lash out – you can always buy a new wardrobe. It'll be worth it, right? After all, aren't we all getting older and wider?

Cheesy creamy mixed potato mash

[*SERVES 4–6*]

The addition of the sweet potato to this recipe makes a simple mash just that little bit different. Cheese lovers will be happy too! I serve these potatoes with all sorts of recipes and use a similar mash to top my cottage pie.

1 sweet potato (kumara)
4 desiree potatoes
sea salt and freshly ground
 black pepper
1 cup grated cheese
 (cheddar is great,
 but I love Comté)
60 g unsalted butter
¼ cup cream
¼ cup warm milk

Peel the potatoes and cut into even-sized pieces. Place into a saucepan, cover with water and season with salt.

Bring to the boil and cook for about 15 minutes or until the potatoes are soft enough to push a fork through.

Drain well and return the potatoes to the pot. Add the cheese, butter, cream and milk. Mash until all the lumps are gone. Season with salt and pepper to taste.

[COOK'S NOTES]

I find the desiree potato a good all-purpose spud for mashing, roasting and frying. But Dutch creams, kipflers and Tasmanian pink eyes are my favourites for roasting.

CLOCKWISE FROM TOP: CREAMY POTATO BAKE WITH CHESTNUTS, ROSEMARY AND GARLIC, PAGE 198;
CHEESY CREAMY MIXED POTATO MASH; POTATOES BAKED WITH TOMATOES, ESCHALOTS AND SAFFRON, PAGE 199

Creamy potato bake with chestnuts, rosemary and garlic

[*SERVES* 8]

Look for cooked chestnuts at good delis or speciality shops. They are usually vacuum packed.

2.5 kg desiree or Dutch cream potatoes, peeled and thickly sliced

200 g cooked chestnuts, sliced

3 garlic cloves, smashed and sliced

6 sprigs rosemary, leaves only

sea salt and freshly ground black pepper

500 ml pouring cream

50 g unsalted butter, sliced

Preheat the oven to 200°C (180°C fan-forced).

Layer the potato slices in a 5 cm deep, 2.8 litre ovenproof dish, adding chestnuts, rosemary and garlic, and seasoning with salt and pepper between each layer.

Pour the cream over and scatter sliced butter over the top. Cover the dish tightly with foil and bake for 40 minutes.

Remove the foil and bake for a further 10 minutes or until the top is golden and crunchy.

[COOK'S NOTES]

If your potatoes start sprouting eyes, cut them off and plant them in the garden (cut side down). You'll be pleasantly surprised when you later dig them up.

Potatoes baked with tomatoes, eschalots and saffron

[*SERVES 4–6*]

Desiree potatoes are great for this dish. Any type of tomato will work – cherry, roma, heirloom, ox heart – just ask your grocer which are best at the time. I add the saffron to make it a bit fancy.

4 desiree potatoes, washed and quartered

1 litre homemade or good-quality purchased chicken or vegetable stock (page 298)

500 g tomatoes, quartered (or halved if you're using cherry tomatoes)

4 eschalots, roughly chopped

4 garlic cloves, smashed

2 tablespoons olive oil

1 tablespoon butter

3 strands saffron

sea salt and freshly ground black pepper

Preheat the oven to 200°C (180°C fan-forced).

Par-boil the potatoes in a saucepan of simmering stock for 8–10 minutes. They should still feel firm when pierced with a fork.

Drain the potatoes and place into a large mixing bowl. Add the tomatoes, eschalots, garlic, oil, butter and saffron. Toss to combine and season with salt and pepper.

Transfer to a shallow ovenproof dish and bake for 20 minutes, or until the potatoes are golden with charred edges.

A new outlook

ONE OF THE THINGS THAT most astonished me when I first moved to Canberra, and later attended boarding school there, was instant mashed potatoes: somehow, they miraculously manifested following the simple addition of a cup of hot water to the powdery contents of a cardboard box. Those were also the days of powdered eggs and tinned spaghetti, another two foods – if you could call them that – I had never encountered elsewhere.

In 1976, I was accepted for tertiary studies at the Australian National University (ANU), and it was time to leave my parents' latest home in Papua New Guinea. Suddenly, there were no more family cooks or restaurant outings paid for by my generous and worldly parents, no more five-star buffets at the Sports Club or hotel room service. Once again, I was back in the suburbs of Canberra – this time in my own apartment, with my own little kitchen – and back in a culinary no-man's land. Australia's gastronomic offerings were then somewhat dispiriting: sausage rolls and meat pies, or fish and chips with greasy potato scallops. Even the more upmarket fare in those days included tired standards, such as oyster Kilpatrick, lobster mornay, steak Diane, chicken Kiev, veal bananas, sweet-and-sour pork, and tuna vol au vents, usually preceded by prawn cocktail, accompanied by garlic bread and followed with chocolate mousse or bombe Alaska.

Fortunately, things improved through the 1970s. Specialist delis sprang up that offered cold meats other than Devon, Berliner and Danish salami. 'Oriental' sauces began appearing on shop shelves, including fish sauce, oyster sauce, soy sauce and sweet chilli. Parmesan cheese was still largely of that yellow, powdery, ready-grated and ready-packaged variety that, when opened, jolted your head back with its disgusting reek, but you could find the odd wedge of real Parmigiana if you knew where to look. First cold-pressed olive oil became available in small quantities, though initially for medicinal purposes – you could get it at pharmacies before it was sold in delis.

Most of all, as a young woman cooking for herself for the first time, I was thankful for Margaret Fulton. In 1968, she had released *The Margaret Fulton Cookbook*, which became hugely popular throughout the 1970s and was the spark that ignited the fire of the modern Australian foodie scene. She even wrote and promoted authentic Italian and Chinese recipes, which were among the first to appear in Australia. It's no exaggeration to say that her cookbooks and advice columns changed the way our generation looked at food.

Roast potatoes with garlic and rosemary

Rarely a week passes without at least a tray of these crunchy Tuscan-style potatoes coming out of our oven. The smell of them cooking takes me right back to the cobbled streets of Siena. Rosemary grows abundantly in several of our garden beds, and it's a good companion plant for cabbage, beans, broccoli and sage, as it helps to draw insect pests away and allow the other plants to thrive.

1.5 kg desiree potatoes, peeled and cut to similar size
¼ cup olive oil
sea salt
1 bunch rosemary, leaves removed from stalks
8 cloves garlic, peeled and smashed

Preheat the oven to 200°C (180°C fan-forced).

Par-boil the potatoes in a large saucepan of water for 8–10 minutes. They should still feel firm when pierced with a fork. Drain well.

Heat the olive oil and a good pinch of salt in a roasting pan. Add the potatoes and turn to coat in the oil. Roast for 20 minutes. Remove from the oven, add the rosemary and garlic and turn the potatoes. Add a splash more olive oil, if needed.

Return to the oven for a further 20 minutes or until golden brown and crispy. Season with salt to taste.

CLOCKWISE FROM TOP: ROAST POTATOES WITH GARLIC AND ROSEMARY; FANCY POTATO SALAD, PAGE 207;
NEW POTATOES BOILED IN STOCK WITH BAY LEAVES AND PEPPERCORNS, PAGE 206

New potatoes boiled in stock with bay leaves and peppercorns

[SERVES 6]

Different varieties of new potatoes are appearing on the market all the time: purply black, brown, white, creamy yellow and red ones. I love the look of them boiled up and all mixed together. They say to eat as many colours as you can, so here's a chance to add some more.

1 kg baby potatoes,
 washed well
1.5 litres chicken or
 vegetable stock
 (page 298)
10 black peppercorns
2 bay leaves
1 teaspoon sea salt
butter, to taste
sea salt and freshly ground
 black pepper
handful of chopped fresh
 herbs

Place the potatoes in a large saucepan. Fill with enough stock to cover the potatoes by about 3 cm. Add the peppercorns, bay leaves and salt.

Bring to the boil over medium-high heat. Boil for 15–20 minutes or until you can easily push a fork through the flesh.

Drain the potatoes, remove the bay leaves and transfer the potatoes to a serving bowl. Add the butter, season with salt and pepper, and stir in the chopped herbs.

[COOK'S NOTES]

For the herbs, I like to use rosemary, parsley, oregano or thyme. Even lavender works if you're feeling adventurous!

Fancy potato salad

Who doesn't love a potato salad? It's a favourite, especially in the summer, and so substantial it's almost a meal on its own. It's also great paired with anything from the barbie. You can use all one colour of potato, but I like to use two just for the look of them.

1 kg white and red baby
 potatoes
sea salt and freshly ground
 black pepper
2 free-range eggs
1 tablespoon olive oil
3 eschalots, peeled and
 finely sliced
2 stalks celery, diced
1 carrot, diced and
 par-boiled
1 cup fresh or frozen peas,
 steamed and cooled
¾ cup bread and butter
 cucumber pickles,
 chopped
4 slices ham or cooked
 bacon, chopped
 (optional)
¼ cup extra virgin olive oil
1 tablespoon wholegrain
 mustard
1½ cups Kewpie
 mayonnaise
½ cup flat-leaf parsley,
 finely chopped

Cook the potatoes in a large pan of salted boiling water (or stock) for 20 minutes or until tender. Drain and leave to cool.

Meanwhile, put the eggs into a small saucepan. Cover with cold water, add a pinch of salt and bring to the boil. Cook for 15 minutes. Drain and rinse under cold water to cool. Peel, chop and set aside.

Heat the olive oil in a frying pan over medium heat and sprinkle with a pinch of salt. Add the eschalots and cook for about 5 minutes, until soft and turning golden. Remove from pan and cool.

Halve the potatoes and place into a large bowl with the celery, carrot, peas, pickles, eschalots and ham or bacon (if using).

Combine the olive oil and mustard and add to the salad. Stir in the mayonnaise. Gently fold through the egg so it doesn't crumble too much. Season with salt and pepper to taste, and sprinkle with chopped parsley to serve.

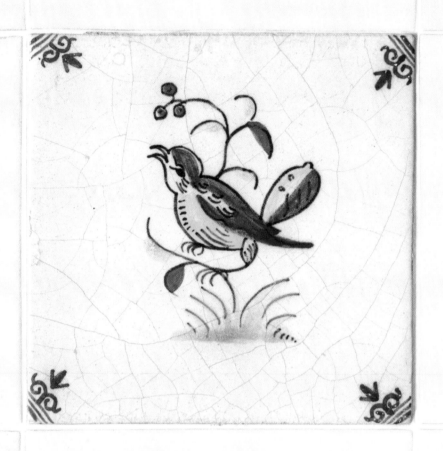

Vegetable
Sides

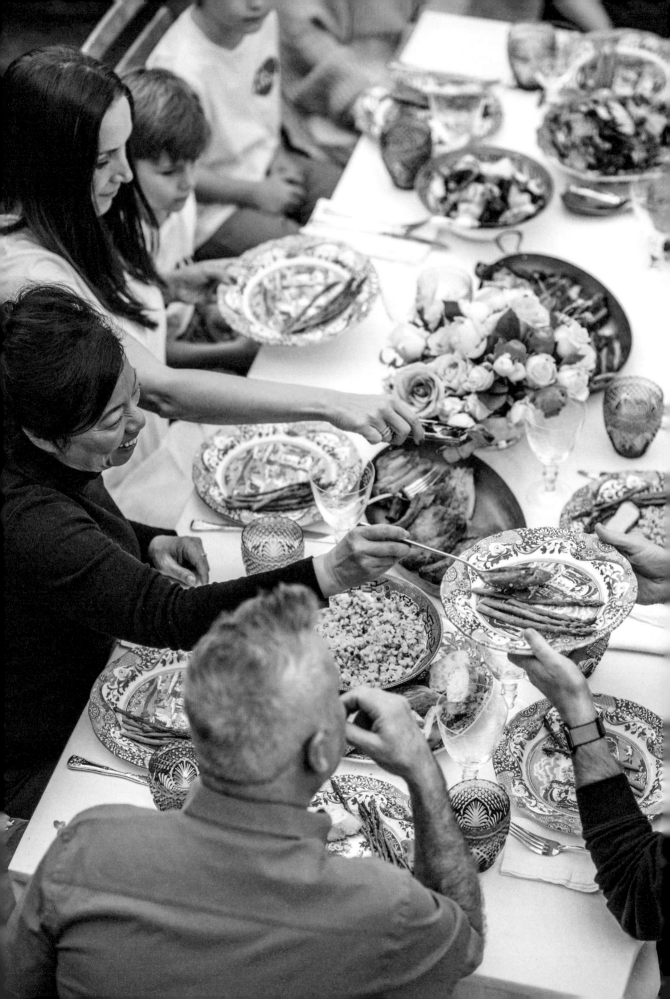

IT'S NOT GREAT PLAYING SECOND fiddle to anyone, and I can't help feeling that veggie side dishes are like the backing band behind a singer: working hard to bring out the best of whoever is out front, but always stuck in the shadows and almost never in the spotlight. Yet, as any good singer will tell you, you're only as good as the band you play with, and some stars are lost without their back-up. Think of it this way: what good would the Lone Ranger be without Tonto? Batman without Robin? Laurel without Hardy? Sonny without Cher? Okay, maybe I'm going a bit too far with the comparison now, but you get the idea. Some things just seem to work better with a bit of help, and that includes foods. You know, fish and chips, pie with peas, sausages and mash. And so on.

Vegetables don't have to be served with meat or fish to become a meal.

The side dish is just as important as the main course, I think. The humble lamb chop, for example, is elevated to something special with the addition of fresh peas and carrots cooked with butter and brown sugar. A simple roast chicken becomes a delight with a creamy mash and a splash of gravy. A piece of fish rises to new heights when served with fennel baked in cheese sauce.

Vegetables don't even have to be served with meat or fish to become a meal. In the South of France, my friends quite often sit down to a plate of cauliflower gratin served with a crunchy baguette and a glass of wine. It's simple but perfect. Jane makes vegetable pies that are wholesome and delicious, such as spinach and warrigal greens mixed with wild nettles baked in pastry with feta cheese, pine nuts and herbs – absolutely outstanding.

Minestrone soup sprinkled with freshly grated parmesan cheese warms the soul on a cold winter's day. Cabbage stir-fried with oyster sauce and served with a bowl of rice can be a totally satisfying lunch. In the right hands, vegetables can be the king of any table.

In the right hands, vegetables can be the king of any table.

Salads are often side dishes, but they too can be the headliner. A simple lettuce and tomato salad with a dressing of olive oil, vinegar, salt and pepper can steal the spotlight from almost any bowl of pasta. Roasted vegetables tossed with lettuce, olive oil and sweet balsamic vinegar are absolutely delicious. A salad Niçoise with fresh bread and a glass of sparkling water is a perfect light lunch, always hitting the spot. And a Greek salad made with lettuce, tomato, feta and sweet onions and served with a roast shoulder of lamb is one of the best things in the world to eat, at any time, but especially if you are sitting under a tree somewhere by the sea.

So, use your imagination. Go wild. Side dishes are taking over the table.

Burnt cauliflower, caramelised onions and shiitake mushrooms

[*SERVES 6*]

Cooking Vegetables, Rule #1: Please. Do. Not. Over. Cook. Cauliflower is no exception; the trick is to get it to caramelise and have an almost burnt look at the edges of the florets, without them turning to mush and falling apart.

This dish is just as good served at room temperature as it is served warm.

1 tablespoon butter
2 tablespoons olive oil
sea salt and freshly ground
 black pepper
1 small to medium
 cauliflower, cut into
 bite-sized pieces
1 brown onion, sliced
8 shiitake mushrooms,
 stalk ends removed,
 sliced
2 garlic cloves, finely
 chopped
¼ cup shoyu (Japanese
 soy sauce)
2 teaspoons mixed black
 and white sesame seeds
coriander leaves, to garnish

Melt the butter with half the olive oil and a pinch of salt in a frying pan over medium-high heat. Add the cauliflower, covering the whole base of the pan, and cook until dark brown (almost burnt). Turn and cook until dark brown on all sides. Remove from the pan and set aside.

Add the remaining oil to the pan, add the onion and cook for 8–10 minutes, until soft, brown and caramelised. Return the cauliflower to the pan and add the shiitake mushrooms, garlic and shoyu. Stir to combine and cook for a further 3 minutes. Season with pepper, mix well and scoop into a serving dish.

Garnish with sesame seeds and coriander to serve.

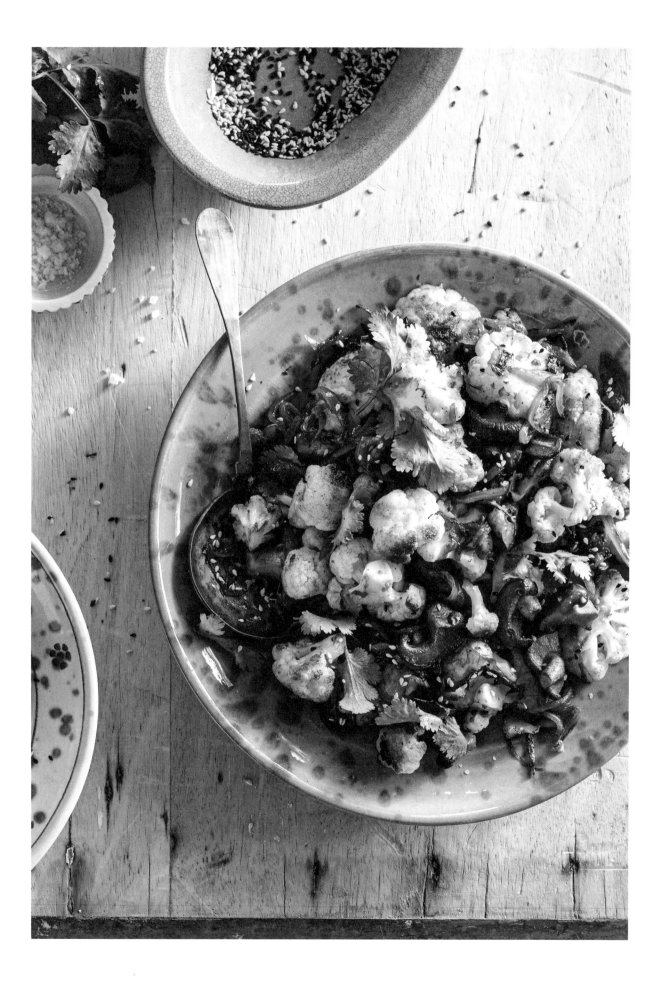

Caramelised Brussels sprouts with bacon

[*SERVES 6*]

In our house, Brussels sprouts don't have their usual poor reputation. We love them – especially when they're cooked in lots of butter. The bacon adds a fantastic smoky flavour too, though you can use speck if you prefer a stronger, even smokier taste.

2 tablespoons unsalted
 butter
500 g Brussels sprouts,
 trimmed and cut in half
4 rashers streaky bacon,
 chopped
sea salt, to serve

Melt the butter in a large heavy-based frying pan over medium-high heat. Add the Brussels sprouts and cook for about 5 minutes, until browned on both sides. Remove from the pan and set aside.

Add the bacon to the pan and fry until crispy. Return the Brussels sprouts to the pan and toss to combine. Serve with a sprinkle of sea salt.

[COOK'S NOTES]

To make the Brussels sprouts a brighter green colour, soak them in cold water with 1 teaspoon bicarbonate of soda before cooking.

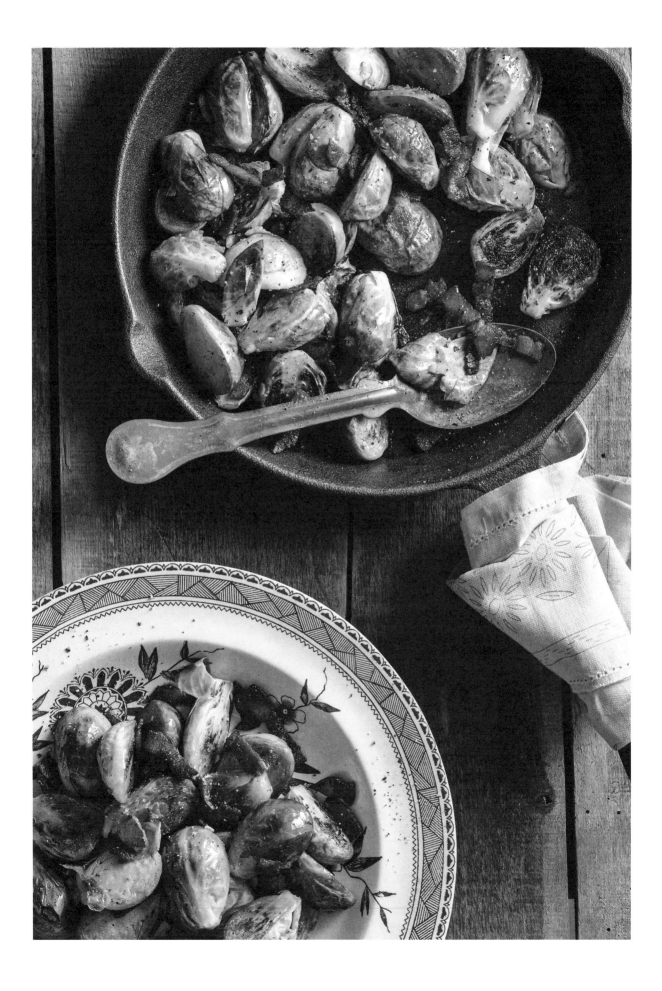

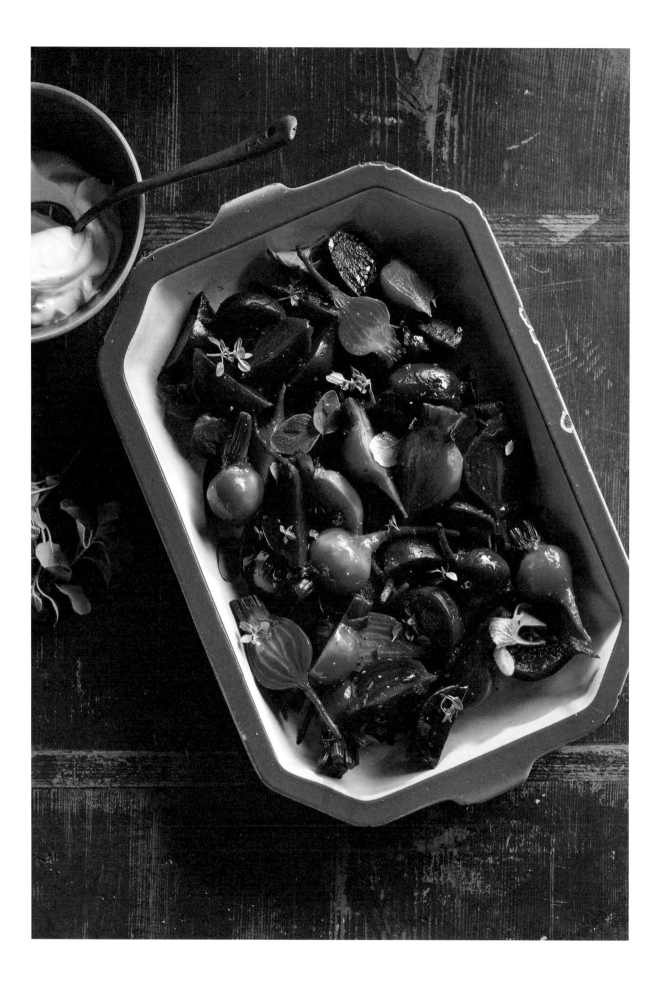

Homegrown organic beetroot

[*SERVES 6–8*]

We grow our own beetroot in our humble little veggie patch. Although it's great to be able to get a variety of fresh beetroots in supermarkets and health food stores, our organic homegrown ones are the sweetest and most delicious I've ever tasted. This recipe is so easy. It's fresh, simple and full of flavour too.

750 g small beetroot
sea salt and freshly ground
 black pepper
fresh thyme and oregano
 leaves
yoghurt or sour cream,
 to serve
extra virgin olive oil,
 as needed

Pick the beetroot from your garden (or off the shelf at your favourite greengrocer). Trim the tops and roots and wash well, leaving the skin on.

Put into a pot and cover with cold salted water. Bring to the boil and cook for 30 minutes or until tender. Drain and leave to cool.

Remove the skin – it should rub off with a little pressure. Cut the beetroot into wedges, quarters or halves, depending on their size, and sprinkle with a little sea salt, ground pepper and herbs.

Serve with yoghurt or sour cream, mixed with some olive oil to taste, and seasoned with salt and pepper.

[COOK'S NOTES]

Until the end of the twentieth century, all we knew of beetroot in this country was that it came sliced in a can. I loved those slices on our Aussie burgers with 'the works', but now I love beetroot straight out of the garden and simply boiled. There's no need to peel beetroot before boiling – just give it a quick scrub; the skin will slide off easily when it's cooked. Also, it doesn't matter if you undercook or overcook beetroot. Either way, it'll be sweet and earthy, especially the organic homegrown golden variety.

Straight from the soil

THESE DAYS, WE SEEM TO eat a lot more veggies than meat in our house, and often the vegetable side dishes become the main meal, especially, of course, when we have vegetarian friends and family over for dinner. David (Campbell) and his wife, Lisa, are both vegan, so we like to make sure we cook up a good selection of tasty veggie goodness for their visits.

Even our grandchildren all love vegetables, which is a big change from my day. I remember that, as kids, we didn't like eating our greens much at all, and we were often forbidden from leaving the table until we had done so. This change is no doubt the result of our improved knowledge of how to prepare and cook vegetables, and the much wider array and higher standard of veggies on offer, not to mention the countless inspiring cookbooks and cooking shows we can now enjoy.

The selection of veggies in our supermarkets and local greengrocers, including organic fare, is increasingly impressive. But whenever I can and wherever I am, whether it be Cairns, Eumundi, Mittagong or Byron Bay, I love buying my veggies from fresh-produce markets. What's there is what's in season, and would only be fresher if you picked it from your own garden patch. It's so great to see, smell and touch the goods the growers have brought in on the day, and that usually inspires me to think up something delicious to cook.

My love of markets comes from the years I spent living in Italy and, later, France. As a young child, I was enthralled by the Campo de' Fiori market in Rome, which was always bustling with locals and tourists from early morning until siesta time. In Aix-en-Provence, in the South of France, where we had the good fortune to spend a couple of years in the mid-1990s, I was a regular at the fabulous markets held in the town centre. First thing in the morning, I would make my way around the stalls with a wheeled basket in tow, breathing in the aroma of roasted coffee beans from the sidewalk cafés that were just opening. The stalls were a veritable feast for the senses, their baskets overflowing with brilliant-red vine-ripened tomatoes, zucchini with their yellow flowers, green beans, artichokes, plump and often white asparagus, rock melons, figs, apricots, cherries and perfect fairy-tale-like porcini mushrooms, all smelling as good as they looked. Growers would call you over to taste their best produce, and then you'd instantly know that a meal with any of these offerings was guaranteed to nourish the body and soul.

Caramelised roasted witlof and radicchio

[*SERVES 6*]

The combination of the purple and green leaves makes this dish both colourful and delicious. Although these veggies can be bitter, the addition of a little sugar helps to soften the flavour and crisp up the edges. If your radicchio is large, use one and cut into wedges.

3 witlof, halved

2 small radicchio, outer
 leaves removed, halved

5 garlic cloves, peeled and
 smashed

¼ cup olive oil

2 tablespoons brown sugar

sea salt and freshly ground
 black pepper

Preheat the oven to 180°C (160°C fan-forced).

Arrange the witlof and radicchio in a baking dish, cut side up, to fit snugly. Add the smashed garlic cloves.

Drizzle olive oil over, then sprinkle with the brown sugar and season with salt and pepper. Bake for 15 minutes or until they are just tender and golden brown on top.

Baked cheesy fennel

The first time we had this, it was as a side dish at one of London's posh fish restaurants. We've had it on our home menu ever since. It can be served with anything, is great even on its own, and is so warm and comforting, especially on a cold winter's night.

4 fennel bulbs, washed, trimmed and cut into 6 wedges
50 g butter, sliced
1 cup double cream
1 cup grated cheddar
2 garlic cloves, smashed and sliced
¼ cup finely grated parmesan
sea salt and freshly ground black pepper

Preheat the oven to 180°C (160°C fan-forced).

Bring a pot of water to the boil. Add the fennel and boil for 5 minutes. Drain well.

Oil a baking dish or ovenproof pan that will accommodate the fennel in a single layer. Lay out the fennel and top with butter.

In a bowl, mix together the cream, cheddar and garlic and pour over the fennel.

Top with parmesan, then season with salt and black pepper and bake for 20 minutes or until nicely golden brown.

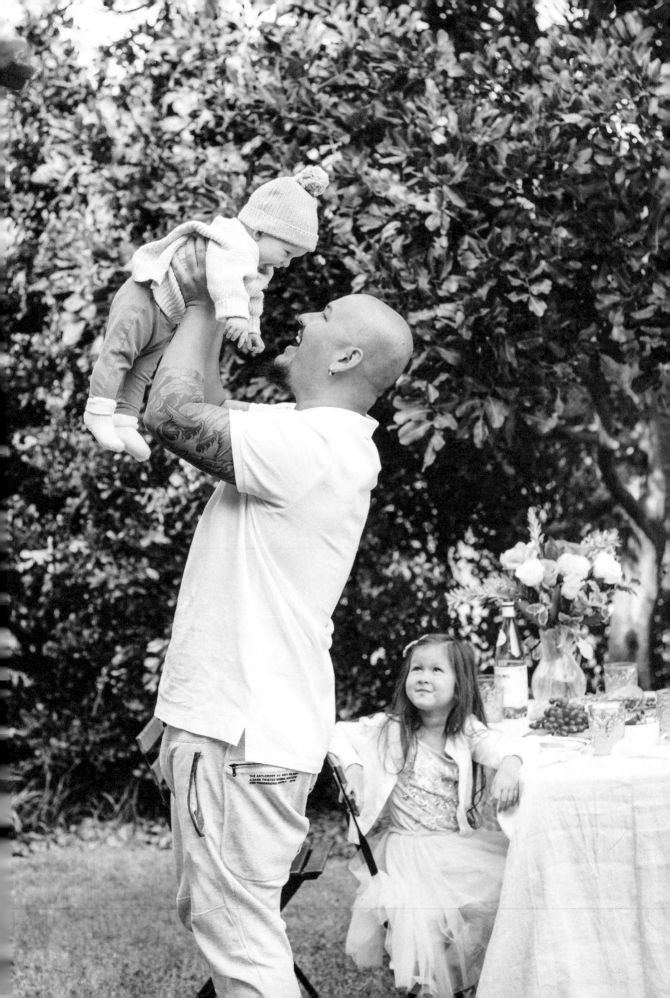

Asparagus with orange zest

[SERVES 4–6]

The first time we had fresh asparagus was in the early 1980s, while we were on tour in Germany. It was white asparagus – steamed to perfection, tender and succulent, not too soft, stringy or bendy – dressed with a Bearnaise sauce sprinkled with crunchy bacon bits. White asparagus is not as commonly available in Australia as the green variety, but it's such a treat when I find it.

2 or 3 bunches asparagus
table salt
extra virgin olive oil,
 to drizzle
sea salt and freshly ground
 black pepper
finely grated or shredded
 zest of ½ orange

To prepare the asparagus, snap the base of each spear – it will naturally break where the tough bit ends. If you want to be a little fancier, you can use a veggie peeler to peel about 3 cm from the bottom of the stalks so you can be sure that there are no tough ends.

Fill a tall saucepan with hot water, add a generous spoon of table salt, cover with a lid and bring to the boil. Prepare a large bowl of iced water.

Put the asparagus into the bubbling water, tip side up, and cook for just 2 minutes. Drain well then transfer to the iced water for 1 minute. This stops further cooking and will keep the bright green colour.

Drain again and pat dry with a paper towel. Arrange on a serving platter with the spears heading in the same direction.

Drizzle with a little olive oil, season with salt and pepper, and sprinkle with orange zest.

[COOK'S NOTES]

Soaking the asparagus in chilled water before cooking will turn the spears a vibrant green. You can also do this with green beans, broccoli and broccolini.

Peas with roasted tomatoes

[*SERVES* 8]

I roast a tray of tomatoes at least once a week. They're not only the base for a lot of dishes but also great to dip a piece or two of sliced baguette into. Unless I'm making a pasta sauce, I use small tomatoes or vine cherry ones. These days there are so many varieties in all different shapes, sizes and colours. This is a side dish that we all love and makes peas a little bit more interesting than when they are served, classically, on their own with butter.

ROASTED TOMATOES
2 tablespoons olive oil
sea salt
300 g mixed cherry tomatoes
strips of lemon zest and thyme sprigs (optional)

PEAS
2 tablespoons olive oil
10 g butter
sea salt and freshly ground black pepper
1 brown onion, chopped
500 g frozen peas
vegetable or chicken stock, as needed (page 298)

To make the roasted tomatoes, preheat the oven to 220°C (200°C fan-forced). Splash the olive oil into a baking dish, sprinkle with salt and add the tomatoes. Throw in some lemon zest and thyme, if you want to jazz it up a little. Roast for 15–20 minutes, until the tomatoes are soft. Set aside to cool.

To make the peas, heat the oil, butter and a pinch of salt in a medium saucepan over medium heat. Add the onion and cook for 4–5 minutes, until soft. Add the frozen peas and cook for a minute or so, until bright green. Add enough stock to come almost to the top of the peas. Bring to a simmer and cook for a few minutes, until the liquid has almost all evaporated.

Add the roasted tomatoes, mix through and taste to see if you need more salt. Grind pepper over and serve.

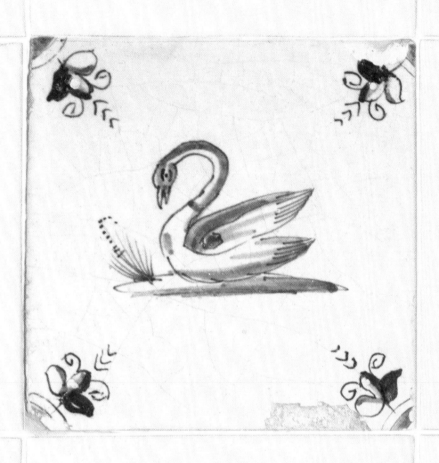

CHAPTER
NINE

On the
Grill

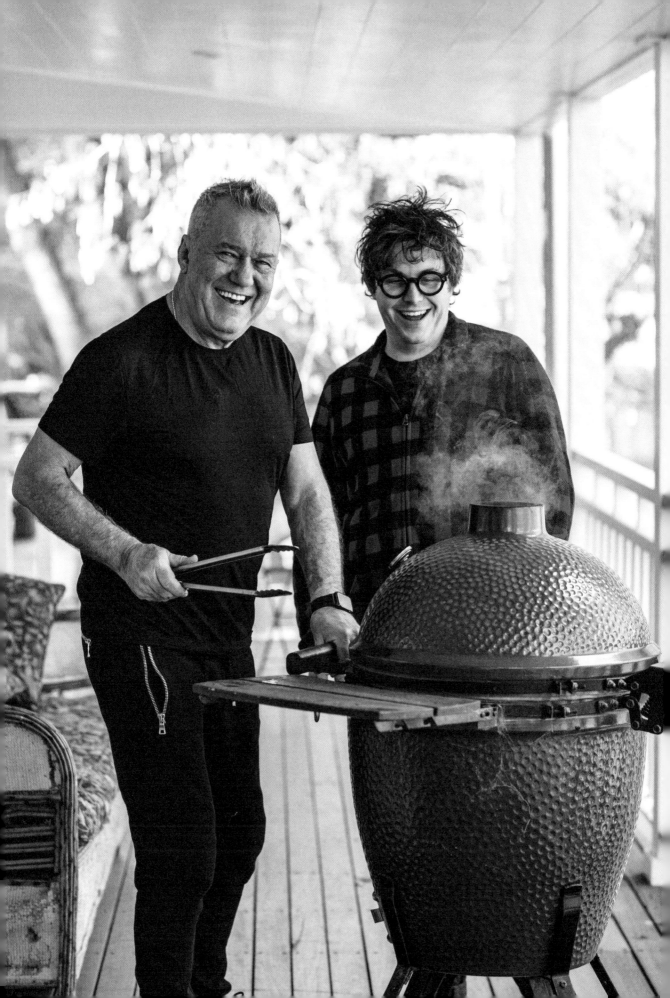

I THINK MY LOVE OF flames and smoke came from my mother. Even though she never barbecued at home, I'd often walk into our kitchen and find things ablaze. After opening the doors and windows, fanning the smoke out of the room and wiping the tears from my eyes, I'd see her standing at the stove, extinguishing the last of the flames coming from the lamb chops she was cooking. On the other side of the stove would be the pot of cabbage she'd been boiling for the last two hours, the pale greens a perfect contrast to the charred meat. 'Sit down, son,' she'd say. 'Dinner's ready!' I'd turn and run for the door. 'No, thanks, Mum, I've got to play football right now.'

Even though I spent much of my childhood in Australia, I didn't know much about barbecues and grilling until later in life. I learned from Jane, of course, but also by paying attention to master grillers, like those we regularly encountered in Japan, or Lennox Hastie, owner and chef at the Firedoor restaurant in Sydney. I loved sitting at the counter there and watching him cook as I sneakily made mental notes of his every move. 'Hey, Lennox, how long will you leave that lobster on for?' I'd ask casually, or 'How long will you rest that steak?' To learn as much as possible, I even got him to cook at one of my birthday parties.

Eventually, I honed my skills to the point where I am now, in our household, the undisputed master griller and chief fire-starter. I build fires to heat the house, and fires in the courtyard for those cold, crystal-clear nights when the sun has gone to bed, the stars have begun to light up the night sky and we sit around in circles gazing up at the constellations as an occasional wisp of smoke drifts overhead. But, most importantly, I build fires to cook on, because we all love an open-flame grill at our house.

To assist me in this vital role, I've acquired nearly every form of grilling equipment you've ever heard of. I've got grill plates that were hand-forged by an Austrian blacksmith and customised to fit my outdoor fireplace. A rotisserie that slowly transforms just about anything you want to turn above the flames into a feast. A smoker like the ones used in the American Deep South, which unhurriedly cooks and tenderises the toughest cuts of meat until they almost fall apart on your plate. A wood-fired oven from Italy, which takes two days of constant chopping and burning wood to bring up to the right temperature – well worth the effort, as it makes perfect pizza, bread, slow-cooked lamb and many other great dishes.

> I am now, in our household, the undisputed master griller and chief fire-starter.

One of my favourites pieces of equipment is the Big Green Egg, an oval ceramic, kamado-style grill ('kamado' is Japanese for stove) with an airtight cooking chamber. I use it to barbecue, smoke and even bake. I've also got a new, high-tech grill whose rack can be wound down when the flames get low or wound back up when they are raging out of control. I have a few small, delicate hibachi grills for using on the porch or putting in the boot of the car for a camping trip – I can even set them up on the dining room table if I need to. And, of course, I have a standard gas barbecue in case it gets too windy or too hot for a fire.

Mostly, I like to cook over open flames, because, with the right type of wood and the right amount of heat you can bring out the best flavour in just about anything – meat,

fish, vegetables, salad, even fruit. Using a gentle heat, you can coax flavour out of a delicate head of lettuce or lightly smoke a fish wrapped in banana leaf. And with a roaring fire you can blacken and burn new character into a potato or root vegetable. There are no rules. Try a few different approaches with different kinds of foods. You'll be surprised what you can create. And don't be afraid to burn a few things as you get used to cooking this way. I still do it now and again, but I learn something new each time.

> With the right type of wood and the right amount of heat you can bring out the best flavour in just about anything.

My absolute favourite way of cooking over flames is with charcoal. Not just any charcoal but Japanese hardwood charcoal. I use binchō-tan, the type used in most Japanese cooking. It is a bit harder to find and tricky to get started, but once it is going it burns very hot and evenly and lasts for hours. Made from Japanese oak, binchō-tan is harder than most other charcoal, and when you bump two pieces together, they make a clinking sound like glass. Occasionally, when you light the pieces, they shatter like glass too, so be a little careful when you start them up. But good things come with persistence and effort, and you will be rewarded.

There are various ways of starting charcoal, but for me the easiest option is to use a little gadget called a chimney, which you can buy in most barbecue shops. You simply place the coals into the chimney, light a small fire underneath and away you go. In ten or fifteen minutes, your charcoal will be glowing and almost ready to use. Then you simply tip the hot coals into your grill. The coals will burn red for a while, but eventually they'll turn grey or white with ash. This is the optimum time to cook, as the heat will be hot and even. (If you can hold your hand six inches over the coals for more than a few seconds, they are not hot enough.)

When I cook over coals, I have a few tricks. I always create a cooler area on the grill so I can move food around and adjust the rate of cooking. I use a fan to pump oxygen into the flames when I want to get things moving faster, and keep a spray bottle full of water nearby to control the odd flare-up. Sometimes I put some apple cider vinegar in the water, to add further flavour to the food.

For me, there is nothing better than standing alone in front of a barbecue full of hot charcoal as the river is rolling by, the sun is setting and the kookaburras are laughing their heads off in the treetops. In those moments, I feel I am at home and life is so good.

Chargrilled grass-fed rib-eye steaks

[*SERVES 6*]

Grass-fed rib-eye steaks on the bone are our pick for the most special barbecue occasions. Resting the steaks is a crucial part of the process.

3 grass-fed rib-eye steaks on the bone (about 3.5 cm thick)
2 tablespoons olive oil
1 tablespoon chopped rosemary
sea salt

Take the steaks out of the fridge about 2 hours before cooking, to bring to room temperature.

Prepare and heat your charcoal grill or barbecue grill plate for cooking.

Mix the olive oil, rosemary and salt together and brush over the steaks. Cook for 6 minutes on each side (or a little longer for well done), then set aside to rest for 12 minutes.

Slice the meat and serve with any salad or greens and, of course, potatoes! You can also serve the beef with salsa in a Mexican taco or with mushroom sauce for an Italian main.

Buttery grilled potatoes

[*SERVES 8*]

Add some soy sauce to these buttery barbecued potatoes to make them even more special.

8 desiree potatoes
80 g butter, melted, plus extra to serve
sea salt flakes
freshly ground black pepper or dried chilli flakes (optional)

Prepare and heat your charcoal grill or barbecue grill plate for cooking.

Scrub the potatoes well and leave the skin on. Cut them in half lengthways.

Par-boil the potatoes in a large saucepan of salted water for about 10 minutes. They should be tender but not so soft they will fall apart on the grill. Drain and cool.

Brush the potatoes with melted butter and sprinkle with sea salt. Grill for about 10 minutes, turning often, until beautifully charred. Brush with butter fairly constantly, at least every time you turn them.

Serve them with knobs of butter on top, sprinkled with more sea salt and with pepper or chilli flakes, if you like.

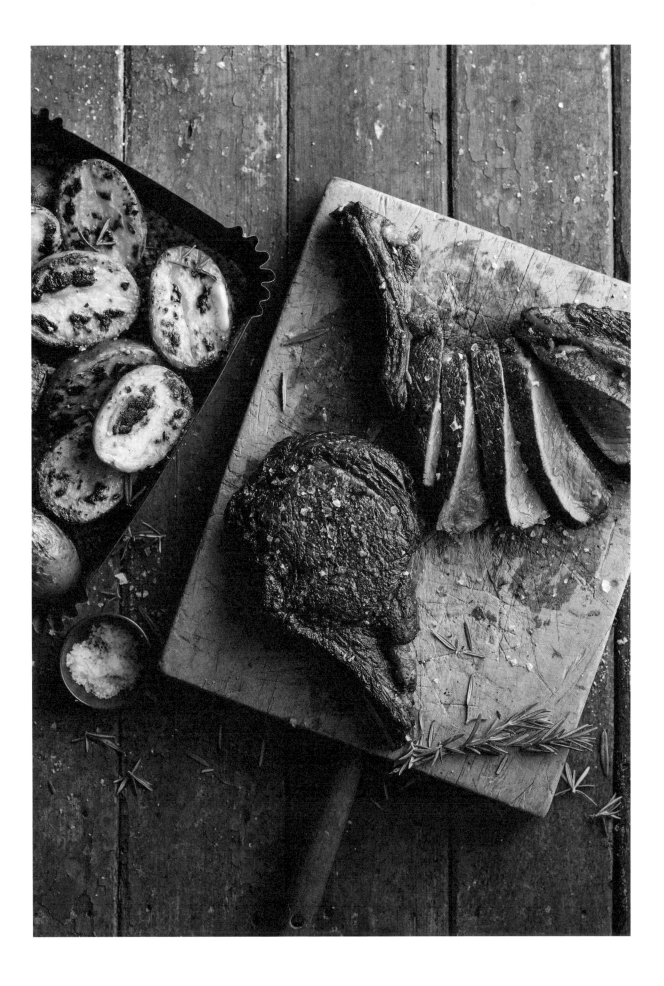

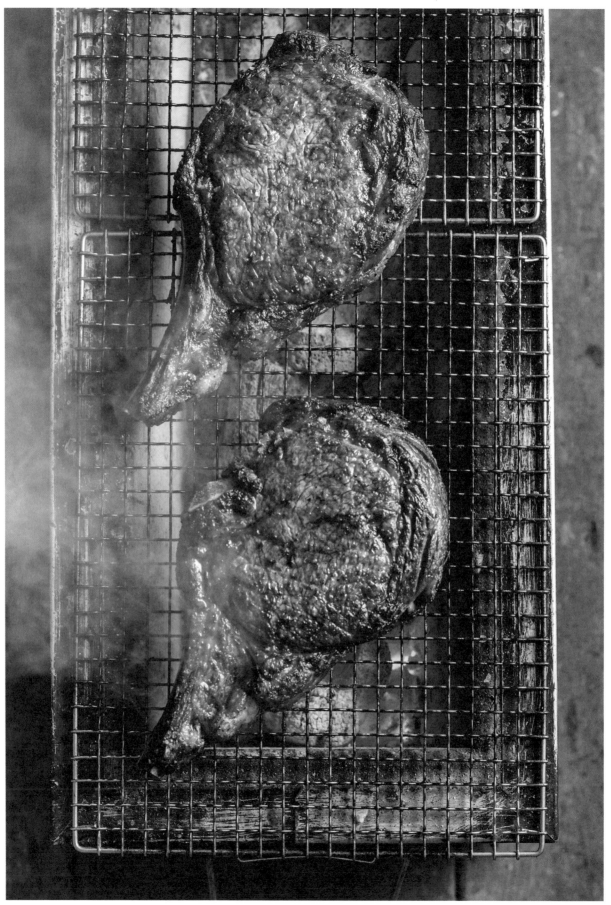

CHARGRILLED GRASS-FED RIB-EYE STEAKS, PAGE 244

BUTTERY GRILLED POTATOES, PAGE 244

Barbecue chicken rubbed with Berbere spice

Berbere spice mix is used in Ethiopian cooking and is a mixture of several ground spices, including cumin, coriander, ginger, chilli, nutmeg and cloves. You can find it where speciality spices are sold, or online. As always, I like to brine my chicken first so it is really tender and juicy.

1 large chicken
½ cup Berbere spice mix
1 lemon, halved

To butterfly the chicken, use heavy kitchen scissors or poultry shears to cut down either side of the backbone (keep the backbone for stock). Turn the chicken breast side up, and use the heels of your hands to press down in the centre of the breast to flatten it out. Alternatively, get your butcher to do it!

Brine the chicken (page 305), using any flavourings you like. Drain well and pat dry before using.

Prepare and heat your charcoal grill or barbecue grill plate for cooking.

Rub the chicken with the Berbere spice mix and cook on the grill for 18–20 minutes on each side. Have an area at one side of your grill that is cooler, in case the meat is cooking too fast, but don't be afraid to burn and blacken it a little.

Add the lemon to the grill, cut side down, and cook for a couple of minutes, until caramelised.

Transfer the chicken to a platter and let it rest for 15 minutes, covered with foil. Cut into large pieces to serve, with caramelised lemon on the side.

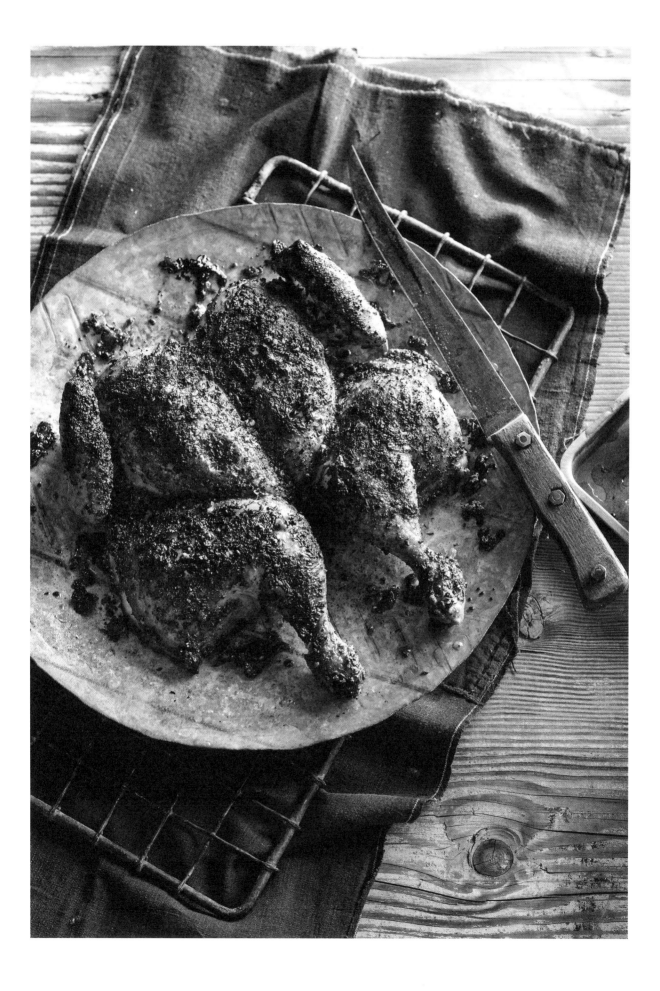

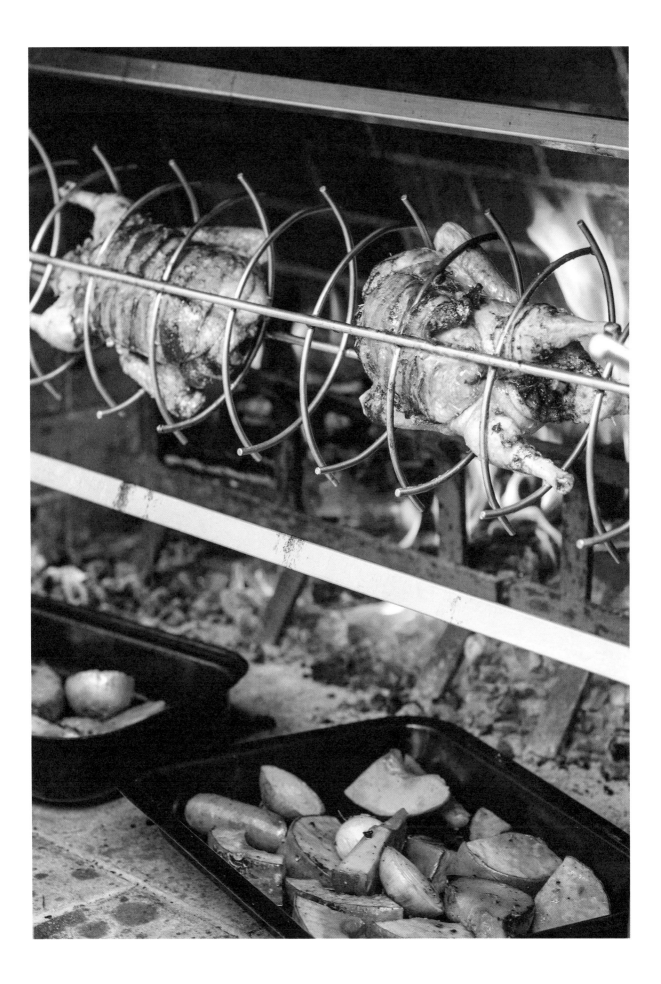

Roast duck with black pudding stuffing

[*SERVES 6*]

When we lived in the South of France, we became friends with Caroline from Montélimar, who was a wonderful cook. She would roast goose and duck wrapped in bacon on a rotisserie over an open fire, and Jimmy loved this so much that he got her to teach him how to do it before we moved back home. Years later, we returned to visit our French friends and, of course, we pleaded for a rotisserie goose. It was midsummer and they were shocked. 'A goose in summer?' they said. But they did it and it was as delicious as ever. In Australia, geese are not readily available, so most of the time we use duck. Our friend Jock Zonfrillo wants to try a magpie goose, a species found in the far north of Australia; the meat is apparently really sweet, because the birds often feed on water chestnuts and mangoes.

1 whole duck
8–10 long rashers of streaky bacon, to wrap around the duck

STUFFING
2 tablespoons olive oil
1 brown onion, diced
1 Italian sausage
2 thick slices black pudding, about 100–200g
2 garlic cloves, crushed
240 g can cooked and peeled chestnuts
4 slices stale bread, torn into small pieces
¾ cup pine nuts
1 cup finely chopped herbs, such as parsley, sage, rosemary and thyme
sea salt and freshly ground black pepper

Bring the duck out of the fridge an hour before cooking to come to room temperature, and prepare the rotisserie coals half an hour before cooking.

Meanwhile, make the stuffing. Heat the olive oil in a medium saucepan over medium heat. Add the onion and cook for about 4 minutes, until soft. Squeeze the sausage mince out of its skin and add to the pan. Use a wooden spoon to break it up as it cooks. Break the black pudding into small pieces, add to the pan and cook through. Stir in the garlic and cook for a further couple of minutes, then turn off the heat.

Break up the chestnuts and mix through the meat. Add the bread, pine nuts and herbs. Season with salt and pepper. Mix well then leave until cool enough to handle.

Stuff the mixture into the cavity in the duck. Wrap the stuffed duck with bacon and tie with kitchen string to hold in place.

Place the duck onto the rotisserie and cook for 50–60 minutes, depending on its size, until golden brown. Let it rest for 30 minutes before serving.

[COOK'S NOTE]

The type of black pudding made with steel-cut single origin oats is best; it comes in pre-cut square slices. If you can't get hold of black pudding, use 1 boudin noir sausage.

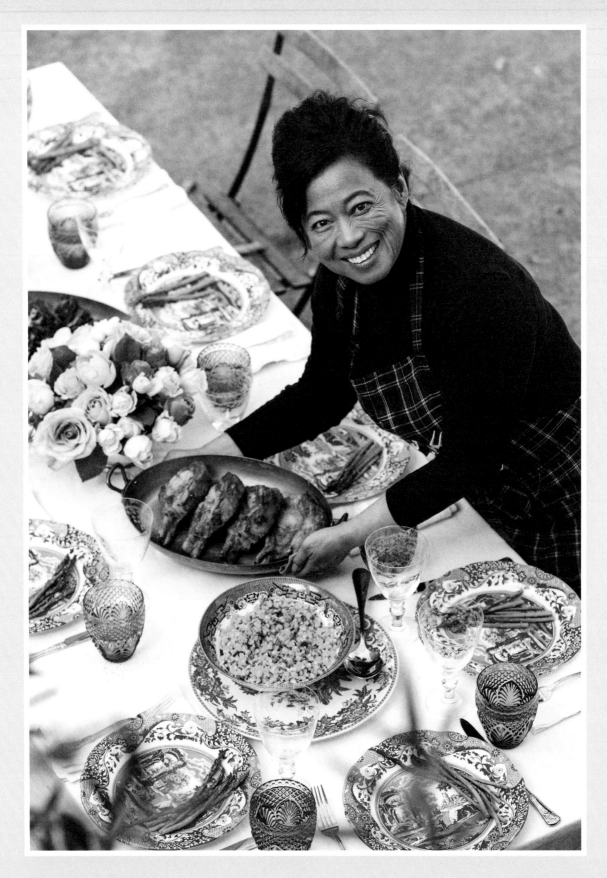

Food as theatre

BY THE BEGINNING OF THE 1980s, my parents were living in Tokyo. Halfway through my fifth and final year of studies, I decided to throw it all in and head over there to live. Japan was a completely different world, and Tokyo was at the cutting edge of everything going on in the country, especially food-wise.

Japanese cuisine was fascinating, and its presentation so artful. Sitting at a sushi counter and observing the careful assembly of these bite-size masterpieces by expert chefs was an amazing experience. Tasting sushi for the first time, I went from fascination mixed with slightly anxious anticipation to relieved appreciation and gratitude that the raw fish was more than palatable; it was, in fact, delicious and the texture was not difficult to negotiate at all.

Similarly, I was drawn to the equally elaborate rituals of sukiyaki, consisting of thin slices of meat cooked in a pot at your table along with vegetables and other ingredients, and tempura, with the chef sometimes bringing the ingredients to the table, coating tasty morsels of seafood and vegetables in batter, and deep-frying them as you looked on, your mouth watering.

In Tokyo, we lived in Minato, within walking distance of Roppongi, where I found what is to this day still my favourite restaurant on earth, Inakaya. In its smoky robatayaki (charcoal grill) room, chefs kneel at stoves, grilling orders and yelling out greetings as patrons step through the curtained doorway. The freshest fare from the market is laid out on ice and greenery in round, flat baskets between the chefs and the diners: fish, prawns, king crab legs, giant clams, sea snails, conch shells, mushrooms, shishito peppers, potatoes, yams, gingko nuts, rice cakes and more. It's a feast for the eyes, and you can't help but yell excitedly, selecting at least one of everything. The chefs use a long-handled paddle to retrieve your chosen ingredients and then to deliver the dishes to you when they are ready. To chase it all down, there's nothing more satisfying than some cold dry sake, served in a square wooden cup full to the brim, sometimes spilling over onto the saucer. Totemo oishii! (Most delicious!) I'm in heaven.

Chargrilled beer-brined pork chops

[SERVES 4]

One day, we planned to brine our pork loin chops in apple cider (which we often do), but someone opened a can of beer by accident and we used that instead. Well, it worked a treat. We've tried it with stout too, with similarly pleasing results.

2 x 375 ml cans beer
2 tablespoons table salt
2 bay leaves
2 garlic cloves, smashed
10 black peppercorns
4 pork loin chops (about
 3.5 cm thick)

Pour the beer into a plastic container big enough to hold the chops in a single layer. Add the salt, bay leaves, garlic and peppercorns, and stir to dissolve the salt.

Submerge the pork chops in the brining mixture. Cover and refrigerate for at least 4 hours or overnight.

Drain the pork and pat dry with paper towel. Set aside on a plate, covered, for about 45 minutes, to come to room temperature.

Meanwhile, prepare and heat your charcoal grill or barbecue grill plate for cooking.

Cook the chops for 7–8 minutes on each side, until well browned.

Charred corn salad

[SERVES 4–6]

This is simple and delicious – definitely a family favourite. We have this with everything from Mexican meals and Middle Eastern grills to Aussie barbecues! I like to use coriander, but for the 'NO CORIANDER' people, just use parsley (or nothing!).

4 corn cobs, husks and silk
 removed
⅓ cup Kewpie mayonnaise
¼ cup finely grated cheese
 (Monterey Jack,
 kefalograviera or any
 mild hard cheese)
ground paprika and chopped
 coriander, to sprinkle

Place the corn cobs into a large pot and cover with cold water. Bring to the boil then cook for 5 minutes. Drain well.

Prepare and heat your charcoal grill or barbecue grill plate for cooking. Grill the corn for about 10 minutes, turning to cook all sides evenly, until nicely charred.

Transfer to a board and leave until cool enough to handle. Slice the kernels off the cob. Place into a salad bowl and mix with the mayonnaise and cheese.

Dust lightly with paprika and garnish with coriander leaves.

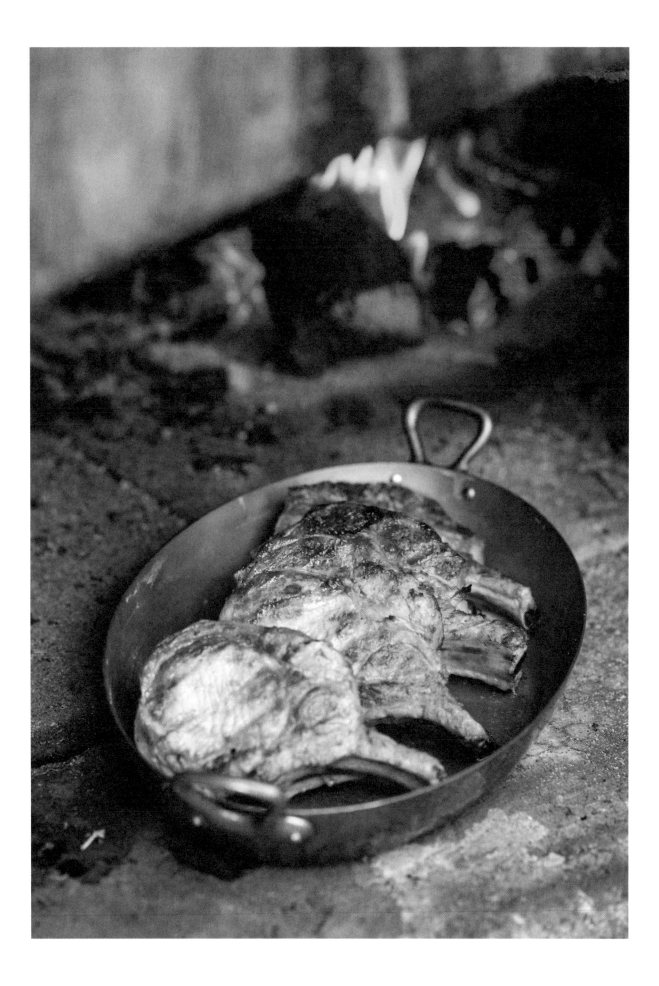

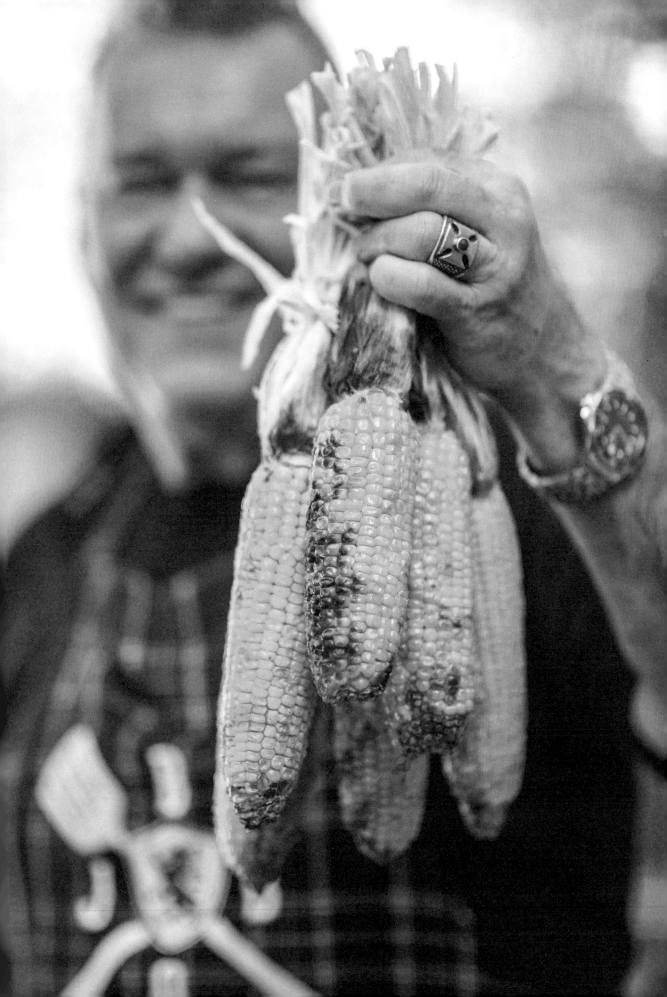

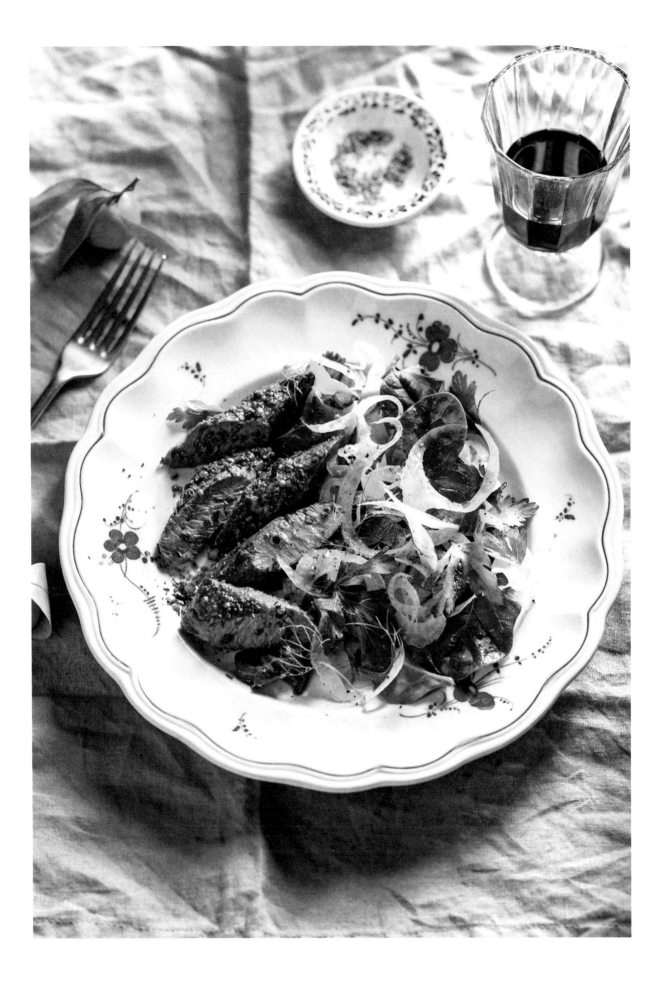

Grilled spiced lamb fillets

This is a wonderful tasty and lean dish. You can team it with a simple cabbage slaw, steamed spinach, or a green salad of cos lettuce, cucumbers and thinly sliced fennel. Toasting the spices brings out their wonderful aroma and flavour, and your kitchen will smell amazing when you crush them in the mortar and pestle.

2 tablespoons olive oil
2 garlic cloves, smashed
 (or confit garlic,
 page 295)
freshly ground black
 pepper
8 lamb fillets
1 generous tablespoon
 coriander seeds
1 generous tablespoon
 cumin seeds
sea salt and dried chilli
 flakes (optional)
shaved fennel and parsley,
 to serve

Combine the olive oil and garlic in a shallow dish and season with pepper. Add the lamb and turn to coat. Set aside.

Place the coriander and cumin in a dry frying pan over low heat. Toast for a few minutes, until aromatic, taking care not to burn. Cool slightly, then crush until finely ground, using a mortar and pestle. Mix the spices, a pinch of salt and chilli flakes (if using) through the marinating lamb, coating on all sides.

Prepare and heat your charcoal grill or barbecue grill plate for cooking.

Sear the lamb until stripes appear – about 1½ minutes on each side (fillets seem to have three sides!).

Take off the heat and let rest for 8–10 minutes, covered with foil. Season with salt and serve with shaved fennel and parsley, or your favourite salad.

Jimmy's chargrilled vegetable stack

[*SERVES 4–6*]

We often do this with just zucchinis and capsicums – you can use yellow zucchini or the light green zucchini, if you like. Using coriander will give this more of a Middle Eastern tilt and parsley more Mediterranean, so choose which you prefer. For a vegan version, replace the fetta and labne with tahini (1 tablespoon per layer).

2 large eggplants, cut lengthways into 5 mm slices
sea salt, to sprinkle
⅓ cup olive oil
2 garlic cloves, crushed (or confit garlic, page 295)
4 zucchini, cut lengthways into 5 mm slices
1 red capsicum, deseeded, cut into 1 cm strips
1 green capsicum, deseeded, cut into 1 cm strips
200 g labne
200 g Persian feta
chopped coriander or flat-leaf parsley, to sprinkle
½ cup pistachio kernels, roughly chopped
seeds from 1 pomegranate

LEMON
VINAIGRETTE
½ cup extra virgin olive oil
1 teaspoon finely grated lemon zest
2 tablespoons lemon juice
sea salt and freshly ground black pepper

Prepare your charcoal grill or barbecue grill plate for cooking.

Lay the eggplant slices on paper towel and sprinkle with salt. Let sit for about 10 minutes, until you see bubbles of liquid appearing on the flesh. Wipe off with paper towel and turn over, repeat the salting on the second side. This will draw out the water and give the eggplant a less spongy consistency when cooked.

Combine the olive oil and garlic in a small bowl. Brush over the vegetables and cook (in batches if necessary) until tender and lightly charred.

To make the vinaigrette, place the oil and lemon zest and juice in a bowl. Season with salt and pepper and whisk to combine.

To assemble, layer the chargrilled vegetables on a platter with labne (or tahini) and a drizzle of vinaigrette between the layers. To finish, crumble the feta over and drizzle with the remaining vinaigrette. Sprinkle with herbs, pistachios and pomegranate seeds.

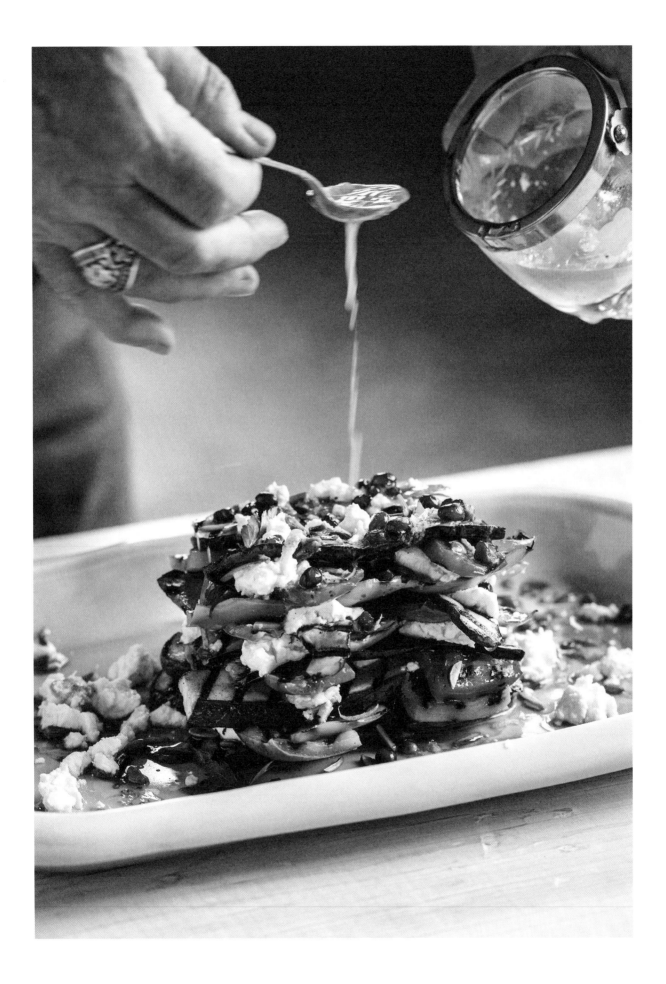

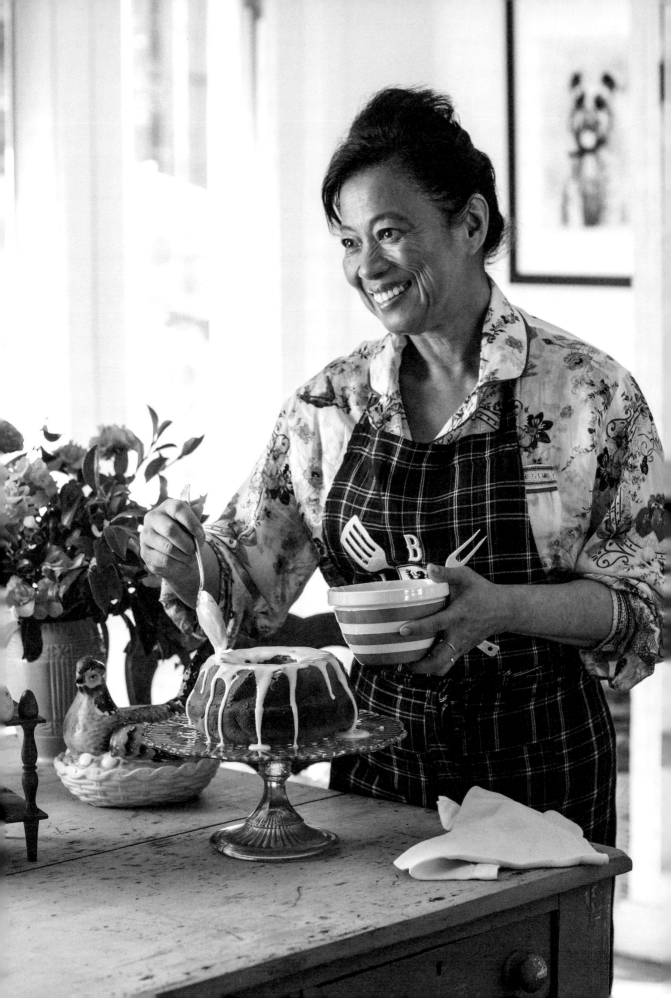

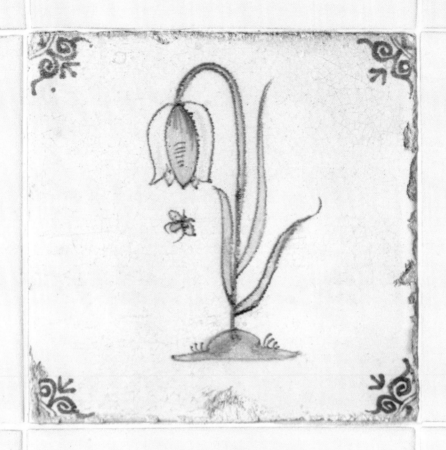

CHAPTER
TEN

Sweet
Things

JANE, AS SWEET AS SHE is, doesn't have a sweet tooth. Given the choice, she would prefer to eat savoury food, at any time of the day. Nevertheless, she will spend hours on end cooking pies and cakes, and large pots of bubbling custard that can be poured over them, just for me. Some nights, if I have a craving, Jane will even make ice-cream for supper. You see, she loves to make desserts almost as much as I love to eat them. I told you she was sweet.

Jane loves to make desserts almost as much as I love to eat them.

I adore most desserts. Explains a lot, don't you think? Have you noticed that the width of my waistline is constantly changing? If I wasn't so busy, I would be the size of a house. Maybe even a block of flats. Anyway, I especially love custard, as do all our kids and grandchildren. We make it runny or thick, and serve it hot or cold, depending on the dish it will accompany. A few times, when it's been really runny and cold, Jane has caught me drinking it by the glassful.

When she makes custard, Jane insists on the best non-homogenised, full-cream Jersey milk, and our favourite one comes from the Fleurieu Peninsula in South Australia. I search the shops of Sydney for this milk, because it's perfect. It's topped with rich cream, so it has to be shaken well to mix the milk and cream together; otherwise, you get large lumps of cream in each glass you pour. Which, by the way, is fine with me.

In our garden we have a small orchard, where we grow mandarins, oranges, lemons, plums, peaches and apples. Late in the afternoon, we can walk out there and pluck whatever is ripe from the trees. Jane will take some fruit and bake a beautiful tart for dessert. Any left over

might be eaten fresh, or turned into jam or marmalade for the breakfast table.

But what good is fruit tart without ice-cream? Fortunately, Jane likes to make ice-cream, too. Malted vanilla or strawberry ice-cream. Even honey-flavoured ice-cream, using the honey from our own hives. Our bees collect pollen from the lavender and roses in the garden, then transform it into the world's best-tasting honey. Sounds idyllic, doesn't it? But you haven't seen me trying to harvest the honey.

The bees have a love–hate relationship with us: they seem to love Jane and hate me. She walks up to the hive, wearing nothing but a summer dress, and looks in to see how they are doing. Not a problem. I walk out the backdoor to help her, covered from head to toe in a bee suit that looks like white medieval armour, and they immediately attack me. Once, I just happened to be walking past, minding my own business, while Jane was tending to them, when out of the blue – whoosh! – they made a, er, beeline for me. I ran for it, but wasn't quick enough to get away, and I was stung on the head multiple times. So now I try to keep my distance. It's like the bees and I have made a deal: they don't sing and I don't make honey.

I do, however, make the odd dessert. Odd being the operative word here. When making cakes, or baking in general, it seems you need to be precise with your measurements. And that's where I go wrong. My style of cooking is way too flamboyant to be accurate. Recently, however, my dear friend and amazing chef from New Zealand, Peter Gordon, showed me how to make his mother's version of a pavlova (I thought it was an Australian dish, but he swears we stole it from the Kiwis.) I might share the recipe in our next book, but don't hold your breath. After all, when it comes to sweets, I'm still just a beginner.

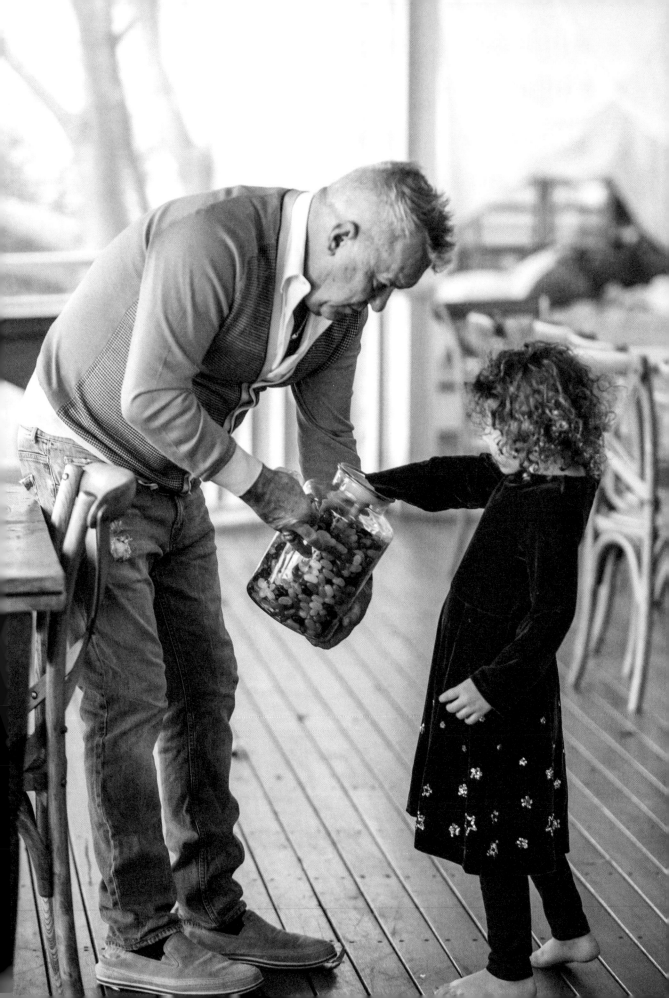

Anzac biscuits

[*APPROX.* 24]

I make sure that there is always a jar of treats in the kitchen, and usually it's Anzac biscuits. Nutritious and delicious, they pick you up and keep you going when it's been a hard-working day, whether it involved after-school sport or chopping wood. Our city friends and family always reach for them after a long drive to the country – a cup of tea and an Anzac biscuit means it's time to kick off your shoes and relax. Anzac biscuits seem to be loved by everyone, and I have sent this recipe to friends all over the world.

1 cup plain flour
1 cup rolled oats
1 cup desiccated coconut
½ cup brown sugar
125 g butter
2 tablespoons golden syrup
2 tablespoons water
½ teaspoon bicarbonate of soda

Preheat the oven to 180°C (160°C fan-forced) and line 2 baking trays with baking paper.

Combine the flour, oats, coconut and sugar in a large mixing bowl and make a well in the centre.

Heat the butter, golden syrup and water in a saucepan, until melted and combined. Stir in the bicarb soda (it will froth up).

Pour into the dry ingredients and stir to combine. Roll level tablespoons of the mixture into balls and place onto the trays, leaving about a 5 cm space in between for spreading. Flatten slightly with a fork.

Bake for 10–15 minutes or until they are golden brown. Leave on the trays for about 5 minutes, to firm up. Lift onto a wire rack to cool completely. Store in an airtight container.

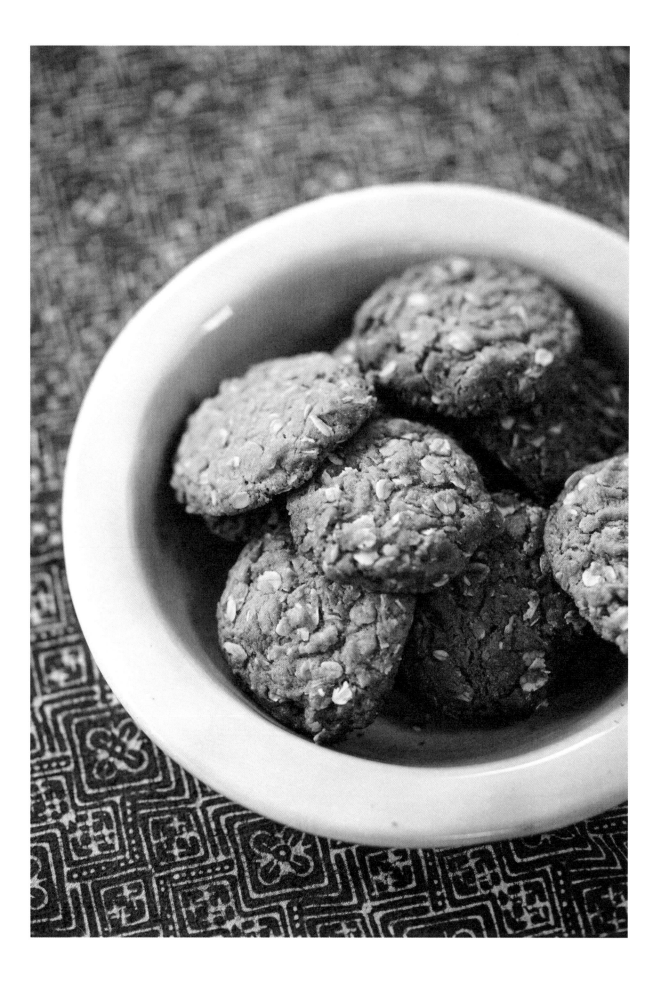

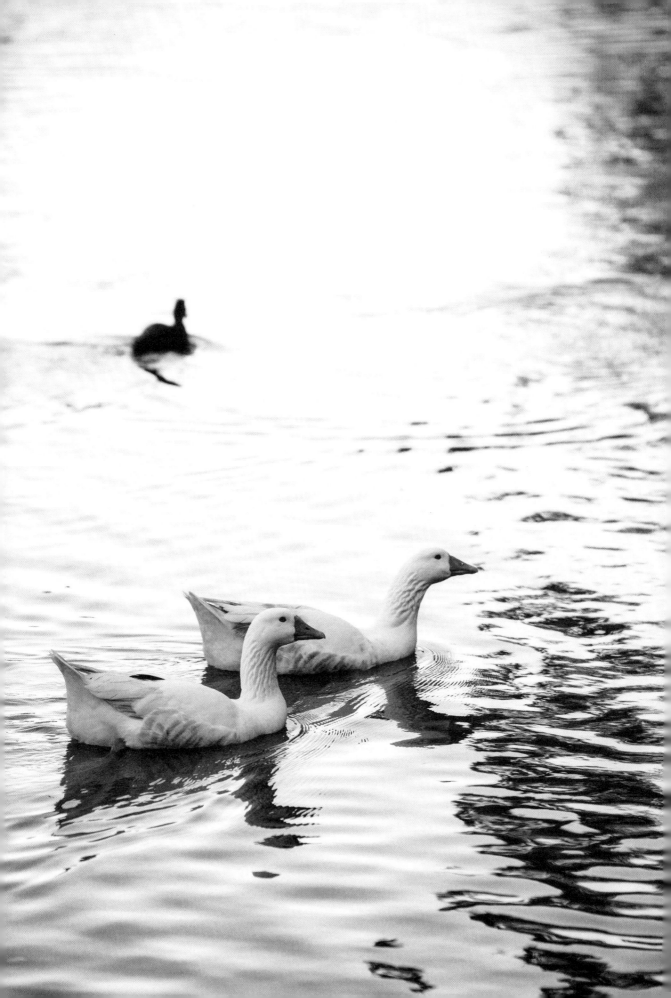

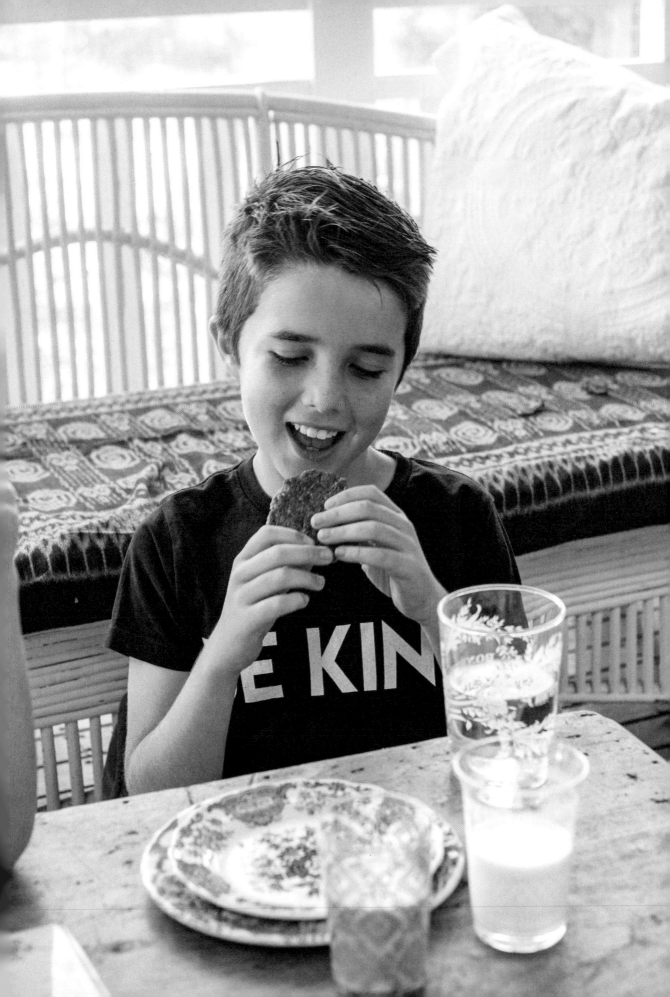

Grandma Violet's shortbread

[*APPROX. 18 SQUARES*]

My Granny Violet made the first shortbread biscuits I ever tasted. I still love this homemade shortbread more than any other. Maybe the love and comfort it brings are to do with my memory of her, or maybe it's simply because it's really yummy and moreish. Probably a bit of both!

I'm no expert on shortbread, though I ought to be, having been married to a Scotsman for 40 years. The Mahoney family are Australians of Irish descent, so technically this is an Irish shortbread recipe. I have to say though that the Scots I've served this to have not been at all unhappy with it.

250 g butter
2 cups plain flour
1 cup icing sugar
caster sugar, to sprinkle

Preheat the oven to 160°C (140°C fan-forced). Line a 30 x 20 cm rimmed baking tray with baking paper.

Take the butter out of the fridge and let it soften a little, then cut into 2 cm cubes.

Place the butter into a mixing bowl and add the flour and icing sugar. Use your fingertips to rub in until evenly combined and it becomes a buttery dough.

Press the dough into the lined tray and smooth with the back of a spoon. Bake for 20 minutes or until lightly golden brown.

While the shortbread is still hot, use a long sharp knife to cut it into squares, rectangles or finger shapes, as preferred. Poke a pattern of holes on the top with a fork and sprinkle with caster sugar.

Leave in the tray to cool completely before lifting out. Store the shortbread in an airtight container.

[COOK'S NOTES]

If you would like to make round biscuits, roll the dough into a log shape, wrap in foil or plastic wrap, and put into the fridge for 10 minutes to firm up (this is so the dough holds its shape when you slice it). Cut into 7 mm thick slices, arrange on a lined tray and cook for 10–15 minutes.

Stone fruit baked in muscat and champagne

Use any combination of stone fruit for this. It turns out to be a beautiful mixture of colours and the aroma fills the house, leaving sweetness on your mind.

2 peaches

2 nectarines

2–3 plums

1 cup muscat

1 cup champagne

few wide strips of orange
 zest

4 cinnamon sticks

3 cloves

2 star anise

50 g butter, cut into
 thin slices

2 tablespoons honey,
 to drizzle

⅓ cup raw sugar, to sprinkle

custard and/or ice-cream,
 to serve

Preheat the oven to 220°C (200°C fan-forced).

Halve the fruit and remove the seeds. Arrange in a baking dish, cut side up. Pour the muscat and champagne over, then add the orange zest and spices.

Scatter thin slices of butter on top, drizzle with honey and sprinkle with raw sugar.

Bake for 20 minutes or until the fruit is soft. Serve warm or at room temperature, with custard and/or ice-cream.

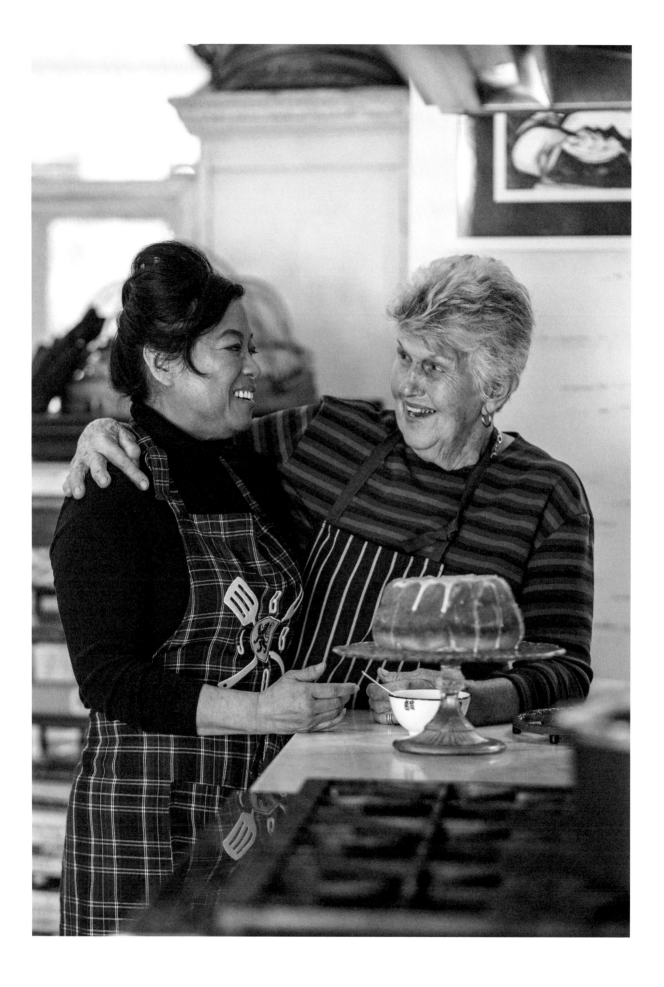

Anna's lemon cheesecake

[*SERVES 12*]

This isn't a 'cheesecake' cheesecake, but a cake with cream cheese in it, which makes it really moist and delicious. We call it a 'bootie cake' because we know what will happen if we eat too much of it!

melted butter and plain flour, to prep tin
250 g unsalted butter, at room temperature, chopped
190 g cream cheese (about ¾ block), at room temperature, chopped
2 teaspoons finely grated lemon zest
1½ cups caster sugar
2 eggs
1½ cups plain flour
½ cup self-raising flour

ICING
1 cup icing sugar
1 tablespoon freshly squeezed lemon juice

Preheat the oven to 180°C (160°C fan-forced). Brush the inside of a 23 cm (top measurement) 9 cup capacity Bundt tin with melted butter. Add a big spoonful of flour and tilt the tin around to coat the inside, then shake out the excess.

Using a stand or hand-held electric mixer, beat together the butter, cream cheese, lemon zest and caster sugar until smooth and the sugar has dissolved.

Beat in the eggs one at a time. Add the flours and beat on low until smooth. Pour the mixture into the tin and bake for 45 minutes.

To check if the cake is cooked, insert and remove a wooden skewer into the centre of the cake. The cake is ready if the skewer is clean. If not, place the cake back into the oven for a few more minutes and test again. Leave the cake to cool in the tin for 10 minutes before turning out onto a wire rack to cool until just warm. Transfer the cake to a serving plate or platter.

To make the icing, sift the icing sugar into a bowl and add the lemon juice. Whisk together until combined and drizzle over the slightly warm cake. Leave to set.

Plum, blueberry and walnut tart

[*SERVES 8*]

A chef friend suggested adding walnuts to my plum tart. A layer of them scattered under the plums soaks up some of the juices and adds a lovely crunch.

⅓ cup very finely chopped
 walnuts
8–12 mixed plums, halved
 or quartered, seeds
 removed
1 cup blueberries
icing sugar, to dust
runny custard, cream and/
 or ice-cream, to serve

PASTRY
180 g unsalted butter
1⅔ cups plain flour
pinch salt
50 ml water mixed with
 a small squeeze of
 lemon juice
runny custard, cream and/
 or ice-cream, to serve

To make the pastry, take the butter out of the fridge and let it soften a little, then cut into 2 cm cubes.

Place the butter into a mixing bowl and add the flour and a pinch of salt. Use your fingertips to rub in, until evenly combined.

Add the water mixture a little at a time and mix with your fingers, bringing the floury flakes together into a ball. You may not need all the water, or you may need a drop more.

Press the ball into a flat disc, wrap in plastic wrap and refrigerate for 30 minutes. Remove from the fridge and leave to soften for about 20 minutes. Meanwhile, preheat the oven to 180°C (160°C fan-forced).

Roll out the pastry on a lightly floured surface to fit a 23 cm (base measurement) loose-bottom flan tin. Press into the tin and trim off any excess. Sprinkle the base evenly with the walnuts.

Arrange the plums over the pastry base, cut side up. Scatter the blueberries over and dust with icing sugar.

Bake for 20 minutes or until the pastry is golden. Serve warm or at room temperature, with runny custard, cream and/or ice-cream.

[COOK'S NOTES]

You could replace the plums with apricots when they are in season. The walnuts should be very finely chopped – almost like walnut meal, but with a little bit of texture.

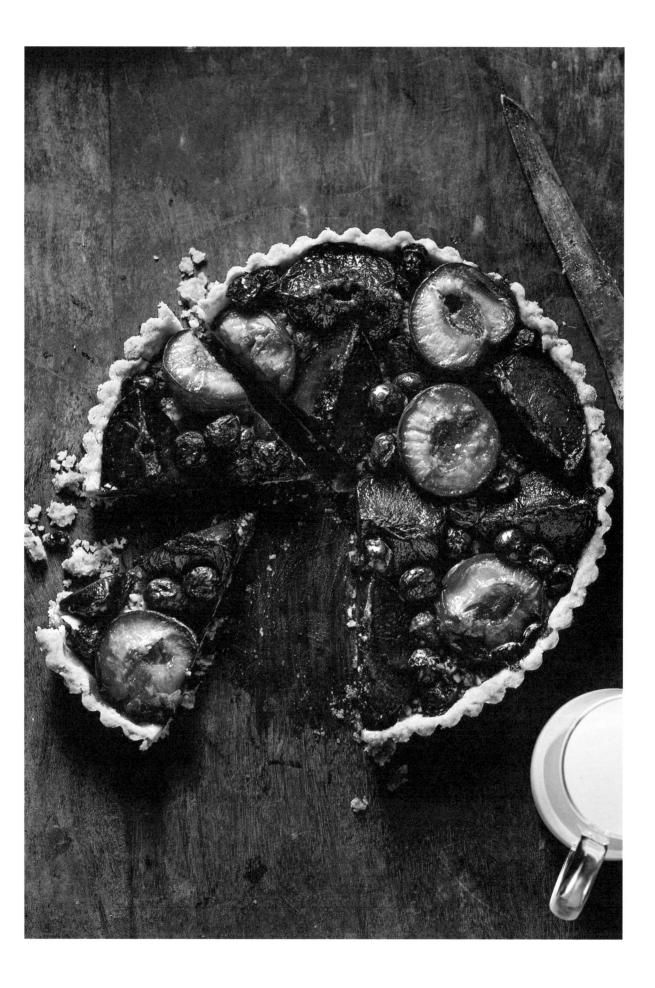

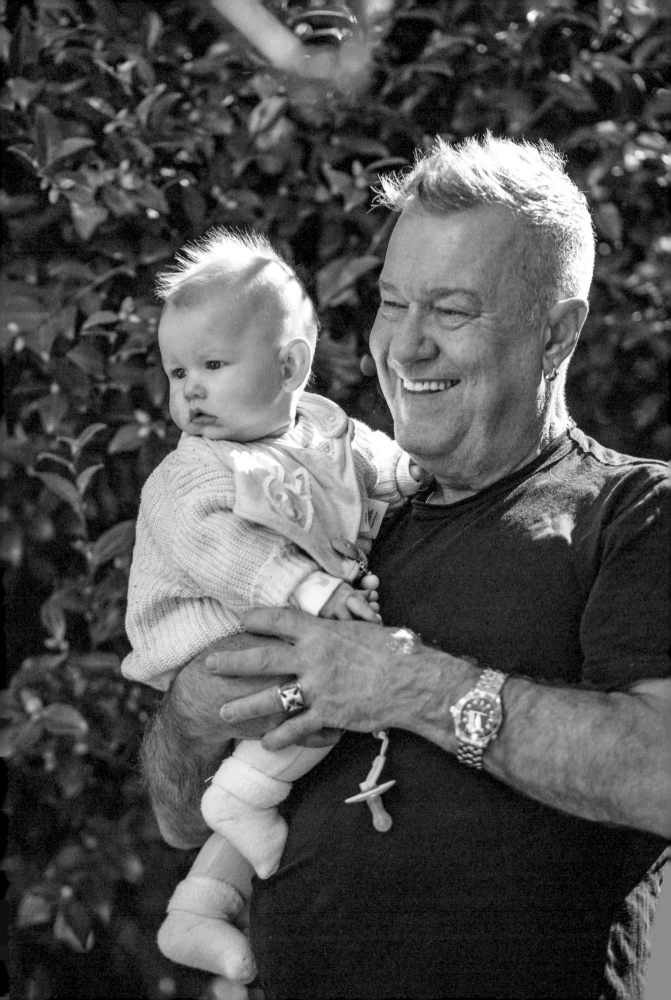

Malted vanilla ice-cream

There's nothing quite like the satisfaction you get from making your own ice-cream. Our favourite flavours are malted vanilla, maple syrup and fresh strawberry, not necessarily in that order. You can use this basic recipe and switch out the malt for any other flavours. You'll need an ice-cream machine for this recipe.

400 ml full-cream milk
 (preferably Jersey)
400 ml double cream
340 ml can creamy
 evaporated milk
1 cup caster sugar
1 teaspoon vanilla extract
7 egg yolks
2 heaped tablespoons
 malted milk powder

Pour the milk, cream and evaporated milk into a saucepan and stir in the sugar and vanilla. Heat over medium heat up to the point just before it bubbles, so the sugar dissolves and mixes in well. Don't let it boil. Take off the heat and let it cool for 10 minutes.

Place the egg yolks into a bowl and mix in the malted milk powder until it becomes a paste.

Very slowly tip the warm milk in a thin stream into the egg mixture, stirring constantly with a whisk all the while, until evenly combined. Cover with plastic wrap and refrigerate until chilled.

Churn the mixture in your ice-cream machine (according to the manufacturer's instructions), until creamy and frozen.

Serve straight away or transfer to an airtight container and freeze. Serve with berries, cakes, tarts, pudding – or just on its own.

A creamy wonder

I HAVE ALWAYS LOVED ICE-CREAM, and it often brings back memories of a particularly exotic version I first encountered on the other side of the world, back in the early 1970s. My parents had been posted to Moscow, and my sister Kaye and I were put into boarding school in Canberra (fortunately, only a couple of kilometres away from Grandpa and Granny, and her shortbread and sponge cakes). In the holidays, however, we would take a thirty-six-hour flight to Moscow, via Singapore, Bahrain, Rome and London. As each school term drew to a close, the arrival of paper tickets and airline bags was much anticipated.

Even after Canberra, Russia was another level of cold. For most of the winter, the air temperature hovered at about −30°C, and outside you could always see your breath and feel the air as it passed icily through your sinuses. We had to wear seal-skin boots and fur sharpkas, hats with flaps that covered your ears and tied up under your chin. Winter sports warmed and excited us, however, and we learned to ice-skate in Gorky Park and cross-country ski through the birch forests surrounding our dacha, or country house.

As foreigners, we were given coupons to purchase goods at the American supermarket. It was a rare thing to find any fresh produce, and buying anything was a long process: we had to find what it was we needed, queue at the cashier to pay for it, then line up at another counter with the receipt to collect the goods. Fortunately, we had to shop for very little – mainly bread – because our cook, Yulia, would bring most of the ingredients for whatever she was going to prepare. Often it was borscht, a hearty beetroot and cabbage soup – as a kid, I wasn't keen on it, but these days I love it when our Yugoslavian–Ukrainian cook, Anna, makes it for us. Or it might have been cabbage leaves stuffed with pork and rice, slow-cooked in a tomato sauce; piroshki, fried yeasty buns filled with seasoned mince and cabbage; beef stroganoff served with pasta, sour cream and paprika; or some other dish, usually featuring lots of paprika and cabbage!

The gastronomic highlight, though, was the fabulously rich and delicious local ice-cream, morozhenoe, which remains on my 'best in the world' list to this day. It's a big call, I know, but when I next go back to Moscow, after a visit to magnificent St Basil's Cathedral in Red Square, morozhenoe will be the next thing on my list. Just to see if the long-lasting memories I have of this creamy wonder can be explained and justified.

Bread and butter pudding

Anything sweet and with custard is always a winner for the sweet-tooths (sweet-teeth?) in this family. This dish is great for using up any not-so-fresh leftover bread. I have used a few brown bread slices in the recipe a couple of times and it works well and looks great too.

10 slices white bread
soft butter, to spread
raspberry jam, to spread
handful sultanas
handful dried cranberries
2 cups milk
300 ml pouring cream
6 eggs
⅔ cup caster sugar
1 teaspoon vanilla extract
pinch ground cinnamon
pinch ground nutmeg
raw sugar, to sprinkle
maple syrup, to drizzle
pouring cream and
 ice-cream, to serve

Preheat the oven to 180°C (160°C fan-forced). Grease a 5 cm deep, 10 cup capacity baking dish.

Cut the crusts off the bread, if you like, then cut the bread slices into triangles. Butter both sides of the bread and lay out one layer in the dish. Spread a thin layer of raspberry jam over and scatter with some sultanas and dried cranberries. Repeat the layering, making sure the top layer is dotted with the red of the jam and dried cranberries.

Whisk the milk, cream, eggs, caster sugar, vanilla, cinnamon and nutmeg together. Pour slowly and evenly over the bread. Sprinkle with raw sugar and drizzle with maple syrup.

Bake for 30 minutes, until the custard has set and the top is golden brown.

If you want to be really fancy, decorate this humble pudding with some gold leaf! Serve with cream and ice-cream.

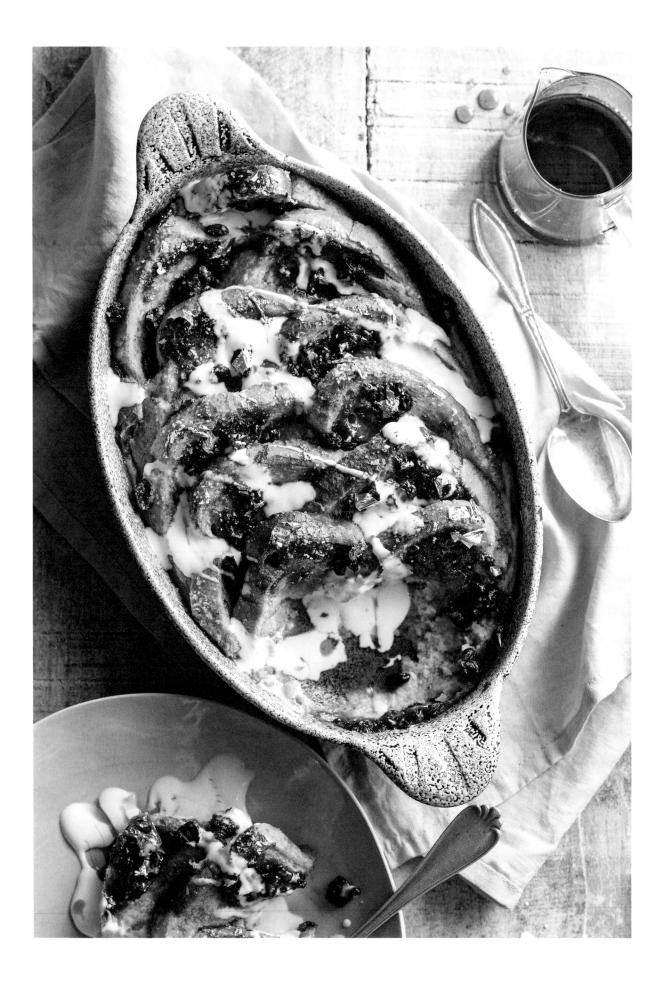

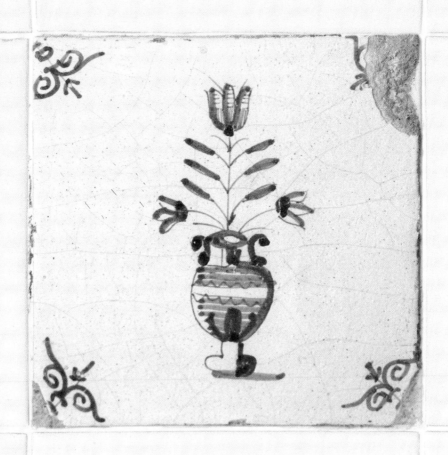

CHAPTER
ELEVEN

Pantry Basics

THESE ARE RECIPES FOR SAUCES, dressings, stocks and pastes that go with or into meals that I often cook. I always have them in my pantry.

Other basics for me include good-quality cooking oil – if you are frying, it makes the world of difference to start with the best oil. When it comes to olive oil, first cold-pressed olive oil is the only type I would use to make a Mediterranean salad dressing. It's great that you can now find so many wonderful oils at delis these days. In 1970, when our family first came back from living in Italy for four years, no olive oil was readily available.

Caramelised balsamic vinegar is another essential. It's perfect just drizzled on an avocado with a pinch of salt and pepper – no fussing!

I use salt on pretty much everything. My preferred sea salt is Maldon, which is now available in supermarkets and greengrocers everywhere. It is not as salty as regular table salt and I use it in most dishes. I use table or cooking salt for boiling pastas or vegetables, and brining.

White pepper is a must for Thai dishes, while black pepper is better for Western meals. But if you only have one type, it's not that important which you use.

This family loves Maggi seasoning sauce. We use it on eggs, rice, in soups, gravies, stews – any dish turns to comfort food with a few shakes of this sauce.

Garlic oil

I use this oil in my Thai soups, rice soup and noodle dishes, so I always keep some handy. You can also mix it with dry or fresh chillies and scatter it over pizzas and pasta. The crunchy garlic is great for heaping over fried fish too.

½ cup rice bran or
grapeseed oil
3 garlic cloves, crushed

Combine oil and garlic in a small saucepan and heat over very low heat for a few minutes, so the garlic is just cooked and lightly golden. Cool and transfer to an airtight jar. Store at room temperature for up to 1 week.

Confit garlic

A confit is any food that has been cooked at a low temperature in oil or fat for a very long time to create a kind of preserve. I often use confit garlic instead of raw garlic, as it's gentler on the digestive system. We can't live without it in our kitchen and use it in all kinds of dishes.

2 heads garlic
1½ cups olive oil

Preheat the oven to 125°C (115°C fan-forced). Separate the garlic cloves and peel them. Place into a small baking dish and cover with the oil.

Cook in the oven for 2 hours, until the garlic is soft and just lightly golden. Cool completely then store in an airtight jar in the fridge for up to 2 weeks.

Persillade (parsley sauce)

'Persil' is the French word for parsley, and persillade is a parsley sauce, much like a salsa verde. When we lived in the south of France, our French friends would serve this on baguette slices with aperitifs before a dinner party. If you are vegetarian or don't like anchovies, you can still make a tasty version of this, adding a bit of salt and garlic or even other fresh herbs such as rosemary, thyme or oregano. We have persillade with grilled steaks or lamb, frittata, boiled potatoes – anything that serves as a vessel for it, in fact. It's so easy, you can whip it up in 10 minutes.

1 bunch flat-leaf parsley, finely chopped (all but the thick stalks)
80 g anchovy fillets
2 garlic cloves, crushed (see Cook's Notes)
1 small red chilli, deseeded and finely chopped
½ teaspoon dried chilli flakes
½ cup extra virgin olive oil
freshly ground black pepper

Place the chopped parsley in a mixing bowl. Pull the anchovy fillets into skinny strips and add to the bowl, along with the garlic, fresh chilli and chilli flakes.

Add the olive oil, season with pepper and mix well. Taste and adjust the flavours to your liking.

[COOK'S NOTES]

Use confit garlic (above) if you're feeding sensitive stomachs. This recipe is best made with a good-quality, first cold-pressed olive oil.

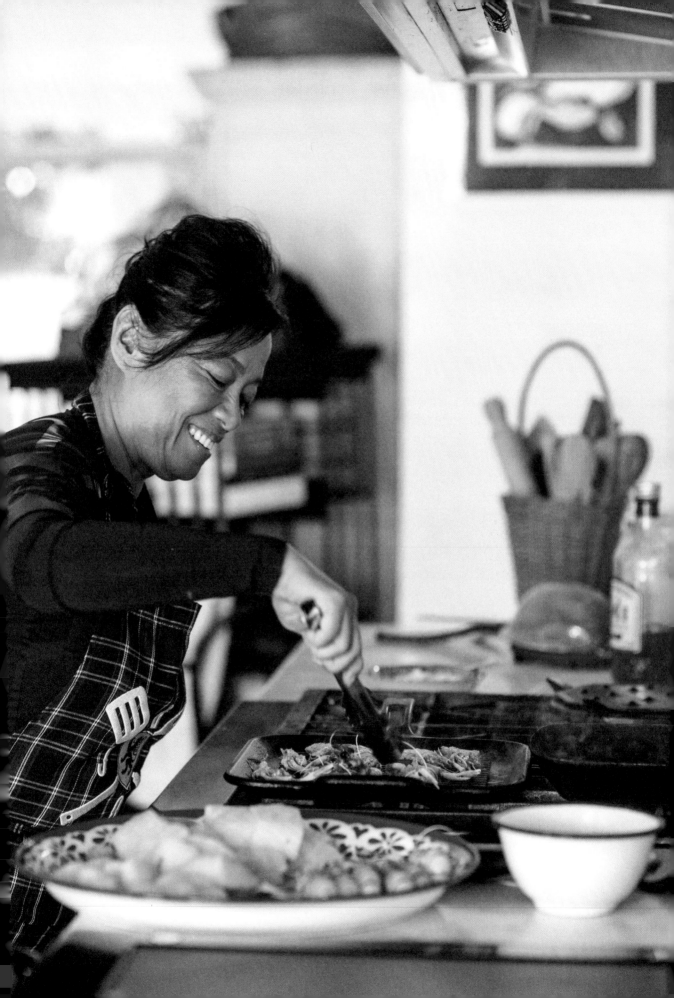

Vegetable stock

I make stock at least once a week. It's handy to have in the fridge or in the freezer. I use as much of our vegetable scraps and peels as I can. Whenever I prepare veggies, I save the ends and peels in a bag in the fridge, whether it be onion skin, carrot ends, spinach stalks, outer cabbage leaves or broccoli stems. Any vegetables that have seen better days can be used up in stock too.

celery stalks, chopped
carrots, chopped
veggie peels and ends
vegetables that you may
 want to use up
1 onion, cut into quarters
 (skin on is fine)
3 garlic cloves, flattened
2 bay leaves
parsley
1 tablespoon salt
1 tablespoon peppercorns
1 tablespoon vegetable
 stock powder (optional,
 I use Vegeta)

Place everything into a large saucepan or stockpot and add water until it is two-thirds full. Bring to the boil and turn the heat to medium-low and let it bubble gently away for about an hour. Always taste what you cook and adjust to what tastes good for you.

Cool slightly then strain to remove the solids. You can portion the stock into smaller amounts and freeze for later use, or keep in the fridge for up to 5 days.

[COOK'S NOTES]

For chicken stock, start with 2 or 3 chicken carcasses then add the ingredients as for the vegetable stock. My butcher always has chicken carcasses, mostly fresh; if not, frozen ones are fine. You can add a spoonful of chicken stock powder, if you like. For beef stock, use beef bones instead of chicken. Ask your butcher for the best ones to use.

Shellfish stock

You'll need 2 cups of this stock for the zuppa di pesce (page 180). Any leftover stock can be frozen. It's great to use in any seafood dish, such as risotto.

2 tablespoons olive oil
1 brown onion, chopped
sea salt
lobster, crab, prawn or
 Balmain bug heads
 and shells (see Cook's
 Notes)
½ fennel bulb, sliced
3 garlic cloves, chopped
2 bay leaves
½ teaspoon black
 peppercorns
½ cup dry white wine
vegetable stock powder
 (optional)
pinch saffron threads

Heat the olive oil in a large saucepan or stockpot over medium heat. Add the onion and a pinch of salt and cook for a few minutes, until soft. Add the heads and shells, fennel, garlic, bay leaves and peppercorns. Keep cooking, stirring occasionally, until well browned and starting to catch on the bottom of the pot.

Deglaze with the wine, scraping all the sticky bits from the bottom and bringing it all together. Use a wooden spoon to smash the heads and shells to release more of the juices.

Cover with water and bring to the boil. Reduce the heat to medium-low and gently simmer for 20 minutes, checking and stirring now and again. Have a taste, as you may need more salt or even a spoonful of stock powder. Throw in a few saffron threads and leave for a few minutes for the colour to infuse.

Strain the stock through a fine sieve. Return the liquid to a clean pan and simmer further, until the flavour has intensified to your taste.

[COOK'S NOTES]

If you are making zuppa di pesce, use the heads and shells from the 2 lobsters in the recipe to make this stock.

Green curry paste

You will need a mortar and pestle for this – you can get them from most Asian grocery stores. I have a large, heavy, stone one.

4 cm knob young ginger

4 cm knob galangal

2 cm knob turmeric

2 lemongrass stalks

peel of 1 makrut lime

4 makrut lime leaves, chopped

2 garlic cloves

4 coriander roots, cleaned

string of fresh green peppercorns (see Cook's Notes)

2 small red eschalots

6 long green chillies, with seeds if you want heat

sea salt

1 teaspoon shrimp paste

Chop the ginger, galangal, turmeric and lemongrass into small chunks and start pounding in the mortar and pestle with the makrut peel and leaves. I begin with the tougher, stringier ingredients, because they take a bit more pounding than the softer ones.

Once the mixture starts becoming paste-like, chop the other ingredients, then add and pound in. Salt generously – the crystals will help cut through the fibres and pulp. Add shrimp paste at the end and mix in well. I find my paste is never as smooth as bought paste, but I'm really happy with that.

[COOK'S NOTES]

Fresh green peppercorns are available from Asian grocers and some large greengrocers. Alternatively, use 1 tablespoon canned green peppercorns.

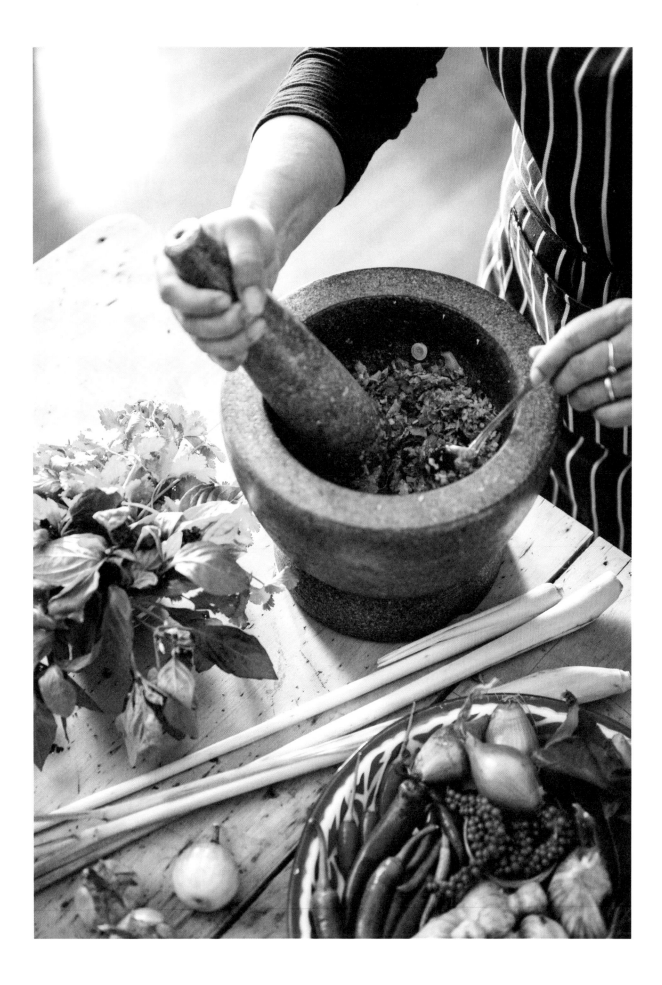

Japanese toasted sesame salad dressing

We love a great sesame dressing, and this one is really quick and simple to make. This dressing is delicious with noodles, rice bowls, salads – just about anything. As an alternative to making your own, I can highly recommend the Kewpie brand Roasted Sesame Japanese Dressing.

⅓ cup sesame seeds
 (white, black or a mix!)
¼ cup rice vinegar
1 tablespoon shoyu
 (Japanese soy sauce)
2 teaspoons brown sugar
1 teaspoon sesame oil
1 teaspoon mirin

Toast the sesame seeds in a small pan over low heat, tossing them around so they colour evenly. They're ready when they turn a light brown colour and start to pop. Cool slightly then use a mortar and pestle to grind into a powder.

Place the sesame powder in a bowl and stir in the remaining ingredients. Taste and add more shoyu, if you'd like it saltier, or mirin and/or brown sugar, if you want it sweeter.

Ginger, green shallot and sesame sauce

I always keep this sauce at hand for serving with Hainan chicken.

4 green shallots, white and
 pale green parts, sliced
sea salt
5-8 cm piece young ginger,
 finely grated
⅓ cup sesame oil

Sprinkle the sliced green shallots with sea salt and finely chop. Combine in a bowl with the ginger and mix well.

Heat the sesame oil in a small saucepan over medium-low heat, until just warm. Add to ginger and shallots and mix well.

[COOK'S NOTES]

I like Spiral Foods' Organic Sesame Oil because it has a mild flavour.

Sweet soy sauce with chilli

If you add a splash of this sauce to any stir-fry, it will give the dish a sticky sweetness – and you won't get any complaints from the kids. It's the essential sauce for Hainan chicken; I heat it up with chillies and ginger for the adults and leave it plain for the little ones.

½ cup kecap manis (thick sweet soy sauce)

3 cm knob ginger, finely grated

6 coriander leaves, finely chopped (some stalk is okay)

1 garlic clove, crushed

1 teaspoon yellow soybean paste (optional)

1 teaspoon brown sugar

½ long green chilli, sliced

½ long red chilli, sliced

1–2 teaspoons chicken stock (page 298), if needed

Mix all the ingredients (except the stock) together in a bowl. If you need to thin out the sauce, stir in a little chicken stock.

Thai seafood sauce (nam jim)

Most visitors to Thailand will know this seafood sauce as nam jim.
It's great for enhancing the flavour of all seafood, especially deep-fried
crispy fish, steamed crab legs and grilled lobster.

1 coriander root, cleaned

1 garlic clove

1 long green chilli, sliced

1 small red bird's-eye chilli,
 sliced

⅓ cup fish sauce

1 tablespoon lime juice

1 teaspoon palm sugar

Use a mortar and pestle to crush the coriander root, garlic and chillies. You want to keep a bit of texture in the mixture, so don't grind to a pulp.

Combine the mixture in a small bowl with the fish sauce, then stir in the lime juice and palm sugar.

Taste and, if needed, add more lime, fish sauce, sugar and/or chilli. You're looking for a balance of salty, sour, sweet and hot – the golden rule of Thai cuisine.

[COOK'S NOTES]

If you don't like too much heat, remove the seeds from the chillies. And remember to always wash your hands after handling chillies, as it will burn if you accidentally touch your eyes or face.

How to brine

Brining isn't an absolutely necessary step when you're cooking meat or chicken, but, if you have the time to do it, it makes all the difference – it both tenderises and infuses flavour. Speaking of flavour, the only rule for what you add to the brine mix is that it is to your taste.

A basic brine is 8 parts water to 1 part salt by volume. I just use table salt for this.

Make up the brine by stirring salt into the cold water, in a large enough container to hold your meat so that it will be fully submerged. Choose a glass, ceramic or plastic container rather than metal.

Add your favourite flavourings – choose flavours that will complement the recipe the meat is to be used in. We often use a dash of Maggi sauce, apple cider vinegar, bay leaves, peppercorns, garlic and fresh herbs. For Asian recipes, include flavours such as ginger, chilli and soy sauce.

Add the meat, cover and refrigerate for at least 4 hours, or up to 24 hours. Drain well and pat dry before cooking.

You can also brine in beer – see the pork chop recipe on page 254.

Index

A

Anna's crêpes 37
Anna's lemon cheesecake 281
Anna's meatballs with mushroom
 sauce 144
Anzac biscuits 270
asparagus with orange zest 232

B

baby squid stuffed with pork in
 chicken & shiitake broth 123
baked cheesy fennel 229
bangers & mash with onion
 gravy 140
barbecue chicken rubbed with
 Berbera spice 248
beef: roast fillet with porcini & wild
 mushroom jus, roasted eschallots
 & peas 170
beetroot: homegrown organic 223
biscuits: Anzac 270
black pudding stuffing 251
blueberry, plum & walnut tart 282
bread & butter pudding 290
brining 305
brown sugar carrots 151
Brussels sprouts (caramelised)
 with bacon 218
burnt cauliflower, caramelised onions
 & shiitake mushrooms 216
buttery grilled potatoes 244

C

cake: Anna's lemon cheesecake 281
campfire eggs 30
caramelised Brussels sprouts with
 bacon 218

caramelised onions, burnt
 cauliflower, & shiitake
 mushrooms 216
caramelised roasted witlof &
 radicchio 226
carrots: brown sugar 151
cauliflower (burnt), caramelised
 onions & shiitake mushrooms 216
champagne chicken 187
charcoal barbecue marinated pork
 skewers 108
chargrilled beer-brined pork
 chops 254
chargrilled grass-fed rib-eye
 steaks 244
charred corn salad 254
cheese toastie 74
cheesecake, Anna's lemon 281
cheesy creamy mixed potato
 mash 196
chicken
 barbecue, rubbed with
 Berbera spice 248
 & boiled eggs in sweet soy
 sauce 124
 champagne 187
 -fat rice 130
 green curry, Thai 113
 macaroni, Thai 128
 roast saltbush, with root
 vegetables 176
 schnitzels stuffed with Comté
 cheese & spinach 142
 steamed 130
 Thai-style Hainan 130
comfort ragu 95
confit garlic 295
corn salad, charred 254
cottage pie 147

creamy potato bake with chestnuts,
 rosemary & garlic 198
crêpes, Anna's 37
curry
 chicken, Thai green 113
 paste, green 300
 roast duck, red 114

D

dressings & sauces
 garlic oil 294
 ginger, green shallot & sesame
 sauce 302
 Japanese toasted sesame salad
 dressing 302
 lemon vinaigrette 260
 mushroom sauce 144
 parsley sauce 295
 persillade 295
 sage butter sauce 90
 sweet soy sauce with chilli 303
duck
 with black pudding stuffing 251
 red curry 114

E

egg noodle & wonton soup 65
eggplant pasta, Jimmy's Sicilian 98
eggs
 campfire 30
 & chicken in sweet soy sauce 124
 lobster tail scrambled 54
 potato, cheese & herb frittata 58
 Rico 30
eschallots, roasted 170

F

fancy potato salad 207
fennel: baked cheesy 229
fish & seafood
 baby squid stuffed with pork in chicken & shiitake broth 123
 khao tom goong (rice & prawn soup) 44
 lobster tail scrambled eggs 54
 rainbow trout tagine 159
 sang choi bow 152
 seafood soup 180
 seared tuna fillets with spinach, mushrooms & toasted sesame dressing 70
 Thai deep-fried whole fish 118
 zuppa di pesce 180
French toast 32
frittata: potato, cheese & herb 58

G

garden greens & ricotta gnudi with sage butter sauce 90
garlic
 confit 295
 oil 294
ginger, green shallot & sesame sauce 302
gnudi (garden greens & ricotta) with sage butter sauce 90
grain-free muesli 28
Grandma Violet's shortbread 274
gravy
 Jimmy's 178
 onion 140
 see also jus
green curry paste 300
grilled lamb cutlets with brown sugar carrots 151
grilled spiced lamb fillets 259

H

Hainan chicken (Thai style) 130
homegrown organic beetroot 223
homemade pasta 80

I

ice-cream: malted vanilla 286
Italian sausage pasta 96

J

Japanese toasted sesame salad dressing 302
Jimmy's chargrilled vegetable stack 260
Jimmy's gravy 178
Jimmy's Sicilian eggplant pasta 98
jus 178
 porcini & wild mushroom 170
 see also gravy

K

khao tom goong 44

L

lamb
 cutlets with brown sugar carrots 151
 grilled spiced fillets 259
 slow-roasted shoulder with lemon & oregano potatoes 168
leftover-roast sandwiches 73
lemon
 cheesecake, Anna's 281
 vinaigrette 260
lobster tail scrambled eggs 54

M

mac & cheese 87
macaroni: Thai chicken 128

malted vanilla ice-cream 286
mash 140
 cheesy creamy mixed potato 196
meatballs with mushroom sauce, Anna's 144
moo ping 108
muesli, grain-free 28
mushroom
 jus 170
 sauce 144
 shiitake, burnt cauliflower & caramelised onions 216

N

nam jim 304
new potatoes boiled in stock with bay leaves & peppercorns 206

O

onion
 burnt cauliflower, & shiitake mushrooms 216
 gravy 140
osso buco 184

P

parsley sauce 295
pasta
 garden greens & ricotta gnudi with sage butter sauce 90
 homemade 80
 Italian sausage 96
 Jimmy's Sicilian eggplant 98
 mac & cheese 87
 ragu 95
 tagliatelle in creamy porcini mushroom sauce 84
 Thai chicken macaroni 128
peas 170
 with roasted tomatoes 235
persillade (parsley sauce) 295
plum, blueberry & walnut tart 282

porcini & wild mushroom jus 170
pork
 charcoal barbecue marinated
 skewers 108
 chargrilled beer-brined chops 254
 -stuffed baby squid in chicken
 & shiitake broth 123
porridge volcano 40
potato
 bake with chestnuts, rosemary
 & garlic 198
 baked with tomatoes, eschallots
 & saffron 199
 boiled in stock with bay leaves
 & peppercorns 206
 buttery grilled 244
 cheese & herb frittata 58
 mash 140
 mash, cheesy creamy 196
 roasted with garlic &
 rosemary 204
 salad, fancy 207
prawn
 & rice soup 44
 seafood sang choi bow 152
pudding: bread & butter 290

R

radicchio & witlof: caramelised
 roasted 226
ragu 95
rainbow trout tagine 159
red curry with roast duck 114
rice
 chicken-fat 130
 & prawn soup 44
ricotta filling (savoury) 66
Riverbend spanakopita 60
roast duck with black pudding
 stuffing 251
roast fillet of beef with porcini
 & wild mushroom jus, roasted
 eschallots & peas 170

roast potatoes with garlic
 & rosemary 204
roast saltbush chicken with
 root vegetables 176
roasted eschallots 170

S

sage butter sauce 90
salad
 charred corn 254
 dressing, Japanese toasted
 sesame 302
sandwiches
 leftover-roast 73
sang choi bow 152
sauces – *see* dressings & sauces
sausage
 & mash with onion gravy 140
 pasta, Italian 96
seafood
 sang choi bow 152
 seafood soup 180
 see also fish & seafood
seared tuna fillets with spinach,
 mushrooms & toasted sesame
 dressing 70
shellfish stock 299
shiitake mushrooms, burnt
 cauliflower & caramelised
 onions 216
shortbread: Grandma Violet's 274
skewers: charcoal barbecue
 marinated pork 108
slow-roasted Greek lamb shoulder
 with lemon & oregano
 potatoes 168
soup
 egg noodle & wonton 65
 khao tom goong 44
 seafood 180
spanakopita 60
squid stuffed with pork in chicken
 & shiitake broth 123

steaks: chargrilled grass-fed
 rib-eye 244
steamed chicken 130
stock
 shellfish 299
 vegetable 298
stone fruit baked in muscat
 & champagne 278
stuffed zucchini flowers 66
sweet soy sauce with chilli 303

T

tagliatelle in creamy porcini
 mushroom sauce 84
tart: plum, blueberry & walnut 282
Thai chicken macaroni 128
Thai deep-fried whole fish 118
Thai green chicken curry 113
Thai seafood sauce (nam jim) 304
toastie, cheese 74
tomatoes, roasted 235
 with peas 235
tuna fillets with spinach, mushrooms
 & toasted sesame dressing 70

V

vegetable
 stack, chargrilled 260
 stock 298
vinaigrette, lemon 260

W

witlof & radicchio: caramelised
 roasted 226
wontons 65

Z

zucchini flowers, stuffed 66
zuppa di pesce 180

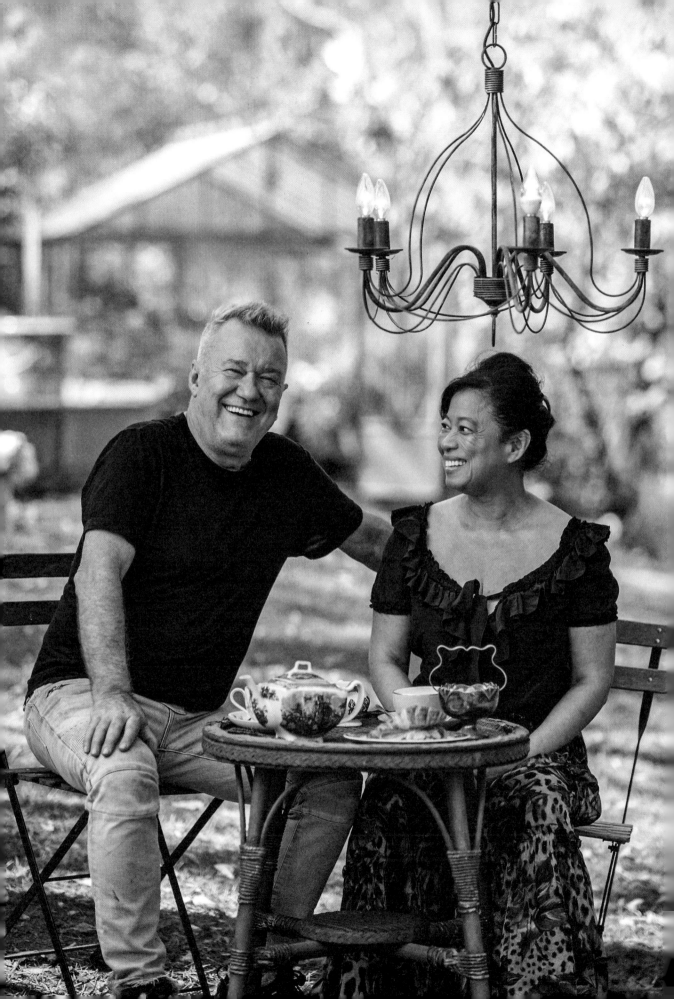

Acknowledgements

We would like to acknowledge the hard work of all our friends at HarperCollins, with special thanks to Helen Littleton, Scott Forbes, Mark Campbell, Fiona Luke, Janelle Garside, Alice Wood, Georgia Williams and Karen-Maree Griffiths.

Thank you Alan Benson for your beautiful photos, Tracy Rutherford for editing the recipes and getting them right, chef James Callaway for recreating all our favourites, Emily O'Neill for the design of the book, Deborah Kaloper for food styling and Kate McAuley for assistance with compiling the recipes. Mia Hawkswell, thanks for always making us look good.

Special thanks to our dear friends John Watson and Rina Ferris. You guys rock.

Thanks to Sharon Finn (Sharondelier) for providing the chandeliers. And a big shout-out to Jep Lizotte, Mahalia Barnes and Stephanie Barnes for helping with the shoots. We love you so much.

Each and every one of you has helped transform this book from a dream into a reality. It means the world to us and so do you.

Let's eat, drink and make music!

Jane and Jimmy

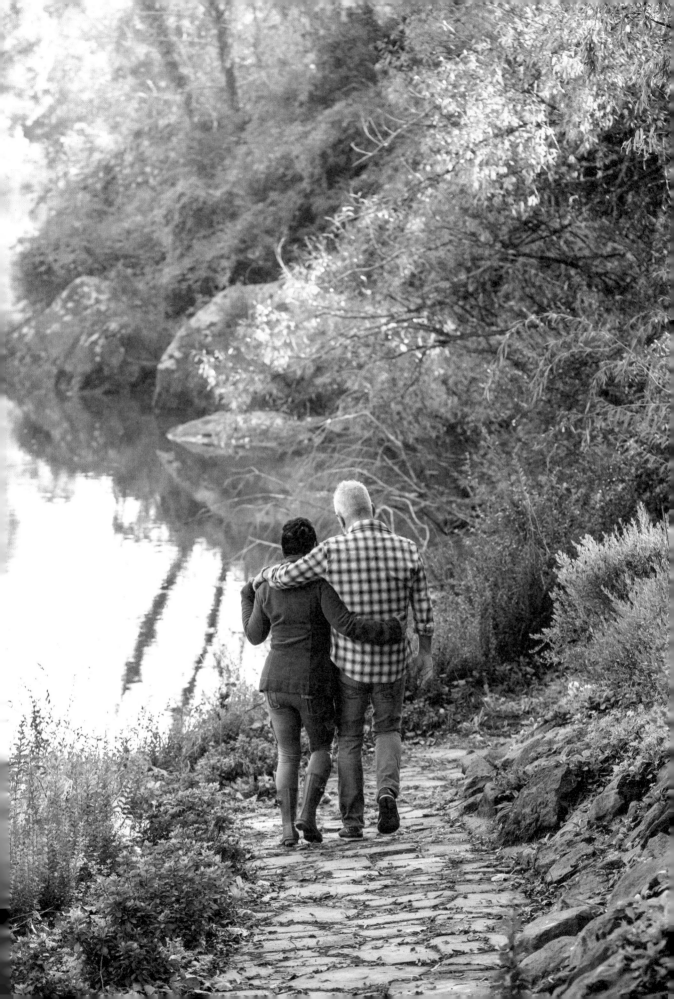

JANE AND JIMMY BARNES have spent forty years together, sharing a life of music, cooking and travel and raising their family. During that time, Jimmy has become one of the most successful artists in Australian music history, selling more records locally than any other rock 'n' roll artist and scoring eighteen number one albums. Unable to tour during the Covid-19 pandemic, Jane and Jimmy launched a series of 'at home' online performances, which attracted more than 100 million views on social media and brought their many thousands of fans and followers directly into the Barneses' living room.

HarperCollins_Publishers_

Australia • Brazil • Canada • France • Germany • Holland • Hungary
India • Italy • Japan • Mexico • New Zealand • Poland • Spain • Sweden
Switzerland • United Kingdom • United States of America

First published in Australia in 2021
by HarperCollins*Publishers* Australia Pty Limited
Level 13, 201 Elizabeth Street, Sydney NSW 2000
ABN 36 009 913 517
harpercollins.com.au

A catalogue record for this book is available from the National Library of Australia

ISBN 978 1 4607 6004 8 (hardback)

Art direction: Mark Campbell, HarperCollins Design Studio
Cover and internal design by Emily O'Neill
All photography by Alan Benson, except pages 230 and 237, by Stephanie Barnes
Stylist: Deborah Kaloper
Home economist: James Callaway
Recipe editor: Tracy Rutherford
Colour reproduction by Splitting Image Colour Studio, Clayton VIC
Printed and bound in China by RR Donnelley on 140gsm woodfree

8 7 6 5 4 3 2 1 21 22 23 24

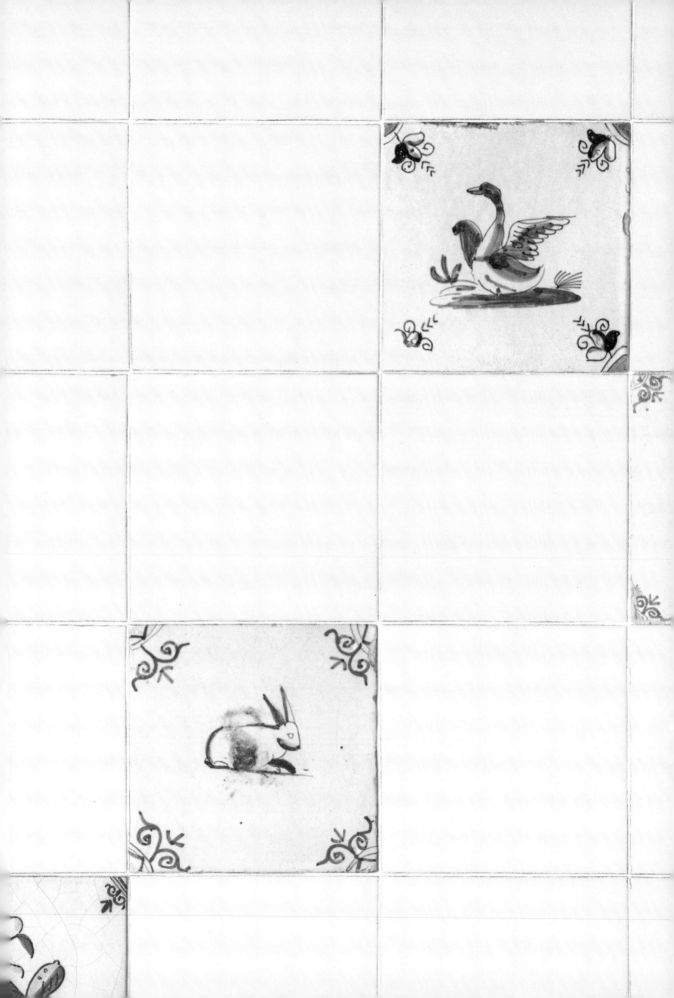